Scoundrels, Cads, and Other Great Artists

Scoundrels, Cads, and Other Great Artists

Jeffrey K. Smith

ROWMAN & LITTLEFIELD
Lanham • Boulder • New York • London

Published by Rowman & Littlefield
A wholly owned subsidiary of The Rowman & Littlefield Publishing Group, Inc.
4501 Forbes Boulevard, Suite 200, Lanham, Maryland 20706
www.rowman.com

6 Tinworth Street, London SE11 5AL, United Kingdom

Copyright © 2020 by The Rowman & Littlefield Publishing Group, Inc.

All rights reserved. No part of this book may be reproduced in any form or by any electronic or mechanical means, including information storage and retrieval systems, without written permission from the publisher, except by a reviewer who may quote passages in a review.

British Library Cataloguing in Publication Information Available

Library of Congress Cataloging-in-Publication Data

Names: Smith, Jeffrey K., author.
Title: Scoundrels, cads, and other great artists / Jeffrey K. Smith.
Description: Lanham : Rowman & Littlefield, [2020] | Includes
 bibliographical references and index. | Summary: "Scoundrels, Cads, and
 Other Great Artists introduces people to great art by showing the more
 salacious side of the personal lives of great artists. The book not only
 tells the stories of nine artists, but explores how to look at art and
 the separation between art and artist. This lively narrative is enhanced
 by over 100 full-color images"— Provided by publisher.
Identifiers: LCCN 2020011083 (print) | LCCN 2020011084 (ebook) | ISBN
 9781538126776 (cloth) | ISBN 9781538126783 (ebook)
Subjects: LCSH: Artists—Biography—Anecdotes. | Deviant
 behavior—Anecdotes. | Art appreciation.
Classification: LCC N7460 .S647 2020 (print) | LCC N7460 (ebook) | DDC
 700.92/2 [B]—dc23
LC record available at https://lccn.loc.gov/2020011083
LC ebook record available at https://lccn.loc.gov/2020011084

∞™ The paper used in this publication meets the minimum requirements of American National Standard for Information Sciences—Permanence of Paper for Printed Library Materials, ANSI/NISO Z39.48-1992.

Scoundrels, Cads and Other Great Artists is dedicated to my brothers,
Timothy D. Smith, Gregory P. Smith, and Kevin H. Smith.

I am immensely proud of all you've accomplished in your lives and of your wonderful families. To Tim and Greg, I forgive you for tying me to my play pen along with my stuffed bears when I was two, and to Kevin, I apologize for throwing that hose nozzle through your lower lip when we were six and four. Sorry about that.

Contents

List of Figures		ix
Acknowledgments		xv
Preface		xvii
1	Introduction: The Rogues' Gallery	1
2	Caravaggio: A Life in Chiaroscuro	9
3	Courbet: The Most Arrogant Man in the World	23
4	Whistler: Peacock Pugnacious	41
5	Gentileschi: A Woman for All Seasons	59
6	Remington: The Cowboy from New Rochelle	75
7	Schiele: Moth to the Flame	91
8	Yoshitoshi: Holding Back the Night	107
9	Pollock/Krasner: Collision Course	121
10	Conclusion: Finding Your Own Scoundrel	137
Notes		145
Recommended Readings		153
References		157
Index		163
About the Author		171

List of Figures

1.1	*David*, Michelangelo, 1501–1504. Galleria del Accademia, Florence.	xx
1.2	*The Birth of Venus*, Botticelli, 1485–1486. Uffizi Gallery, Florence.	1
1.3	*Proserpine*, Dante Gabriel Rossetti, 1874. Tate Britain, London.	2
1.4	*The Third of May 1808, in Madrid*, Francisco de Goya, 1814. Museo del Prado, Madrid.	3
1.5	*Back View*, Philip Guston, 1977. San Francisco Museum of Modern Art.	4
1.6	*Still Life with Apples and a Pot of Primroses,* Paul Cézanne, 1906. The Metropolitan Museum of Art, New York.	5
2.1	*A drawing of Caravaggio*, Ottavio Leoni, circa 1621. Biblioteca Marucelliana, Florence.	8
2.2	*The Beheading of St. John the Baptist*, Michelangelo Merisi da Caravaggio, 1608. St. John's Co-Cathedral, Malta.	9
2.3	*The Cardsharps*, Michelangelo Merisi da Caravaggio, 1594. Kimbell Art Museum, Fort Worth, Texas.	11
2.4	*Bacchus*, Michelangelo Merisi da Caravaggio, 1595. Uffizi Gallery, Florence.	12
2.5	*The Conversion of Mary Magdalene* (Also: *Martha and Mary Magdalene*), Michelangelo Merisi da Caravaggio, 1598. Detroit Institute of Arts.	13
2.6	*Portrait of Alof de Wignacourt*, Michelangelo Merisi da Caravaggio, 1607–1608. The Louvre, Paris.	15
2.7	*David with the Head of Goliath*, Michelangelo Merisi da Caravaggio, 1610. Galleria Borghese, Rome.	16
2.8	*Madonna with the Long Neck*, Girolamo Francesco Maria Mazzola, "Parmagiano," 1534–1540. Uffizi Gallery, Florence.	18

2.9	*The Crucifixion of Saint Peter*, Michelangelo Merisi da Caravaggio, 1601. Santa Maria del Popolo, Rome.	19
2.10	*The Supper at Emmaus*, Michelangelo Merisi da Caravaggio, 1601. National Gallery, London.	20
3.1	*Self-Portrait (Man with Pipe)*, Gustave Courbet, 1848–1849. Musée Fabre, Montpellier.	22
3.2	*Woman with a Parrot*, Gustave Courbet, 1866, The Metropolitan Museum of Art, New York.	23
3.3	*Self-Portrait with a Black Dog*, Gustave Courbet, 1842–1844. Petit Palais, Paris.	25
3.4	*Man in Despair*, Gustave Courbet, 1841(?). Private Collection.	26
3.5	*Liberty Leading the People*, Eugene Delacroix, 1830. The Louvre, Paris.	28
3.6	*Joséphine-Éléonore-Marie-Pauline de Galard de Brassac de Béarn (1825–1860), Princess de Broglie*, Jean Auguste Dominque Ingres, 1851–1853. The Metropolitan Museum of Art, New York.	29
3.7	*After Dinner at Ornans*, Gustave Courbet, 1848. Palais des Beaux-Arts de Lille, Lille, France.	31
3.8	*A Burial at Ornans*, Gustave Courbet, 1849–1850. Musée d'Orsay, Paris.	32
3.9	*The Sleeping Spinner*, Gustave Courbet, 1853. Musée Fabre, Montpellier.	34
3.10	*Caricature of Courbet*, Andre Gill, 1867.	36
3.11	*The Painter's Studio: A real allegory summing up seven years of my artistic and moral life*, Gustave Courbet, 1855. Musée d'Orsay, Paris.	38
4.1	*Portrait of Whistler*, William Merritt Chase, 1885. The Metropolitan Museum of Art, New York.	40
4.2	*Milly Finch*, James McNeill Whistler, 1884. Freer Gallery of Art and the Arthur M. Sackler Gallery, Washington, DC.	41
4.3	*Sketches on the Coast Survey Plate*, James McNeill Whistler, 1854–1855. The Metropolitan Museum of Art, New York.	43
4.4	*Fumette, etching*, James McNeill Whistler, 1858. The Metropolitan Museum of Art, New York.	44
4.5	*Symphony in White No. 1: The White Girl*, James McNeill Whistler, 1861. National Gallery of Art, Washington, DC.	45
4.6	*Crepuscule in Flesh Colour and Green—Valpariso*, James McNeill Whistler, 1866. Tate Britain, London.	47

LIST OF FIGURES

4.7	*Arrangement in Grey and Black: Portrait of the Artist's Mother*, James McNeill Whistler, 1870. Musée d'Orsay, Paris.	48
4.8	*Whistler's butterfly signatures*, James McNeill Whistler. James McNeill Whistler Collection, Boston Public Library.	49
4.9	*Nocturne in Black and Gold, the Falling Rocket*, James McNeill Whistler, 1875. Detroit Institute of Arts.	51
4.10	*Marianna*, John Everett Millais, 1851. Tate Britain, London.	53
4.11	*The Embroidered Curtain*, James McNeill Whistler, 1889. The Metropolitan Museum of Art, New York.	55
4.12	*Nocturne in Blue and Gold: Old Battersea Bridge*, James McNeill Whistler, 1872–1875. Tate Britain, London.	56
5.1	*Allegory of Painting*, Artemisia Gentileschi, 1638–1639. Royal Collection, London.	58
5.2	*Susanna and the Elders*, Artemisia Gentileschi, 1610. Schloss Weißenstein, Pommersfelden.	59
5.3	*Judith and Holofernes*, Artemisia Gentileschi, 1612–1613. Uffizi Gallery, Florence.	61
5.4	*Cleopatra*, by either Artemisia Gentileschi or Orazio Gentileschi, either 1613, or 1621–1622, Amedeo Morandotti Collection, Milan.	63
5.5	*Drawing of the Hand of Artemisia Gentileschi with Paintbrush*, 1625. Pierre Dumonstier le Neveu, British Museum, London.	65
5.6	*Allegory of Inclination*, Artemesia Gentileschi, 1615–1616. Casa Buonarroti, Florence.	67
5.7	*Sleeping Venus,* Artemesia Gentileschi, 1625. Virginia Museum of Fine Arts, Richmond.	69
5.8	*Jael and Sisera*, Artemesia Gentileschi, 1620. Museum of Fine Arts, Budapest.	70
5.9	*Judith and Her Maidservant*, Artemesia Gentileschi, 1613–1614 (?). Palazzo Pitti, Florence.	72
6.1	Photograph of Remington, 1888. Frederic Remington Art Museum, Ogdensburg, New York.	74
6.2	*Self-Portrait*, Frederic Remington, 1890. Sid Richardson Museum, Fort Worth, Texas.	75
6.3	*Cow-boys of Arizona—Roused by a Scout,* William Allen Rogers and Frederic Remington, 1882.	77

LIST OF FIGURES

6.4	*In from the Night Herd*, Frederic Remington, 1886. The Museum of Fine Arts, Houston.	79
6.5	*A Dash for the Timber*, Frederic Remington, 1889. Amon Carter Museum of American Art, Fort Worth, Texas.	81
6.6	*Illustration for "Chicago Under the Mob" in Harper's Weekly*, Frederic Remington, 1894.	83
6.7	*An Indian Trapper*, Frederic Remington, 1889. Amon Carter Museum of American Art, Fort Worth, Texas.	84
6.8	*The End of the Day*, Frederic Remington, 1904. The Frederic Remington Art Museum, Ogdensburg, New York.	85
6.9	*The Bronco Buster*, Frederic Remington, 1895. The Metropolitan Museum of Art, New York.	86
6.10	*The Outlier*, Frederic Remington, 1909. The Brooklyn Museum, New York.	87
6.11	*The Scout: Friends or Foes*, Frederic Remington, 1902–1905. Sterling and Francine Clark Art Institute, Williamstown, Massachusetts.	88
7.1	*Self-Portrait*, Egon Schiele, 1912. Leopold Museum, Vienna.	90
7.2	*Seated Woman with Bent Knee*, Egon Schiele, 1917. National Gallery, Prague.	91
7.3	*Trieste Harbor*, Egon Schiele, 1907. Neue Galerie am Landesmuseum, Graz.	93
7.4	*Judith II (Salome)*, Gustav Klimt, 1909. Galleria d'Arte Moderna, Venice.	95
7.5	*Woman with Black Hat (or Standing Girl in a Plaid Garment)*, Egon Schiele, 1910. Minneapolis Institute of Art, Minneapolis.	95
7.6	*Standing Nude with Large Hat (Gertrude Schiele)*, Egon Schiele, 1910. Private Collection.	96
7.7	*Portrait of Wally*, Egon Schiele, 1912. Leopold Museum, Vienna.	97
7.8	*Reclining Woman*, Egon Schiele, 1917. Private Collection.	98
7.9	*Galerie Arnot Poster*, Egon Schiele, 1914.	100
7.10	*Four Trees*, Egon Schiele, 1917. Belvedere Gallery, Vienna.	100
7.11	*Summer Landscape, Krumau*, Egon Schiele, 1917. Private Collection.	101
7.12	*Reclining Nude*, Egon Schiele, 1911. Albertina Museum, Vienna.	103
7.13	*The Family*, Egon Schiele, 1918. Belvedere Gallery, Vienna.	104
8.1	*Portrait of Yoshitoshi*, Tanaki Toshikage, 1894. Art Gallery of New South Wales.	106

LIST OF FIGURES xiii

8.2	*Jade Rabbit—Sun Wukong*, Tsukioka Yoshitoshi, 1889. Art Gallery of New South Wales.	107
8.3	*The Woman Kansuke Slaying an Assailant with a Sword*, Tsukioka Yoshitoshi, 1866. Los Angeles County Museum of Art, Los Angeles.	110
8.4	*The Wrestler Chōgorō Throwing a Devil,* Tsukioka Yoshitoshi, 1866. Los Angeles County Museum of Art, Los Angeles.	111
8.5	*Sketch of Hanai Oume Killing*, Tsukioka Yoshitoshi, c. 1887. Los Angeles County Museum of Art, Los Angeles.	113
8.6	*Hanai Oume Killing Minekichi*. Tsukioka Yoshitoshi, 1887. Los Angeles County Museum of Art, Los Angeles.	114
8.7	*Wanting to Meet Someone: A Courtesan of the Kaei Period (1848–1853)*, Tsukioka Yoshitoshi, 1888. Los Angeles County Museum of Art, Los Angeles.	115
8.8	*Bōtarō's Nurse Otsuji Prays to the God of Konpira for His Success,* Tsukioka Yoshitoshi, 1892. Los Angeles County Museum of Art, Los Angeles.	116
8.9	*The Old Warrior Tomobayashi Rokuro Mitsuhira,* Tsukioka Yoshitoshi, 1888. Los Angeles County Museum of Art, Los Angeles.	117
8.10	*Cooling off at Shijō by the Kamo River,* Tsukioka Yoshitoshi, 1885. Philadelphia Museum of Art, Philadelphia.	118
9.1	*Portrait and a Dream,* Jackson Pollock, 1953. Dallas Museum of Art, Dallas.	120
9.2	*Lee Krasner and Jackson Pollock in their garden, Springs, East Hampton*, 1949. Photograph by Wilfried Zogbaum. Pollock-Krasner House and Study Center, East Hampton, NY.	120
9.3	*Silver over Black, White, Yellow and Red,* Jackson Pollock, 1948. Centre Pompidou, Musée national d'art moderne, Paris.	121
9.4	*America Today*, Thomas Hart Benton, 1930–1931, Metropolitan Museum of Art, New York.	124
9.5	*Going West*, Jackson Pollock, 1934–1935. Smithsonion American Art Museum, Washington, DC.	124
9.6	*Igor,* Lee Krasner, 1943, Private Collection.	126
9.7	*Imperative*, Lee Krasner, 1976, National Gallery of Art, Washington, DC.	127
9.8	*Stenographic Figure*, Jackson Pollock, 1942. Museum of Modern Art, New York.	129
9.9	*American Gothic*, Grant Wood, 1930, Art Institute of Chicago.	130

9.10	*No. 1A*, Jackson Pollock, 1948. Museum of Modern Art, New York.	131
9.11	*The Deep*, Jackson Pollock, 1953. Centre Pompidou, Paris.	132
9.12	*Right Bird Left*, Lee Krasner, 1965. David Owsley Museum of Art, Muncie.	133
9.13	*Convergence*, Jackson Pollock, 1952. Albright–Knox Art Gallery, Buffalo.	134
10.1	Visitor to Museum of Modern Art, New York City, 2019, Photograph by Jeffrey K. Smith.	136
10.2	*The Shoe Shop*, Elizabeth Sparhawk-Jones, 1911. The Art Institute of Chicago.	137
10.3	*The Dreamer*, Elizabeth Sparhawk-Jones, c. 1942. Delaware Art Museum, Wilmington.	138
10.4	*Paris Street; Rainy Day*, Gustave Caillebotte, 1877. The Art Institute of Chicago.	140
10.5	*Ploughing in the Nivernais,* Rosa Bonheur, 1849. Musée d'Orsay, Paris.	142

Acknowledgments

I have thoroughly enjoyed writing *Scoundrels, Cads, and Other Great Artists*, and the people I acknoweldge here are responsible for a major portion of that enjoyment. First, Rowman & Littlefield is a great publisher to work with. Charles Harmon has been immensely supportive and encouraging throughout this project, and I truly appreciate his efforts. He is a great editor and supporter of art and cultural institutions. Thank you, Charles. Erinn Slanina was a pleasure to work with, and the look of the book is testament to her creativity, skill, and attention to detail. I wrote *Scoundrels* while on sabbatical leave from the University of Otago; I greatly appreciate the support given to me by the University, particularly Pro-Vice-Chancellor Tony Ballantyne.

My wonderful research assistant, Fiona Stuart, helped with editing, reference checking, permissions finding, and reminding me of things that I'd forgotten. She remained a consistent source of good cheer even during the sixth time I rearranged the chapters. Eveyone needs a Fiona, and I am most fortunate to have her assistance. David Bell is my comrade-in-arms at Otago on all things aesthetic, and it was he who put me on to Tsukioka Yoshitoshi (chapter 8) as a scoundrel worthy of inclusion here. His advice is always sage, and he provided ample amounts of it graciously. My colleague and dear friend, Ana Lipnevich, read every chapter and provided great feedback and encouragement. She also lent me some of her amazing enthusiasm when mine occasionally waned. My collaborator on aesthetic research, Pablo Tinio, was an excellent sounding board for ideas and provided feedback on individual chapters. His positivity is always infectious. Thank you to Fiona, David, Ana, and Pablo.

My family has supported me in all my endeavors. They read drafts, ask me how the work is going, and are sincerely happy for me when a work is published. To my son, Benjamin Smith and his wife, Andrea; daughter Leah Smith; step-daughter Kaitlin Bishop and her husband, Ben; I hope you enjoy the final version of *Scoundrels*. Lord knows you've been hearing about it for long enough. And to my wonderful granddaughters, Daria, Olenna, Gwendolyn, and Elodie, I smile just thinking of you, and I hope that when you are old enough to read this, you will enjoy it as well.

I thank all of my friends at the Metropolitan Museum of Art, where I spent eighteen wonderful years researching how people used the museum and how they looked at art. I also thank my museum friends at other institutions and my colleagues in the field of the psychology of aesthetics, in particular, Professor Paul Locher. Thank you to great teachers who taught me about writing, the arts, and life: Dr. Beth Newman, Norman Linton, Richard Hart, and Larry Bowers.

As this book is intended for a wide audience, I asked for help in responding to drafts of chapters from a number of my friends both inside and out of academe who were not specialists in art or aesthetics. Their assistance was absolutely invaluable. I thank Judy and Ian Tucker, Laura Link, Brian Brownell, Jeff Sisco, Tom Berg, C. John Tarter, Danelle Radel, Tom Guskey, Kristin Nielsen, Nicola Beatson, Jonathan Plucker, Loic Tallon, Larry Sorensen, Franklin Turner, David Berg, Linda and Clive Doubleday, and Betty and Bob Melville. And I particularly would like to acknowledge Paula Mullins, who not only provided incredibly helpful feedback on the book but farm fresh eggs as well. I thank her and the chickens. I truly hope I haven't forgotten anyone.

I go through life with the best partner imaginable, my wife, Lisa. She is always willing to tell me, "You are the most wonderful person in the world, and *this* is really good. But *that* isn't." Every chapter in this book is better because Lisa read it first. And every aspect of my life is better because she is in it.

Preface

Have you ever stood next to a couple in an art museum who were speaking in hushed tones with arched eyebrows and wondered if they were discussing the deepest of meanings of the work of art under consideration while you were contemplating how the artist made that water look so wet? If so, I've written a book for you.

Scoundrels, Cads, and Other Great Artists portrays the lives of nine great artists—eight of whom were also reprehensible human beings—exploring their amazing artistic creations simultaneously with their often appalling personal behavior. This book is for people who are nervous that they aren't doing art right. It is for everyone who has felt inadequate, inexperienced, or incompetent when looking at what they understood to be a masterpiece. *Scoundrels* blends art history and connoisseurship with exposés of lewd, lascivious, and frankly, outrageous behavior. And, even if you are not afflicted with a sense of aesthetic inadequacy, you might still enjoy learning about the nefarious activities and artistic achievements of a group of fascinating artists.

I had three basic goals in writing this book. First, I wanted to explore the question of why we like great art that was done by people whom we could, at best, call disreputable in terms of their private lives. Second, I wanted to introduce readers to nine great artists—some who are well-known to those who frequent museums, but perhaps less so to those who only occasionally explore the world of two-dimensional art. And third, I wanted to suggest approaches to looking at art that will encourage individuals who are reluctant to engage in aesthetic endeavors to think of art viewing as a creative process where one makes the meaning of a work a personally relevant activity. Each encounter of a person and a work of art is different, unique to that individual, time, and place—and valid. As my dear friend and great museum scholar, the late David Carr would say, "Save touching the works, you cannot fail museum."

How did I come to pick these nine artists and not others? The answer is this: in part, because I've spent decades working in art museums, and I have come to have some favorites, and some artists I simply uncovered when looking into the lives of many artists in researching for this book. One great difficulty that I had in coming up with the artists to include was finding women. This was in some measure because I

wanted to talk mostly about artists from the past. The gender discrimination that has persisted in art for centuries makes the total number of female artists available fairly small, and those who did succeed were apparently so busy fighting off bigotry and bias that they couldn't invest much time in being horrible human beings themselves.

And so, I cheated a bit. As the title of the book is *Scoundrels, Cads, and Other Great Artists*, I included the amazing Baroque artist, Artemisia Gentileschi, as an *Other Great Artist*. She wasn't a scoundrel or a cad, but rather fought against despicable men as well as the confines of the era in which she lived. Then there is abstract expressionist Lee Krasner, who is presented with her husband Jackson Pollock. She wasn't nearly as obnoxious as he, but most contemporaries considered her offensive and unpleasant in her own right. They were quite a pair.

So, who made the list? In order of appearance, they are as follows.

Michelangelo Merisi Caravaggio: The great Baroque artist, Caravaggio, revolutionized painting at the entry to the seventeenth century. By day he depicted scenes from the Bible for cardinals, popes, and those of great wealth. By night, he drank, brawled, caroused, and was offensive to almost all that he met, including a man he killed in a duel while attempting to castrate him.

Gustave Courbet: As with Caravaggio, Courbet was also a great drinker and carouser, but it is massive ego and relentless self-promotion that characterized the life of this realist painter of the mid- to late 1800s. He is also the painter of what may be the most scandalous painting in the history of art.

James Abbott McNeill Whistler: Whistler was basically Oscar Wilde, but with the ability to paint. In fact, they were, for a while, great friends. Sadly, Whistler's ability to make friends was exceeded by his ability to make enemies (he wrote a book called, *The Gentle Art of Making Enemies*). A brilliant artist of the Impressionist era, with his own very distinctive style, Whistler was eventually seen as insufferable to almost everyone.

Artemisia Gentileschi: It would be difficult to learn about Artemisia Gentileschi—her life and her art—and not become a fan. Raped by her art tutor at age seventeen, she went on to overcome the gender discrimination of seventeenth century Italy to become a great artist, frequently depicting heroic women from the Bible, working in teams, to even the score (and often the necklines) of offensive men.

Frederic Remington: Frederic Remington's self image was that of a bronco-bustin' cowpoke of the Wild West, who was equally adept with a paint brush as a branding iron. He burnished this image from the parlors and salons of Manhattan and New Rochelle, New York. A bigot and a dandy, his paintings of Native Americans and cavalrymen can still take us back to days of yore.

Egon Schiele: Schiele pushes the envelope here. Whereas the other artists included in *Scoundrels* had lives of disrepute separate from their art, for Schiele, they are one and the same. In fact, his personal life, while falling far short of admirable, was not as outrageous as a Caravaggio or Courbet. What was outrageous was his art, as

he frequently depicted young teenagers in various states of undress and in sexually suggestive poses. He is a source of controversy to this day.
Tsukioka Yoshitoshi: Yoshitoshi was the last of the great Japanese ukiyo-e ("floating world") woodblock print artists. Many of his prints are incredibly beautiful, and many are incredibly disturbing. In addition to making some wonderful and some strange art, his personal life was filled with drinking binges and frequenting local brothels. He ran up his tab so dramatically that on two occasions his wife had to sell herself to the brothel to cover the debts (different wives!).
Jackson Pollock and Lee Krasner: Pollock absolutely revolutionized Abstract Expressionism, and his wife, Lee Krasner, was a brilliant practitioner in that style as well. Pollock battled alcoholism (mostly unsuccessfully) his whole life, and was remarkably rude to almost everyone he knew. Krasner spent much of her life promoting Pollock's work, not truly realizing her own artistic abilities until after his death.

A note on the structure of the book: Each of the chapters about the artists includes a two-page layout called "A Closer Look." This is an opportunity to consider a work of art by each of the artists and to engage in a bit of a dialogue (as much as can be done in a book) about what one might observe in the work. To do that, I invite you to spend some time looking at the work, and then I present my take on it. It is not an art historical take, as I am a psychologist and not an art historian. Rather, it is a starting point for your own exploration. Your take on a work will bring out what is important to you; your understanding will, in all likelihood, be different from mine. I offer mine *not* as the correct interpretation, but as a possibility for interpretation, one to contemplate along with your own.

Finally, as a research scholar, I am accustomed to documenting every claim made in a work, but here, that seemed as if it would clutter the reading of the book. Most of the facts about the lives of the artists presented are fairly easily located, and if that is the case, I won't document it separately. But for more particular claims and quotations, I will use Chicago Style footnoting, with the references at the end of the book by chapter. Thus, you will see little numbers at the end of sentences occasionally. They will not send you to illuminating bits of the discussion about an artist—if I have something to say, I'll say it in the chapter—but they will provide the reader with documentation where I thought it necessary. (What I'm saying is to skip over them.)

My sincere hope is that what I have presented encourages you to explore these artists further and to discover ones of your own. If you do, I assure you that it will be an incredibly rewarding adventure!

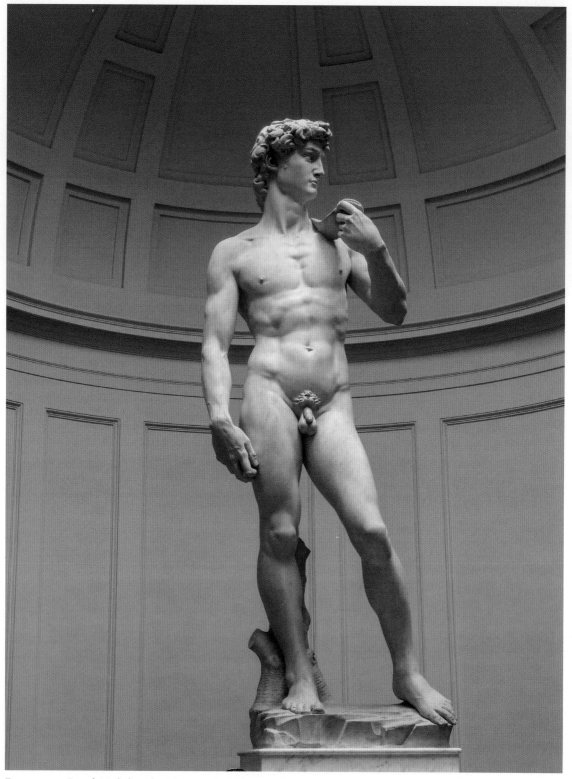

Figure 1.1. *David*, Michelangelo, 1501–1504. Galleria del Accademia, Florence.
https://commons.wikimedia.org/wiki/File:%27David%27_by_Michelangelo_JBU03.JPG–/media/File:'David'_by_Michelangelo_JBU03.JPG

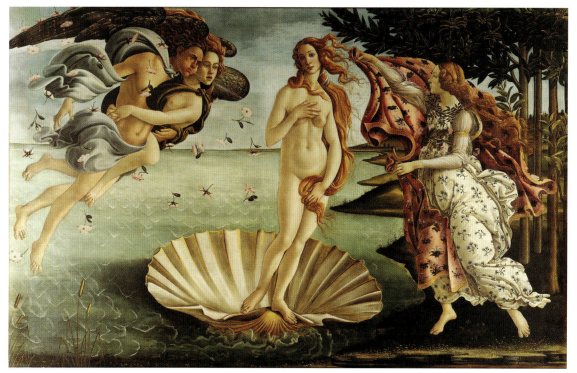

Figure 1.2. *The Birth of Venus*, Botticelli, 1485–1486. Uffizi Gallery, Florence.
https://commons.wikimedia.org/wiki/File:Sandro_Botticelli_-_La_nascita_di_Venere_-_Google_Art_Project_-_edited.jpg

CHAPTER 1

Introduction

THE ROGUES' GALLERY

David has stared down his opponent, Goliath, for over 500 years now. Seventeen feet tall, ideal in proportion and musculature, his presence often causes viewers to gasp when they first encounter the perfection of *David* that Michelangelo gave the world. Although his artistic genius is unquestioned, Michelangelo's personal habits were a different issue. He rarely bathed or changed clothes. He was so uniformly unpleasant a person that he had few students; there is no personal legacy of Michelangelo other than the wonders of his work.[1]

Venus makes a fitting counterpoint to David. She is the epitome of beauty, love, and sexual desire, and she is also over 500 years old. Her creator, Sandro Botticelli, became a follower of the religious fanatic, Savonarola, and burned many of his paintings because he felt they were lewd. He also idolized the likely model for this painting,[2] Simonetta Vespucci, who tragically died very young. Botticelli painted her likeness from memory here and for the rest of his life, and had himself buried at the foot of her tomb, thirty-five years later.[3]

Stunning art from stunningly strange artists.

In "The Rich Boy," F. Scott Fitzgerald wrote, "Let me tell you about the very rich. They are different from you and me."[4] So are the very great artists. But they differ from you and me in more interesting ways than do the rich. El Greco once said, "I paint because the spirits whisper madly inside my head."[5] The great Pre-Raphaelite painter, Dante Gabriel Rossetti, kept a pet wombat that he let sleep on the dining room table. This might have been less strange had Rossetti lived in Australia rather than in London. Henri Rousseau was arrested for petty theft as a teenager, and then again in his sixties. Georgia O'Keeffe often painted in the nude, whereas René Magritte wore a suit and tie in his studio. Whether Van Gogh ate paint and drank turpentine is a matter of debate. That he cut off his left ear, is not.

And yet, each one of these artists produced works that, when seriously contemplated, can evoke the strongest of emotions and noblest of feelings in us. We look to art for inspiration, rejuvenation, contemplation, beauty, and to engage in self-reflection. If the creators of the art we love were not the best at personal hygiene, interpersonal relationships, or choice of cuisine, so be it. Wombat or no, Rossetti could capture beauty exquisitely, as he did in this portrait of Jane Morris as *Proserpine* (figure 1.3), who was the Empress of Hades. Jane Morris was the wife of textile designer William Morris, but had a long-running affair with Rossetti.[6]

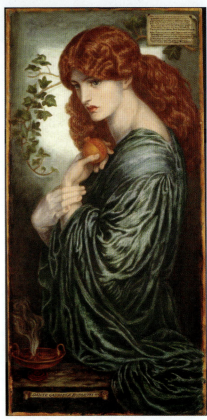

Figure 1.3. *Proserpine*, Dante Gabriel Rossetti, 1874. Tate Britain, London. JQFW5c2ZLfpmbw at Google Cultural Institute, zoom level maximum, Public Domain, https://commons.wikimedia.org/w/index.php?curid=29659886

We are all passionate about something in life. It might be soccer for some and Sacher tortes for others, but each of us possesses things that quicken our heartbeat. Yet, most of us might not consider ourselves to be particularly passionate people. Indeed, when someone is called "a highly passionate person," it is almost never intended as a compliment. Exploring the passionate side of life comes with risk, and exposing ourselves to risk is, well, risky. One might get hurt. The hurt could be a loss of self-esteem or financial security, a broken ankle or a broken heart. So we tend to approach urgings, cravings, angers, wraths, tragedy, and zeal with appropriate caution. Often, we marvel at those who encounter the wilder side of life with more enthusiasm than we do, and occasionally we like to live vicariously through their exploits. And we sometimes send them notes of sympathy and commiseration while suppressing our schadenfreude when their lives go askew.

Art is like that good friend. Art provides us a vehicle to explore our passions, both positive and negative. We can contemplate that which is noble, pleasant, joyful, and inspiring when we look at art. We can also be brought to tears, repulsed, or have our beliefs challenged, as art holds that power as well. Usually, we don't really care who made the art. It is the image itself that allows

CHAPTER 1: INTRODUCTION 3

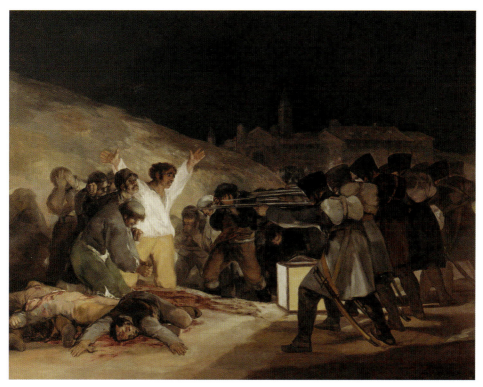

Figure 1.4. *The Third of May 1808, in Madrid*, Francisco de Goya, 1814. Museo del Prado, Madrid.
This file was derived from: El Tres de Mayo, by Francisco de Goya, from Prado in Google Earth.jpg:, Public Domain, https://commons.wikimedia.org/w/index.php?curid=18777858

us to engage the emotions associated with loss, lust, and longing from a safe distance. We can see the power of art in the great and famous Goya work, *The Third of May, 1808, in Madrid* (figure 1.4), pathos in the relatively uknown work, *Back View* (figure 1.5) by Philip Guston, and a puzzle in *Still Life with Apples and a Pot of Primroses* (figure 1.6) by Paul Cézanne.

In *The Third of May 1808, in Madrid*, Goya depicts Napoleon's troops executing Spanish rebels who had participated in an uprising against Napoleon's duplicitous occupation of Spain and installation of his brother on the Spanish throne. The main character in the work is a Christ-like figure whose expression is more of sorrow and disbelief than fear. His companion to the left shows defiance, and another in the rear cannot bear to look. To the left in the picture is a heap of Spaniards already dispatched, and to the right is an endless line of those awaiting a similar fate. The troops are almost not real people, but simply a mechanically evil extension of Napoleon's treachery. A single lantern illuminates the entire scene and draws our attention to the central figure.

With his last breath, the central figure appears to be appealing to his killers, not asking that they spare his life so much as consider their actions. Why are they doing this? Are they not human, the same as he is? This is not their country, but his! Have they no sense of honor? Goya's painting sparked outrage among his countrymen, and it still can stir us today.

Philip Guston's *Back View* (figure 1.5) may not appear inspiring, but the story behind it exemplifies the notion that art allows us to explore our feelings from a safe distance. In *Back View*, we see a cartoonish painting of a man walking away from us, perhaps over a hill, off to the left of the picture. Attached to his coat, which hangs over his shoulders, are a number of old shoes. And that's about it. What on earth is this painting about? It seems a kind of self-centered joke that we are not in on.

Some background helps. Guston was born Philip Goldstein in 1913, but changed his name to Guston because it sounded less Jewish at a time when anti-Jewish sentiments were strong, even in the United States. At age ten, his father committed suicide by hanging, and young Philip discovered the body. Anti-Semitism and the loss of his father can be seen as influences in his work. In 1977, when he painted *Back View*, his wife of forty years, artist Musa McKim, had recently suffered a debilitating stroke.

Guston's back story turns *Back View* into a self-portrait of a man crushed by life. His wife's stroke and his own sense of mortality (he died three years later) have caused him, in this portrait, to pack up what memories he has (the shoes) and start his traipse downhill, off to the left, and metaphorically "out of the picture." The colors are a bit garish, and there is indeed a comic book quality to the work. I think this is Guston ridiculing his life. "It's all come down to this. I'm done. I am a cartoon, garish and unattractive." The pathos, for me, is powerful, but, and this is critical, just as the outrage of *The Third of May* isn't *our* outrage, the sadness of *Back View* isn't *our* sadness. It is Guston's. We are just borrowing it, putting ourselves in his shoes (so to speak), and feeling his pain—as if it were our own—as much as we want to, and then we can back away from it when it gets too intense. Try it. Try putting yourself into that space and feel his pain. By pouring his heart into this painting and baring his soul, Guston lets us in on those emotions. Also, the longer we look, the more we see. Four of the six shoes are large and unpaired; two of them are smaller and are a pair. Are those his wife's? The analysis I have presented here is my

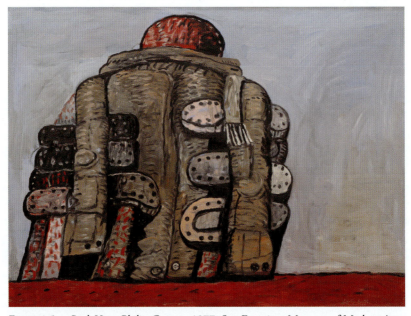

Figure 1.5. *Back View*, Philip Guston, 1977. San Francisco Museum of Modern Art.
© The Estate of Philip Guston, courtesy Hauser & Wirth

own. It may be completely wrong, but for me, it "fits the data" of the painting and allows me to empathize with what I believe is Guston's message. As for Guston, according to his daughter, the forms that appeared in his work were as mystifying to him as to the viewer.[7]

Paul Cézanne's *Still Life with Apples and a Pot of Primroses* (figure 1.6) is a very calm and modest work, and yet it is intriguing in its own way. Cézanne frequently painted still lifes of fruit and objects such as bottles, pots, and pitchers, but rarely flowers, as they would wilt before he had completed the painting. So we see here a somewhat unusual work for him, but one that is very pleasing to contemplate. The colors of the apples contrast very nicely with the wall behind them and the linen on the table. In Cézanne's typical style, the painting is rather flat, with not much of a sense of depth to be seen.

What captivates me about this work is the arrangement of the apples and the linen tablecloth on the table. If you had a linen tablecloth and two dozen apples (and were not assembling them for a painting), would you arrange them like this, with the tablecloth bunched this way and that, and the apples grouped in sets almost as if they were interacting with one another? Or would the tablecloth be spread neatly and smoothly, and the apples in a bowl? The composition, which initially gives the appearance of a naturally occurring scene, is actually carefully constructed. The apples almost look like people in a street scene or a gathering in the country. Some are comfortably nestled into the linen while others are a bit "on the outside looking in." Some groupings look like parents and children, or a conversation among friends, or, off to the right, an assignation of young lovers. And there are a couple of sad, lonely strangers.

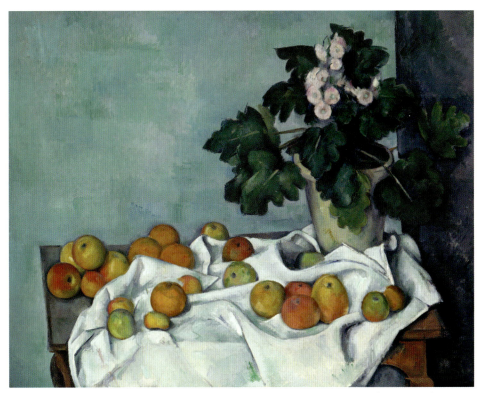

Figure 1.6. *Still Life with Apples and a Pot of Primroses,* Paul Cézanne, 1906. The Metropolitan Museum of Art, New York.

One particularly thing interesting about the fruit is that most of them tend to be touching one another. Why is this interesting? Because, as Cézanne grew older, he became increasingly irritable, and ultimately could not stand for anyone to touch him. He was crazed about not being touched, was generally rude and unpleasant, and yet, his fruit, on the whole, seem absolutely convivial. This same type of arrangement can be seen in other still lifes by Cézanne.

Is this an appropriate interpretation? Well, that is a good question. I certainly have never read it anywhere else, but it is an approach to viewing his still lifes that is appealing and makes sense to me. It fits with what I know about Cézanne as well. And so I will conclude that it is "appropriate enough for me for now," and I will remain open to modifying my opinion.

Being amused by the story I have created on Cézanne's work, feeling the outrage of injustice from Goya's work, and being touched deeply by Guston, are three of the amazing things that art does for us. With some works, it allows us to be creative in our interpretation, spinning stories to our own delight. With other works, we can take on the feelings conveyed by the work (sadness, anger, maternal love, the exuberance of youth) from a distance of our choosing. Just as we can do with a sad movie, we can explore those feelings, and then back away from them, as they are not essentially ours. We borrow the feelings from the work, and then can leave them when we wish to.

But Why Do We Like Art from Bad People?

What about artists who were not simply odd, but objectively bad people? Bigots, philanderers, even murderers? Walk into almost any art museum and you are likely to find works created by individuals who engaged in unacceptable, even inexcusable behavior. As a visitor to the museum, you may be unaware of an artist's past, but it is highly unlikely that the curator in the museum is. With some very famous artists, such as Picasso, the misdeeds are widely known. The simple fact is that when contemplating art, we typically either ignore the artist's past or forgive it; or perhaps we even revel in it.

If you spend a significant portion of your life researching behavior in art museums, as my wife and I have, you occasionally take the opportunity to get close enough to visitors to hear what they are saying. In the course of decades of eavesdropping on people in museums, we have never heard words spoken such as the following: "That murderer could really depict the pathos and anguish of a martyr's death." "For a bigot, he was exceptionally good at revealing the tragedy of the plight of the Native American." "Yes, he disowned his children, but just look at that sunset."

Exploring a work of art involves the viewer and the work. Nothing else has to come into play, but more *can* be considered if the viewer chooses. One can read the label accompanying the work (if there is one), or study the artist, the era, or the style of the painting either before going to the museum, or after the visit is over. Note that in the discussion of *The Third of May*, there was nothing about Goya the person, whereas in *Back View*, all of the discussion was about Guston, the person. Cézanne was a mix of the

work and the artist. And in all honesty, one can view *David* without knowing anything about the work or Michelangelo. It is overwhelming all on its own.

But what about artists who were awful people? Do we ignore their lives when we look at their art? Do we forgive them their transgressions and focus on their works? Or do the scandalous pasts of these artistis add spice to the viewing of their works? My colleagues and I have conducted research on this question and found that knowing about an artist made a work more interesting than not knowing, whether that information was salacious or just normal biographical information.[8] But to a degree, it depended on just how salacious the information was. In our research, we found that being a boastful, grandstanding, philandering degenerate was not really much of a problem for our participants. Murder did not appear too upsetting, either. On the other hand, they did seem to object to selling one's wife to a brothel.[9]

Is it the case that when artists, especially those of the past, have engaged in behavior we would find objectionable today, we tend to try to understand their misdeeds and to put their art in the context of their passionate personalities? Is the street brawler better able to depict violence? Does the serial womanizer portray romance more passionately? Does the disregard for the norms, rules, and even values of society lead an artist to more easily discard convention in art and break new aesthetic ground? Are artists "natural-born rebels" whose behavior we tolerate because we value their artistic contributions? As we examine the lives of nine artists in the pages to follow, my hope is that you will come to an understanding of some of these issues that is satisfactory to you. My take on these matters is unsettled, and at times unsettling.

CARAVAGGIO

Figure 2.1. *A drawing of Caravaggio*, Ottavio Leoni, circa 1621. Biblioteca Marucelliana, Florence.
By Ottavio Leoni–milano.it, Public Domain, https://commons.wikimedia.org/w/index.php?curid=331612

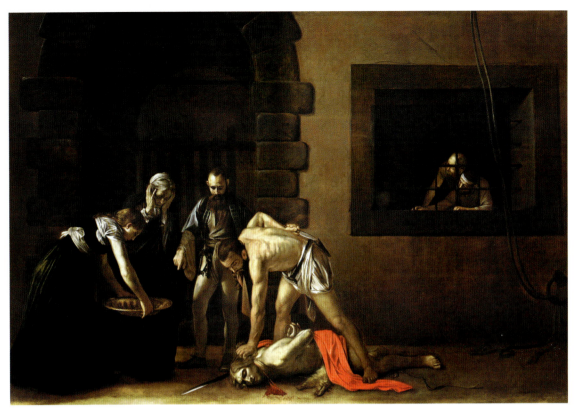

Figure 2.2. *The Beheading of St. John the Baptist*, Michelangelo Merisi da Caravaggio, 1608. St. John's Co-Cathedral, Malta. https://commons.wikimedia.org/wiki/File:The_Beheading_of_Saint_John-Caravaggio_(1608).jpg

CHAPTER 2

Caravaggio

A LIFE IN CHIAROSCURO

On a crisp and cloudless evening in late May of 1606, Ranuccio Tomassoni lay bleeding on a tennis court in Rome, the victim of a failed attempt by his dueling opponent to castrate him. Tomassoni was a scoundrel and a cad to be sure. He was a gang member, a pimp, and a bar brawler. What he was not was a great artist. That honor belonged to the man looking down upon him as he slowly bled to death. His assailant, Michelangelo Merisi, was known then as we know him now, as the great Baroque artist, Caravaggio! The details of the duel between Caravaggio and Tomassoni are somewhat contested, as the seconds on hand all told fabrications of the event to spare themselves from the consequences of having participated in what was illegal duelling.[1] After all, even in early seventeenth-century Rome, murder was considered to be bad form. Caravaggio was forced to flee the scene and then the city where he had held incredible fame. He was *the*

painter of Rome at the turn of the century, in continual demand to produce works both for the church and wealthy patrons. But his brilliance as an artist had been eclipsed once again by the darkness of his odious behavior. The law would be after him, and no doubt, Tomassoni's gang as well.

It was time to go.

Caravaggio's Life and Times

> ### Chiaroscuro
>
> Chiaroscuro is an artistic technique that involves sharp contrast between light and dark in order to create a dramatic effect. The word basically means "light and dark," with *chiaro* meaning clear or light, and *oscuro* meaning obscure or dark. (Note that in Italian, the letter I often appears where there would be an L in English, as in *piazza* in Italian being *plaza* in English.)

Michelangelo Merisi da Caravaggio (1571 to 1610) was born into the upper middle class in the town of Caravaggio, near Milan, but did not enjoy life in that status for very long. His father and grandfather died within hours of each other from the plague when he was six years old, and his mother died when he was eighteen.[2] Deciding he wanted to be an artist, at age thirteen he became an apprentice to Simone Peterzano and trained with him for four years, not unusual for aspiring artists. Similarities in style between Peterzano and Caravaggio are easy to see.

He completed his apprenticeship with Peterzano in Milan, and then struck out on his own. In some fashion, which isn't entirely clear, striking out included spending a year in prison. It's not certain what he did, but it appears to have involved people being stabbed and slashed (perhaps a police officer), prostitutes, and refusing to cooperate with the authorities. Kids!

FROM MILAN TO ROME: FAME, FORTUNE, AND FOLLY

Extracurricular activity in Milan left Caravaggio penniless and deciding to seek greener pastures in the Big City, in this case, Rome. At the end of the sixteenth century, Rome was a city of extravagance and magnificence, dedicated to pleasure and lavish living. An orphan, a convict, and an immense talent, Caravaggio was all of twenty years old.

For several years, Caravaggio peddled his talents painting portraits for sale and working in various studios, gradually moving up the hierarchy of fame of the master who employed him. He ultimately decided he was tired of painting "flowers and fruits" (as he put it) for other artists, and began a career of his own.[3] *The Cardsharps* (figure 2.3), painted when Caravaggio was only twenty-three years old, is one of his earliest complete works and provides an idea of his immense talent. It also suggests the nature of the activities he engaged in when not painting. The longer you look at this work, the more you see. That is a constant in art viewing.[4] Caravaggio is telling a story here. The boy on the left is the

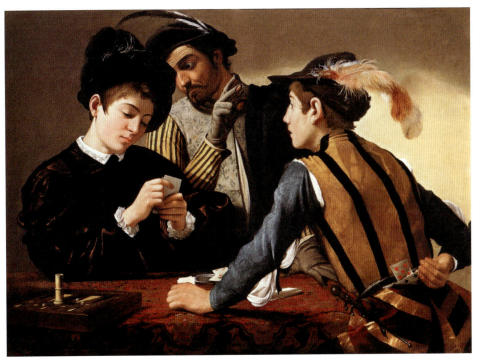

Figure 2.3. *The Cardsharps*, Michelangelo Merisi da Caravaggio, 1594. Kimbell Art Museum, Fort Worth, Texas.
https://commons.wikimedia.org/wiki/File:Cardsharps.jpg

mark, being worked over by another boy his age and a con man who is signaling to his accomplice. Notice that all six hands are visible in the painting. The mark's hands are clean and soft; the accomplice's hands are similar, but note the dirt under the fingernails. And the con man wears gloves with holes in them, pretending to be a dandy, but with a well-worn wardrobe. The con man and the accomplice each have a hand on the gaming table, and with the other hand they are cheating the mark.[5] They are in charge here. The boy being cheated by the cardsharps bears a bit of a resemblance to Caravaggio himself, based on other works that are known to depict the artist as a youth.

As was the case throughout his career, the light of Caravaggio's incandescence blinded the elite to its heat. Eventually, he was taken on by Cardinal Francesco Maria del Monte, whose patronage gave him commissions and widespread visibility. He had graduated from painting fruit and decorations in the frescoes

> **Baroque**
>
> Baroque is a style of art (in painting, architecture, sculpture, and music) that followed the Renaissance and Mannerism. It featured dramatic scenes, deep color, strong facial expressions and often, movement in the characters depicted. Baroque painters include Caravaggio, Rembrandt, Reubens, and Velazquez. The Catholic Church endorsed this style as it provided a stark contrast to the simpler (plainer?) approach to life and art espoused by the Protestant Reformation.

designed and executed by more famous artists to becoming the sought-after artist of Rome. His newfound fame as an artist, however, did not temper his temperament. There are reports in the popular press and court records of Caravaggio engaging in street brawls, attacking a waiter because he did not like the plate of artichokes he had ordered,[6] and throwing stones at the house of his landlady while singing lewd songs because she had the audacity to want him to pay his rent. These were his evening activities; during the daytime hours, he was busy spreading the gospel through his artistic genius and courting the clergy and other clientele.

If you look at Caravaggio's oeuvre as a whole, you cannot help but notice that in a number of his works, especially in his early days, there are young males depicted in suggestive poses, with full lips and languid eyes looking out invitingly to the viewer. His painting *Bacchus* in 1595 (figure 2.4) is a good example of this. These works have led to speculation at various times (contemporaneous to Caravaggio's time, as well in the 1960s and 1970s) that

> **Oeuvre**
>
> *Oeuvre* is a word of French origin that means the body of work of an artist or composer. It is sometimes used to refer to a single or subset of work, but usually means the entire work of an artist.

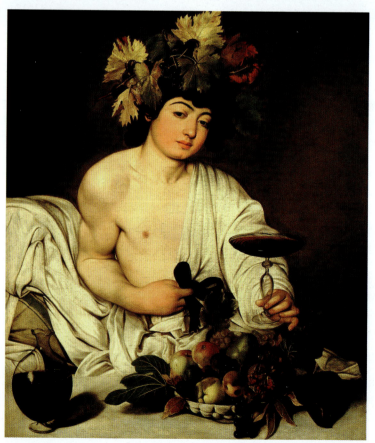

Figure 2.4. *Bacchus*, Michelangelo Merisi da Caravaggio, 1595. Uffizi Gallery, Florence.
https://commons.wikimedia.org/wiki/File:Bacchus-Caravaggio_(1595).jpg

he was homosexual. Although recent scholarship casts doubt on that contention,[7] he may well have slept with both women and men. Fortunately, we live in a time where being gay is less of an issue than it was for individuals living in the sixteenth century within the purview of the Holy Roman Empire. In 1532, the Catholic Church declared sodomy a crime punishable by death.

And so, what do we make of a number of paintings that Caravaggio produced that were at least highly suggestive? We will probably never know for certain, but a reasonable speculation was that these works were a way for Caravaggio to "push the envelope" of his work. For certain there would be an audience for them, and they would reinforce Caravaggio's self-image as one not tethered by the laws or the moral strictures of the time. He was a rebel.

ONCE AGAIN FROM LIGHT TO DARK: THE DUEL

His activities in Rome came to a head in 1606. He was working on half a dozen different altarpieces and related paintings in churches in Rome at the height of his fame and prestige. At the same time, he was carousing and fighting in the taverns and brothels in the evenings. It was a full life. Part of that life involved his relationship with a courtesan named Fillide Melandroni, whom he painted a number of times. In figure 2.5, she is depicted as Mary Magdalene, who at the time, in Catholic circles, was considered to be a repentant sinner. The work is titled *Martha and Mary Magdalene* and portrays Mary as

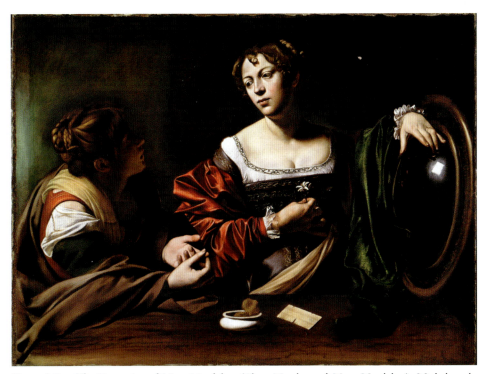

Figure 2.5. *The Conversion of Mary Magdalene* (Also: *Martha and Mary Magdalene*), Michelangelo Merisi da Caravaggio, 1598. Detroit Institute of Arts.
https://commons.wikimedia.org/wiki/File:Martha_and_Mary_Magdalene-Caravaggio_(c.1599).jpg

she "sees the light" and repents her sinful ways. Caravaggio also painted Fillide as Saint Catherine and as Judith methodically beheading Holofernes. She was reported to be a beauty but always appears a bit dour in Caravaggio's renditions of her. Of course, if you are being depicted as beheading someone, or about to be beheaded yourself, perhaps a countenance somewhere between focused and grim is appropriate.

As a courtesan of the time, Fillide Melandroni would have had a pimp, and that pimp is reported to have been none other than Ranuccio Tomassoni, whom we left bleeding to death at the opening of the chapter. Caravaggio was no stranger to sword fighting and had been arrested for carrying a sword when he had no permit to do so. The duel was described in reports of the time as having been due to an argument over a bet on a tennis match. That seems a bit over the top, even for Caravaggio, and besides, who brings four seconds to a game of tennis? It turns out to be much more likely the case that Caravaggio and Tomassoni were at odds over Melandroni; exactly why is not known. An arranged duel—complete with seconds on each side who were known for being helpful in a fight, on a tennis court that would allow ample moves of swordsmanship and which was known for hosting duels—is a far more likely explanation. It is also speculated that once Tomassoni was down, Caravaggio attempted not to kill him but simply emasculate him, accidentally cutting his femoral artery in the process. Apparently a *spada da lato* (side sword popular at the time) is a bit more unwieldy than a palette knife.

Caravaggio was also wounded in the duel, receiving a serious gash to the head. But that was not his most pressing problem. He had killed a man in a duel, a man with political connections of his own. Caravaggio had to flee, and always a man of action, he wasted no time in doing so. There was no advantage to hang around to be arrested and brought to trial. Thus, he was tried and convicted in absentia. His punishment was permanent banishment from Rome, along with a bounty on his head. Literally, a bounty on *his head*. He could be killed by anyone, who could then receive a reward for simply bringing Caravaggio's severed head back to the ministry in charge of such things.

Caravaggio escaped to Naples, which was part of Spain at the time. Naples was substantially larger than Rome, and while certainly Catholic, was much less under the influence of the Pope. In Naples, he worked quickly to reestablish his status. It was just the beginning of what was called the Golden Age of Naples; the port city was thriving. Caravaggio was well-received by the ruling class of Naples, and with tens of thousands of registered prostitutes, seedy taverns, and dangerous quarters, it was his kind of town.

FLEEING TO AND FROM MALTA

Caravaggio received several commissions in Naples, but was soon off to the island of Malta. He had connections in Malta and was attracted by the idea that he might become one of the Knights of Malta, who at the time ruled the island. The Knights of Malta were originally known as the Knights Hospitallers, and their order was dedicated to the care of the sick. As a knight, Caravaggio would have had to take vows of poverty and obedience. He seemed an odd fit for the Knights of Malta, and they for him. But the leader of the

CHAPTER 2: CARAVAGGIO 15

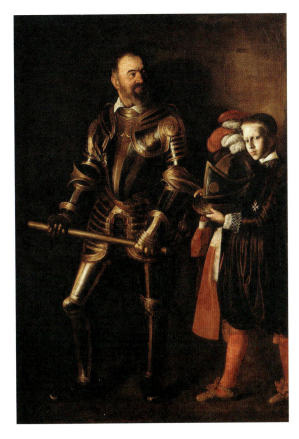

Figure 2.6. *Portrait of Alof de Wignacourt*, Michelangelo Merisi da Caravaggio, 1607–1608. The Louvre, Paris.
https://commons.wikimedia.org/wiki/File:Portrait_of_Alof_de_Wignacourt_and_his_Page-Caravaggio_(1607-1608).jpg

order, Alof de Wignacourt, was a man who liked his portrait painted, and Caravaggio liked his creature comforts and honorifics. It was a match made in Malta.

Caravaggio depicted the vainglorious Wignacourt as both dashing and wise (figure 2.6), in full dress armor. He is also holding a large club or baton across his groin, just in case one had any doubts about the extent of his masculinity. As a convicted murderer, Caravaggio was technically ineligible to become a knight, but there are always exceptions, and after a letter to the Pope (whose portrait Caravaggio had painted before the incident at the tennis court), he became a Knight of Malta in July of 1608.

To essentially seal the deal, Caravaggio painted a new altarpiece work for Wignacourt, *The Beheading of St. John the Baptist* (see figure 2.2, at the opening of the chapter). This is a truly exceptional work, for a number of reasons. To begin, it is twelve feet high and seventeen feet across. The people depicted are all basically life-sized. Next, it is an altarpiece painting in a chapel, intended to inspire religious devotion. St. John is not quite dead, but the job is being finished by the executioner who holds a dagger behind his back and is about to employ it. Blood squirts from the neck of John onto the pavement. The blood then becomes Caravaggio's signature, the only known time that he signed a painting. Thus, Caravaggio tells us that he has done this, and in fact, the executioner looks not dissimilar to Caravaggio. The allusion to Caravaggio's killing of Ranuccio Tomassoni is as plain as can be.

Even as he becomes a knight in a religious order dedicated to the care of those in need, Caravaggio cannot resist the urge to flaunt his inglorious past, and he does so in the house of God. The painting declares, "Here I am! Knight of Malta! The greatest of artists. Killer of Tomassoni in a duel. I am *Caravaggio*—just as it says there in the blood of John the Baptist."

But it did not last. By October of 1608, not even three months after being made a knight, Caravaggio had traded his residence and studio and moved into the less commodious (and more malodorous) quarters of the dungeon of Castel St. Angelo. He appears to have engaged in a dispute with a senior knight, and with rumors of bloodshed, Caravaggio turned light into dark—*chiaroscuro*, once again. Ever resourceful, Caravaggio escaped the dungeon and headed off to Sicily. In all likelihood, his escape was facilitated by Wignacourt, who could not formally forgive Caravaggio, but could ensure that he did not spend his life in a dungeon. No doubt when Caravaggio told the tale of his escape in the bars and brothels of Sicily and Naples, it involved cunning and courage more than connections and collusion.

The Final Years

The last two years of Caravaggio's life were a living hell for him. He still had a bounty on his head from killing Tomassoni, and now there were worries that whomever he had offended in Malta was also in pursuit. Although he continued to work, producing some amazing works, he moved often and reportedly slept with a dagger under his pillow. In 1609, he was attacked by a gang outside a tavern in Naples and severely beaten, his face disfigured.

What is generally believed to be his last work is also perhaps the most emblematic of his troubled but incredible life and career. *David with the Head of Goliath* (figure 2.7)

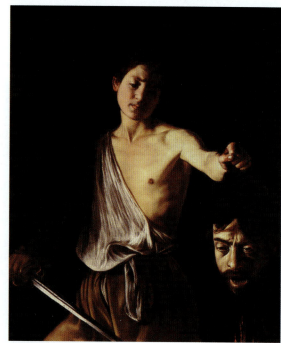

Figure 2.7. *David with the Head of Goliath*, Michelangelo Merisi da Caravaggio, 1610. Galleria Borghese, Rome.
https://commons.wikimedia.org/wiki/File:David_with_the_Head_of_Goliath-Caravaggio_(1610).jpg

presents the severed and still-bleeding head of Goliath held by a David who is not triumphant nor proud, but rather displays consternation, or even a degree of pity for the slain giant. This painting is Caravaggio's biography: clearly Goliath, and possibly David, are images of Caravaggio. He has painted himself as the defeated and grotesque giant head but also as a youth whose whole life is still ahead of him, who seems to be looking at the fate that he holds in his hand, thinking, "I did this . . . to myself." Caravaggio died in a small town called Porto Ercole of a fever while desperately trying to return to Rome where he had hoped he would be pardoned for his murder of Tomassoni. As Giovanne Baglione, Caravaggio's nemesis and later biographer put it, "He died as miserably as he had lived."

Caravaggio's Era and Style

Caravaggio lived during an era of astonishing change, innovation, and creativity. As he was creating his dramatic works and changing the nature of painting, Shakespeare was working on *Macbeth* and Cervantes was writing *Don Quixote*. Galileo was inventing the thermometer, improving the telescope, and arguing that the earth revolved around the sun, and not the other way around (that did not turn out well for him). The Dutch were "discovering" Australia, and not to be outdone, the English sent an expedition to found the first permanent colony in the New World: Jamestown.

In Italy, life was confusing. Well, it's actually difficult to say "In Italy," as the Italian peninsula had different rulers in different regions, and who ruled whom changed often in the sixteenth and seventeenth centuries. Milan, where Caravaggio was born, was under Spanish rule at the time, as was Naples, where he fled after killing Tomassoni. Rome was under the control of the Pope. Florence and Venice were republics unto themselves. You needed a scorecard.

Painting and sculpture, too, were undergoing a revolution, and Caravaggio worked in the vanguard. In some respects, he could not have been better situated. The style of the day, as Caravaggio began to work, was known as Mannerism. It was basically a very fussy version of the late Renaissance. The ideals of beauty, harmony, and proportion were exaggerated in Mannerism for dramatic effect. The aptly named *Madonna with the Long Neck* (figure 2.8) by Parmagiano, is a good example of Mannerism. Not only is the Madonna's neck long, so are her hands, and while we at it, the baby Jesus is impossibly long. There is a column and a sculpture in the background, and drapery, along with a vase in the picture. Just like the manger in which Christ was born!

> ### Mannerism
>
> Mannerism is a style of painting that followed the Renaissance and preceded Baroque. It was essentially a highly stylized and exaggerated version of the high Renaissance. Body parts are often elongated and dramatically presented. Compositions emphasize elegance and sophistication. Notable Mannerist artists are Pontormo, Tintoretto, Bronzino, Parmagiano, and El Greco.

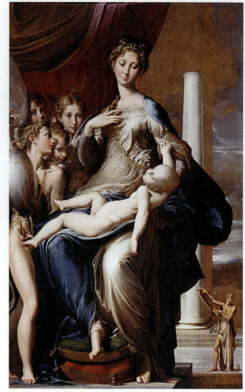

Figure 2.8. *Madonna with the Long Neck*, Girolamo Francesco Maria Mazzola, "Parmagiano," 1534–1540. Uffizi Gallery, Florence. https://commons.wikimedia.org/wiki/File:Parmigianino_-_Madonna_dal_collo_lungo_-_Google_Art_Project.jpg

It is not surprising that Caravaggio rejects it all. Contrast the long-necked Madonna with Caravaggio's *The Crucifixion of Saint Peter* (figure 2.9). This is a real man really being crucified. He is twisting to his left on the cross and looking down at the nail holding his left hand to a wooden beam as he is being crucified head down (as he had requested because he felt he was not worthy of a death so similar to Christ's). Instead of elaborating on the scene in the background, Caravaggio strips it bare and forces us to focus on the act of the crucifixion. Three men are going about the difficult business of executing their assignment. There is real weight to be lifted here, and they strain at their task.

Two items of note here. First, the model used for Saint Peter here looks strikingly like the saint on the right in *The Supper at Emmaus* in the "A Closer Look" feature at the end of the chapter (figure 2.10). One can see models used again and again in Caravaggio's work (only so many people available to serve as models). Second, the use of chiaroscuro seems to be almost extreme in this work. There is basically nothing but the players and the action here. Everything else is in darkness. Caravaggio used this technique so intensely that it was given a separate name, called *tenebrism*.

As far as can be told from X-ray analysis of Caravaggio's work, he did not spend time on preliminary drawing on the canvasses he painted, rather taking a quick sketch with the back end of his brush.[8] This is not to say that he did not make preparatory drawings of his works, but rather, once he knew what he wanted to do, he wasted little time in

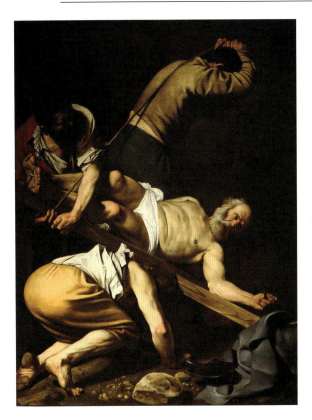

Figure 2.9. *The Crucifixion of Saint Peter*, Michelangelo Merisi da Caravaggio, 1601. Santa Maria del Popolo, Rome. https://commons.wikimedia.org/wiki/File:Martirio_di_San_Pietro_September_2015-1a.jpg

working out details on the canvas itself. He simply dove right into the work. Would we have expected anything else?

Final Thoughts on Caravaggio

The basic question that is posed in this book is why we like art made by people we would find less than admirable human beings, if not outright repugnant? Caravaggio is an excellent starting place for such a discussion, as his greatness and his disreputableness are not in question. Would we be intrigued less by these works if we knew they were done, say, by a gentle monk, well-liked by everyone, or would that make them more admirable? What role does the nature of the artist play in the reception of the artist's oeuvre? Caravaggio's firsthand understanding of passion, lust, anger, violence, and bloodshed seem to be communicated not only in the subject matter he presents, but also in his incredibly dramatic portrayal of his subjects. But if we engage in the aesthetic thought experiment of imagining the same works, but a different artist, where do we arrive? Are our reactions the same, or have we been influenced by what we know, and if so, how, and how much?

20 SCOUNDRELS, CADS, AND OTHER GREAT ARTISTS

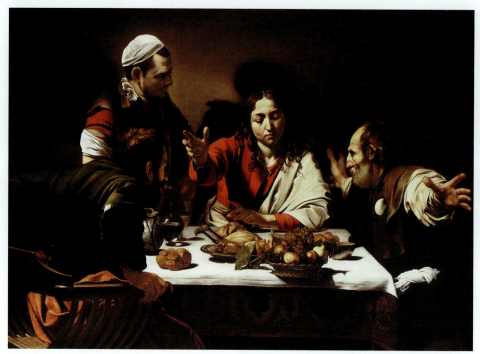

Figure 2.10. *The Supper at Emmaus*, Michelangelo Merisi da Caravaggio, 1601. National Gallery, London.
https://commons.wikimedia.org/wiki/File:Supper_at_Emmaus-Caravaggio_(1601).jpg

Working in Rome in 1601, from a commission from nobleman Ciriaco Mattei, Caravaggio depicted the supper at Emmaus when Christ revealed himself to two of his disciples as having risen after the crucifixion. He had disguised his appearance (in Caravaggio's work, in part by having no beard), and what Caravaggio presents is the moment when the disciples realized who he was. Caravaggio employs his characteristic chiaroscuro technique to heighten the drama of the moment. The disciples are seated and the man standing to the left is the server at the inn where the supper takes place. Caravaggio later painted this event in a more subdued fashion.

A Closer Look: Caravaggio's *The Supper at Emmaus*

The picture featured in figure 2.10 is *The Supper at Emmaus* by Caravaggio. Take a look at the image and the accompanying label, and think about what your reactions are before moving ahead with reading this page. Take your time.

 Welcome back. Let's start by looking at the painting at kind of a "big-picture" level. We see Christ in the direct center of the painting, framed by the disciples and the server of the dinner (standing and wearing a hat). This is the moment when Christ lets his disciples know that they are in his holy presence. The disciple on the right throws his hands out to his sides. His left hand appears to come completely out of the painting.

 Caravaggio is working in a new style from his Renaissance and Mannerist predecessors. He is painting in a style called Baroque. In contrast to the more formal and refined Renaissance approach, Baroque is more real, more immediate. The people in Baroque paintings are not idealized; they are actual people. There is honest emotion and move-

ment in this painting. Christ reaches out to us; the disciple on the left is jumping out of his chair. These are people whom we almost might know.

We don't know if Caravaggio was a particularly religious individual, but with his whoring, drinking, and brawling, if he were, we can safely assume he was somewhat short of "devout." But what he seems to be saying with this painting is that "if Christ rose from the dead, and if, in disguise, he encountered two of his apostles on the road to Emmaus, and if at one point during dinner Christ revealed himself to them—if all that *really* happened, then . . . *this* is what it looked like!" Caravaggio wants to plunk us down right in the middle of that scene. He wants us to be able to richly imagine being there with Christ. In fact, you can imagine you are the apostle on the left. You are in that chair, perhaps leaping out of it, or perhaps what is depicted is him (you) pulling it up closer to be nearer to Christ.

Now look at how Christ is depicted. He and the disciples appear to be European, not Middle Eastern. The apostles depicted here may have been compatriots of Caravaggio, wastrels in the evening, and models of apostles during the day. In Christian art, the holy family and the disciples frequently seem to hail from western Europe. Put that aside for now. Look at how Caravaggio has made Christ beatific. Look at his face and his arms; peacefulness, even holiness, is what you see. In fact, if you hold your arms and hands in the way that Christ has them, and look down in a humble fashion, you may well sense a certain peacefulness yourself. That is what Caravaggio is communicating. And while contemplating this, and the disciples' reactions to him, remember that in the next instant in this scene, Christ vanishes. Allow yourself to imagine that as if it happened just that way.

Let's shift gears and look at technique. This painting strongly employs the chiaroscuro technique described earlier. Note how Caravaggio has cleverly cast the shadow of the server on the back wall to form a dark frame against which Christ stands out even more dramatically. Caravaggio not only uses chiaroscuro, but also symbolism, foreshortening, and trompe l'oeil (French for "trick of the eye," see textbox). The symbolism here includes the slightly rotting apple in the basket, reminding us of the fall of Adam and Eve in the Garden of Eden (Caravaggio is not bothered that the resurrection took place in the spring and apples are an autumn fruit). The bottle of water through which light passes without breaking the glass represents virgin birth, and the bread symbolizes the body of Christ. Foreshortening can be seen in how Caravaggio has stretched out the arms of the apostle on the right in either direction. The trompe l'oeil involves making the basket of fruit and the disciples seemingly come out of the picture, and the bottle of water to look absolutely real.

> **Trompe l'oeil**
>
> *Trompe l'oeil* is French for "trick of the eye." It basically refers to art that is so realistically portrayed that it tricks the viewer into believing it is real.

Now, if you would, take another long look at this work. What else do you see? Put yourself in that work. Imagine that you are there, learning that this stranger you have invited to join you for dinner turns out to be Christ. Your Christ! Your savior! If you are not Christian, just let Caravaggio take you back to an imagined dinner that is some combination of the first century and the seventeenth. In either case, let yourself enjoy— the craftsmanship, the emotion, the drama, the movement, and the fact that this work is four hundred years old.

COURBET

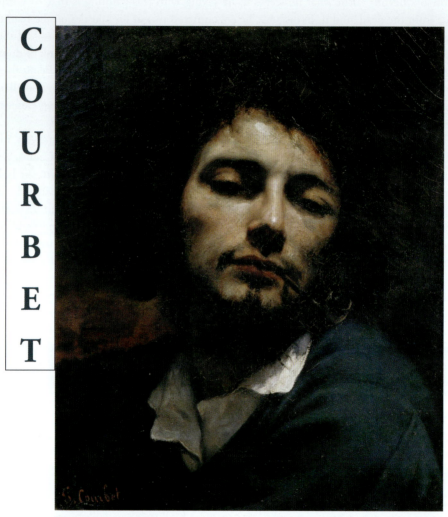

Figure 3.1. *Self-Portrait (Man with Pipe)*, Gustave Courbet, 1848–1849. Musée Fabre, Montpellier.

Web Gallery of Art: Image Info about artwork, Public Domain, https://commons.wikimedia.org/w/index.php?curid=15452598

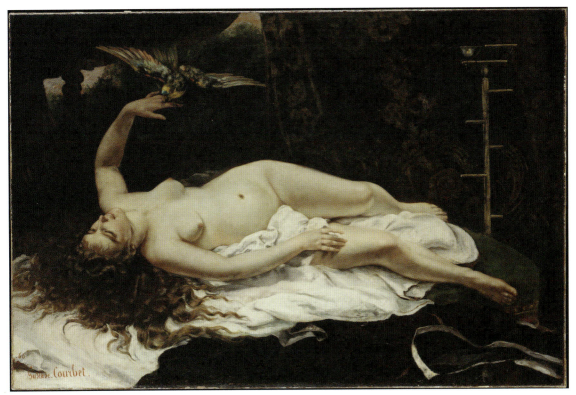

Figure 3.2. *Woman with a Parrot,* Gustave Courbet, 1866. The Metropolitan Museum of Art, New York.
https://commons.wikimedia.org/wiki/File:Gustave_Courbet_-_Woman_with_a_Parrot_-_Google_Art_Project.jpg

CHAPTER 3

Courbet

THE MOST ARROGANT MAN IN THE WORLD

Gustave Courbet holds the intriguing distinction of having painted perhaps the most scandalous work in the history of art.[1] *The Origin of the World*, painted in 1866, is so explicitly explicit that a reproduction is not included here. (The reader can find it on the internet.) *Woman with a Parrot,* depicted in figure 3.2, and also painted in 1866 by Courbet, is mild in comparison, merely depicting a voluptuous naked woman, tresses and legs splayed seductively on a bedsheet, playing with a parrot. Knowing that *The Origin of the World* has maintained its notoriety nearly a century and a half after his death would no doubt have pleased the man who once said of himself, "I am the first and only artist of this century; the others are students or drivellers. . . . They accuse me of vanity! I am indeed the most arrogant man in the world."[2] Gustave Courbet was a provocateur of word and image. Massively egotistical, he revelled in controversy and promoted himself relentlessly. He was a great friend, a passionate adversary, a horrible womanizer, and a

creative visionary who changed the course of art throughout Europe, and the history of France to no small degree as well.

Courbet's Early Life and Schooling

Jean Désiré Gustave Courbet was born into the perfect family for an aspiring revolutionary: wealthy enough to live a life of relative ease, but working class enough to claim proletariat, and even revolutionary roots. His family were well-to-do farmers in the Franche-Comté (Free Country) town of Ornans, France. Franche-Comté was a proudly rebellious region that, in the early 1800s, was still only tenuously attached (at least emotionally) to the mother country. His grandfather, whom he greatly admired, had fought in the French Revolution and provided Courbet with advice on how to live a good life: "Shout loud and march straight ahead."[3]

Family life contributed to Courbet's daring and self-centered nature. He adored his doting mother and his three sisters, and he painted his sisters often. But his relationship with his father was complex and fraught with disagreement. Although Regis Courbet supported his son, in his own overbearing way, the two men rarely saw life eye-to-eye. Père Courbet sent fils Courbet away to Besançon College, a boarding school that was, according to the son's missives home, nothing short of torture:

> I was sent to the College de Besançon where I learned to despise teaching.... When nightmares agitate my sleep, it's seldom they are not college memories. We were hungry and cold in winter.... At 5:30 a.m. the drum was beaten. We got up, shivering, and the basins were frozen. We went to study, then at 8 we ate a bit of dry bread with water ... I vomit only once in a while when hunger drives me to eat their mutton.[4]

And you thought your high school was bad.

Paris: Rebellion and Self-Portraiture

At age twenty, Courbet left Ornans for Paris, ostensibly to study law at his father's insistence. But Paris was far away from Ornans, and whether Courbet actually attended law school at all seems to be in doubt.[5] If so, he quickly gave that up to study art.

Rebelling against his father was important to the young Courbet, but then again, so was having rent money. In his many letters to his father (often exceptionally indignant), he regularly claimed poverty and begged for more support from home.[6] Yet, he somehow managed to dress the dandy and could afford to keep a spaniel, both affectations present in *Self-Portrait with a Black Dog* (figure 3.3), painted when Courbet was about twenty-three. This very early work is one of dozens of self-portraits by Courbet. He was much taken with his own likeness throughout his life, and he almost always managed to present himself in a favorable light. In *Self Portrait with a Black Dog*, he looks straight

The Paris Salon

Usually simply referred to as The Salon, the Paris Salon was an annual or biennial art exhibition held in the Louvre for most of its history. Although the rules to be included, its location, and its timing varied over the decades, at the time that Courbet was painting, it was essential to have one's work selected for the Salon if one wanted to make a mark as an artist. The Salon was reviewed in publications (it essentially created the notion of the art critic) and the opening night was a grand celebration. In the absence of other avenues for promoting one's work, the Salon was a lifeblood for the artists of the day.

out at the viewer as if to say, "Please take note of this superb tailoring, my handsome dog, walking stick, fashionably wide-brimmed hat, and oh yes, this is a sketch book—I am an artist, you know." As a viewer, you stand below Courbet. He is looking down at you (looking down his nose at you?). It was Courbet's first painting to be accepted in the Paris Salon, and it was a source of great pride for him.

Self Portrait seemingly depicts a young man who is immensely self-satisfied. But if we take a second look, it is reasonable to wonder, does the painting hide insecurity or protest a claim to prosperity too much? Is this the real Courbet at age twenty-three, or the Courbet the artist wished to project? What exactly is going on here? Hard to know. It is a handsome dog, though.

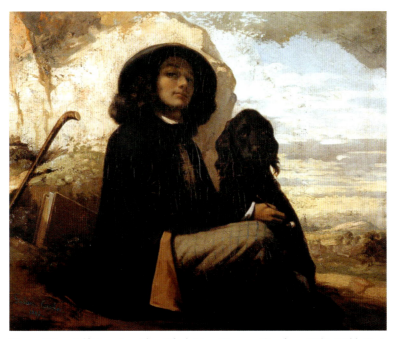

Figure 3.3. *Self-Portrait with a Black Dog,* Gustave Courbet, 1842–1844. Petit Palais, Paris.
https://commons.wikimedia.org/wiki/File:Selbstbildnis_mit_schwarzem_Hund.jpg

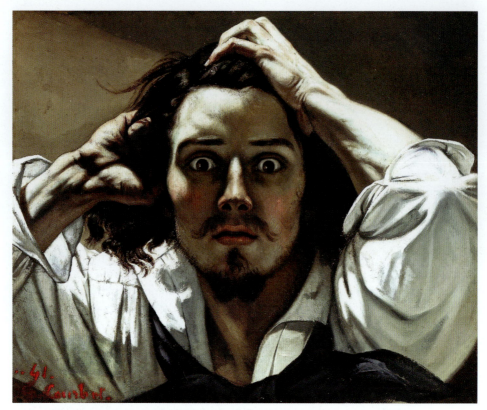

Figure 3.4. *Man in Despair*, Gustave Courbet, 1841(?). Private Collection.
https://commons.wikimedia.org/w/index.php?curid=3011934

In stark contrast to the pretentious dandy we see in *Self-Portrait with a Black Dog* is another self-portrait, *Man in Despair* (figure 3.4). Much has been made of *Man in Despair*, painted in the Romantic style. It has been referred to as reflecting mad genius, or as Courbet's declaration to the world that he was determined to change the course of art history. I find it hilarious. I keep trying not to, but to my eye, it simply looks like a twenty-something year old conveying how awful one's lot is to be in Paris in the 1840s, drinking with the radical literati, artists and models, being supported by one's parents, and living the life bohemian. Having been the same age in the late 1960s/early 1970s, I am simply too reminded of me and my college roommates: tortured, but well-fed (even the hair and the costumes were the same). Fortunately, we, and Courbet, grew up. Courbet apparently also learned that the light doesn't typically come in from the left (his forehead) and the right (his left arm) at the same time.

Courbet painted around two dozen self-portraits in his early years in Paris. To some degree, this might be because self-portraits do not require the expense of a model, but art historian Petra Ten-Doesschate Chu suggested an intriguing alternative: publicity. In Chu's book, *The Most Arrogant Man in France*, she argued that there was a burst of media opportunities in Paris at the time, and that nobody exploited them more for personal gain than Gustave Courbet.[7] He did so by presenting himself (both in person and on canvas)

and his opinions (in letters to the press and in declarations) to as many members of the press as possible. Throughout his life, Courbet courted publicity by being outrageous, contrary, and vain. During the 1840s, Courbet submitted at least one self-portrait to every Salon. Thus, if the work was accepted, Courbet would not only have a work in the Salon, he would have a nineteenth-century "selfie" serving as an advertisement as well.

Paris in the Time of Courbet

Courbet arrived in Paris around 1840, in the midst of a prolonged era of governmental and social upheaval (it was France, after all). To set the scene, following the Revolution of 1789, Napoleon ruled France until 1815. Waterloo ended that, and the royalists brought back monarchy with the Bourbon Restoration. In 1830, the "Three Glorious Days of Battle" of the July Revolution led to the overthrow of the Bourbons, and Louis-Philippe became monarch until 1848. Louis-Philippe's leadership led to the Revolution of 1848, and the establishment of the Second Republic under Napoleon's nephew, Louis Napoleon. Dissatisfied with only being president and not being able to be reelected, in 1852, he performed a coup d'etat on himself and became Napoleon III, ruler of the Second Empire. While all of this is taking place, photography was invented; dozens of publishing houses, newspapers, and magazines were begun; cholera broke out repeatedly; and students barricaded streets and demonstrated against whichever government was currently in power. It was basically a fifty-year version of *Les Misérables*.

Paris saw wealth and its accoutrements grow rapidly, but poverty and its accordant discontent kept pace. Also, the population in Paris doubled from 1830 to 1860, from roughly 750,000 to 1.5 million. As Dickens wrote in the opening of *A Tale of Two Cities*, published in 1859, Paris at the time of the Revolution of 1789 was not unlike Paris in the 1850s. "It was the best of times, it was the worst of times, it was the age of wisdom, it was the age of foolishness." Gustave Courbet embraced it all and left his mark on it.

Realism versus Romanticism and Classicism

There were two competing artistic styles when Courbet began to paint: Romanticism and Classicism, or more properly, Neoclassicism, as it was a return to the Classic style of centuries gone by. To get an idea of what these styles are, we can look at a leading artist from both Romanticism and Neoclassicism: Eugène Delacroix and Jean-Auguste-Dominique Ingres. They are two of the great figures in the history of French painting. Courbet would reject both approaches and create his own.

DELACROIX AND ROMANTICISM

The July Revolution of 1830 inspired Courbet's sometime admirer and sometime critic, the great French Romanticist, Eugène Delacroix, to paint *Liberty Leading the People* in

> **Romanticism**
>
> Romanticism was an artistic movement of the eighteenth and nineteenth centuries that emphasized emotion, imagination, the subjective over the objective, and spontaneity and emotion over rational deliberation and reason. It was a reaction to Classicism and Neoclassicism. Leading Romantic painters were Delacroix (see figure 3.5), J. M. W. Turner, and the Hudson River School painters of America.

honor of the event (figure 3.5). Contrary to what is commonly thought, it was not a painting of the Revolution of 1789 or the French Revolution. *Liberty Leading the People* provides a good contrast between the Romanticism of Delacroix and the Realism of Courbet, while also showing their similarities. To begin, the theme, the action, the overall depiction of *Liberty*, are all glorious. This is not just a woman with an ill-fitting bodice wielding a musket, it is *Liberty* herself, tricolor in hand, leading the way to victory atop the fallen bodies of her compatriots yearning for freedom. There are combatants from all levels of society, including a child armed with two pistols joining in the battle. Note that the man at the bottom left has, bizarrely enough, even contributed his pants to the cause ("I'm sure I was wearing them when I left for the Revolution this morning").

The Romantic style of Delacroix is thus apparent in the choice of topic, but also in how the painting is made. It does not have the precise linework of a Classicist painting, but rather is one color up against another. This brilliant use of color was a signature of Delacroix. Although the overall depiction is one of grandeur, there is an earthiness to the

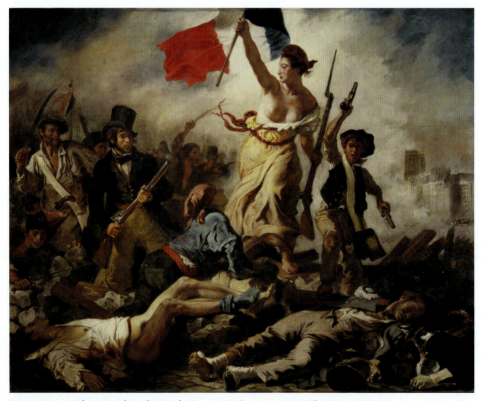

Figure 3.5. *Liberty Leading the People*, Eugene Delacroix, 1830. The Louvre, Paris.
https://commons.wikimedia.org/wiki/File:Eug%C3%A8ne_Delacroix_-_Le_28_Juillet._La_Libert%C3%A9_guidant_le_peuple.jpg

individuals depicted. This is an aspect of painting that can also be seen in Courbet's work. His Realism borrows, to a degree, from Romanticism, especially in style, but rejects the glorification of theme. Courbet wanted to paint what is real, not imagined or fantastic. As Courbet put it in his always unsubtle style, "Show me an angel and I'll paint him."[8]

INGRES AND NEOCLASSICISM

The other prevailing style was Neoclassicim, which emphasized technical quality and enduring themes of historic, classical importance. One of its most prominent practitioners was Jean Auguste Dominique Ingres. His portrait of the *Princess de Broglie* (figure 3.6), while not particularly classical in theme, certainly is in execution. Everything about this painting is perfectly posed. The *Princess* looks more like a porcelain doll than an actual woman. Her dress and the chair upon which she leans are breathtaking in how they depict the lustre of the fabrics. This painting is at The Metropolitan Museum of Art, and my wife, Lisa, and I spent hours admiring it when we worked at The Met. This stunning portrait

Classicism

Classicism refers to art inspired by Greek and Roman art of antiquity. It emphasizes harmony, beauty, line over color, and the exaltation of humankind. Neoclassicism was a revival of classicism that took place in Europe in from about the middle of the eighteenth century to the middle of the nineteenth century. Leading Neoclassical painters included Jacques-Louis David, Jean Auguste Dominique Ingres, and Élisabeth Vigée Le Brun.

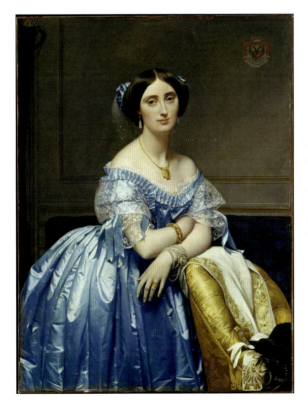

Figure 3.6. *Joséphine-Éléonore-Marie-Pauline de Galard de Brassac de Béarn* (1825–1860), *Princess de Broglie*, Jean Auguste Dominique Ingres, 1851–1853. The Metropolitan Museum of Art, New York.

https://commons.wikimedia.org/wiki/File:La_Princesse_de_Broglie_-_Jean-Auguste-Dominique_Ingres_-_Metropolitan_Museum_of_Art.jpg

is even more amazing in person (as is all art). The brilliance of the colors catches the eye of the viewer from across the gallery room. From a distance of six feet or more away, the dress and chair are absolutely stunning and amazingly real. You feel as if you touched the fabric, it would make a crinkling sound. And then, from two feet away, the brushstrokes through which Ingres created this masterpiece become readily apparent. Incredible. (Any closer than two feet and the guards start to get nervous.)

ENTER GUSTAVE COURBET, THE MOST ARROGANT MAN
IN THE WORLD

This is the world of art into which Courbet entered as a young man. It should be noted that not all art was prototypically one style or the other, but Romanticism and Neoclassicim were the approaches that dominated the era. Spurning both approaches, Courbet presented his dramatic alternative to what art should be. He also insulted the practitioners of both styles and their supporters with his words and behavior. As he put it in a letter to his parents, "When I stop being controversial, I'll stop being important."[9] And being important was oxygen for Courbet.

Courbet Sets Out to Offend and Succeeds Wildly

Courbet started somewhat slowly in his efforts to change the world. His early work, in the 1840s, consisted primarily of self-portraits, portraits of his sisters and others, and country scenes that were relatively inoffensive and hardly dramatic. He was making his way and not rocking the boat. Then in the late 1840s, two events took place that altered the course of his work and his life. First, in 1847, he visited Holland and was greatly impressed by the Dutch masters and their emphasis on painting everyday life and not glorifying their subjects. The second event was the Revolution of 1848. Louis-Philippe, king since 1830 and favorite of the bankers of France, was overthrown and the Second Republic was established under Napoleon III. It was a new day in France. Courbet's socialist leanings were much more in tune with the new government. He spent evenings discussing the events of the day at a beer hall with art critic Champfleury, poet Baudelaire, and radical philosopher Proudhon, among others.[10]

REALIST PROVOCATEUR

With the end of the monarchy and his new found familiarity with the genre (everyday life) paintings of the Dutch masters, Courbet surprised the art world of France with *After Dinner at Ornans* (figure 3.7). It was selected for display at the Salon of 1849. It is a huge work; the figures in it are life-size. One is Courbet's father, who is either in a deep reverie listening to the violin music, or more likely, asleep. The other three are Courbet's friends from his hometown of Ornans, along with a gorgeous bulldog. It is painted in a tenebrist style (strongly chiaroscuro) all in tones of brown. What strikes the eye is that these are real people in a real scene. Contrast this image with the ones by Delacroix and Ingres

> **Realism**
>
> Realism is an approach to art that focuses on painting from real life as opposed to imaginary or classical themes. The Realists wanted to record the everyday life of working people, as opposed to contrived scenes. It was developed in the mid-1800s, and Courbet was a leading proponent. Other Realist painters were Honoré Daumier, Jean-François Millet, and Jean-Baptiste-Camille Corot.

(figures 3.5 and 3.6). Those paintings were what people expected to see at the Salon. Not peasants doing nothing. Although it may seem a quiet and gentle country life scene to a modern eye, in the Paris Salon of 1849, *After Dinner* was shocking.[11] No one at the Salon was indifferent to *After Dinner at Ornans*. It was loved or hated. Reactions included these:

Delacroix: "There's an innovator, a revolutionary, too: he has hatched suddenly, without precedent."[12]

Ingres: "How does it come about that nature herself ruins her finest creations? She has endowed this young man with the rarest gifts. . . . a work that's masterly in the most difficult aspects, the rest, which is art, totally evades him."[13]

Art critic Louis Peisse: "No one could drag art into the gutter with greater technical virtuosity."[14]

Courbet in response to Peisse: "Yes, art must be dragged into the gutter."[15]

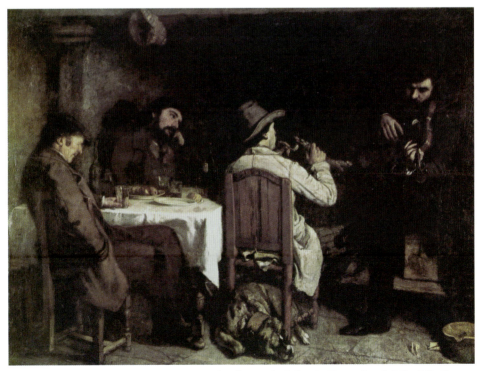

Figure 3.7. *After Dinner at Ornans*, Gustave Courbet, 1848. Palais des Beaux-Arts de Lille, Lille, France. https://commons.wikimedia.org/wiki/Category:After_Dinner_at_Ornans_(Courbet)#/media/File:Gustave_Courbet_031.jpg

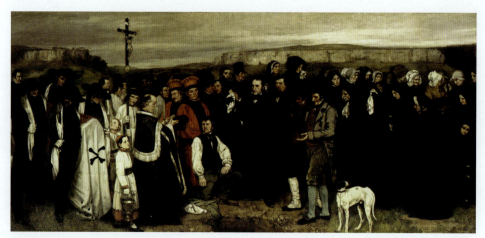

Figure 3.8. *A Burial at Ornans*, Gustave Courbet, 1849–1850. Musée d'Orsay, Paris.
https://commons.wikimedia.org/wiki/File:Gustave_Courbet_-_A_Burial_at_Ornans_-_Google_Art_Project_2.jpg

Courbet could not have been happier. Adulation and outrage deliciously intermingled!

Art was supposed to elevate the viewer, and themes were supposed to be historical and classical in nature. Technical expertise was highly valued. People were supposed to be inspired, not repulsed. And then here comes Courbet, the proud grandson of a *sans coulette* (literally, "without breeches"), a French revolutionary of the lower class.[16] In his grandfather's footsteps, he rebelled against accepted practice and brought to his viewers the real life of the rural working class. He followed *After Dinner* with larger and even more provocative works, perhaps the most famous of which was *A Burial at Ornans* (figure 3.8), which prominently featured forty mourners and clergy at the burial of his radical grandfather.

Presented at the Salon of 1850/1851, *Burial* spanned twenty-three feet in width and eleven in height. It basically mocked classical religious painting by presenting real people, many of them homely, in real mourning over the death of someone who was not a saint or martyr. Included among the mourners on the far left (appropriately enough) is the deceased radical grandfather himself! Also note that the crucifix is positioned such that it appears that Christ is being crucified at the same time in the distance. Sacrilege heaped upon ugliness, and all in life-size. Courbet had hit his stride.

Reaction to *A Burial at Ornans* was even more hostile than for *After Dinner*, savage in some quarters. Critic Claude Vignon said, "One has never seen, and never could see, anything so frightful and so eccentric. Good God, how ugly it is. It is in fact, abominably ugly."[17] Another critic called the work an "ugly and blasphemous caricature,"[18] and another, "there is more to laugh at than to cry."[19] Courbet never flinched in response to his critics, generously giving more than he received. He delighted in the antagonism he engendered. "I am a Courbetist, that is all; my painting is the only true one."[20]

Courbet and Women

A third event took place during the late 1840s for Courbet, one that might have been expected to influence Courbet, but there is little evidence that it did: he became a father. He had an affair of fourteen years with a woman named Virginie Binet, eleven years his senior. In 1847, she became pregnant with his child, and as the due date approached, Courbet decided it would be a good time to visit Holland.[21] He was not present at the birth, nor did he acknowledge her or his son, whose last name became Binet. Desperate and in poverty, receiving no support from Courbet, six years later, Binet finally left him. Courbet later said of this time, "If I suffered from my passions when younger, I suffer more from them today. I have taken . . . one or several years in ridding myself of an attachment. . . . That's how I became free."[22]

Courbet's relationships with women are not well-understood, but it is safe to say they were not generally positive. He bragged of multiple sexual conquests throughout his life. The only exception that paints him in a more sympathetic light was his relationships with his mother and sisters. He returned to see them often in Ornans and painted beautiful portraits of his sisters. In Paris, it was a different story. He felt it important that he not be constrained to any monogamous relationship ("I am as inclined to get married as I am to hang myself"[23]). and had a number of affairs including, apparently, one at the time that Virginie Binet was pregnant. Later in his life, when all aspects of his existence had essentially gone pear-shaped, he wrote the following: "I am in a state of inexpressible anxiety. . . . I have three lawsuits in Paris and I don't know which one to pay attention to. I would give my life for a penny. I could use a wife."[24] Only at the point in his life where it is only worth a penny does he think that a wife would be a good idea. And even then, the phrasing, "I could use a wife" is chilling.

In the 1850s and 1860s, with both his fame and his infamy well-established, Courbet embarked on an intriguing set of paintings of women. Much has been made of these works, both at the time and throughout art history, in a number of reanalyses ranging from Marxist to Freudian to feminist.[25] Without getting too deep into what are no doubt important debates, one can usefully dichotomize Courbet's painting of women into two sets: the domestic and the erotic. The domestic paintings are well-exemplified by *The Sleeping Spinner* (figure 3.9). Here we see a woman of the working class, but nicely dressed, who has fallen asleep at her spinning wheel. There are suggestions that this might be one of Courbet's sisters, but it is generally thought to be another native of Ornans. There are also suggestions of sexual overtones here, including voyeurism (the spinner doesn't know we are watching), and the fact that the spindle with wool sticking out is symbolic, especially since it transverses her thighs. Well, perhaps. But perhaps it is just a lovely picture of a sleeping spinner, reminding us that this is tiring, but noble work, and that the spinner deserves our admiration.

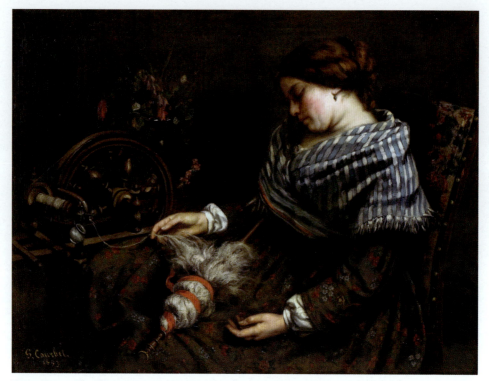

Figure 3.9. *The Sleeping Spinner*, Gustave Courbet, 1853. Musée Fabre, Montpellier.
https://commons.wikimedia.org/wiki/File:Gustave_Courbet_038.jpg

On the erotic side, we might start with the picture that introduced the chapter in figure 3.2, *Woman with a Parrot*. This is a painting of Joanna Hiffernan, who was the model and mistress of James McNeil Whistler (see chapter 4). In 1865, Courbet visited Whistler and Hiffernan to spend the summer in the French coastal town of Trouville where they ate, drank, painted, and discussed art. During this conviviality, Courbet stole Hiffernan away from Whistler, which made the visit less amicable. The contrast in how these two artists saw the beautiful Hiffernan is remarkable. In 1862, Whistler painted Hiffernan as *The White Girl* (or *Symphony in White No. 1*), as is discussed in chapter 4 (figure 4.5). *The White Girl* could be a painting of a young lady on her wedding day. Four years later, Courbet saw her as a focus of unbridled sensuality, naked, on a bed with minimal covering, and playing with a parrot that has been suggested to be a phallic symbol (seriously, a parrot?).

Courbet painted Hiffernan and other models in a number of highly evocative poses, mostly in the 1860s, but some earlier than that. None of these works was more erotic, however, than *The Origin of the World*, which is alluded to at the beginning of the chapter. It is a very close up painting of a woman's torso and legs, in bed, very explicitly detailing her genitalia. This work was commissioned by Turkish/Egyptian diplomat and bon vivant, Khalil Bey, who had sought out Courbet to paint nude women for him.[26] He already had works by Ingres and Corot. After Bey went bankrupt from gambling, the *The*

Origin of the World changed hands a number of times, but was never seen publicly until its last private owner gave it to the Musée d'Orsay in 1995. The identity of the model is not known for certain; it is possibly Hiffernan, but more likely a courtesan of whom Bey was particularly fond. My wife and I have seen the work at Musée d'Orsay. It is particularly amusing that even today, many visitors do not go up to the work directly, but rather view it from a distance and off to the side.

The End Game: The Paris Commune and Exile to Switzerland

As Courbet grew more famous and more prosperous, he also grew larger. The tall, lanky, dashing figure of his younger years evolved into a portly, and then overly portly, middle-aged man. Always controversial, his girth made him the subject of uncharitable caricatures in the public press (figure 3.10). But this was merely acclaim in a different form to Courbet, and he relished the limelight. There was a law that forbade anyone from making a caricature of someone without that person's permission. Courbet wrote a letter to a newspaper in 1867 saying that anyone could make a caricature of him. He was a star in Paris—controversial, opinionated, and self-satisfied. No longer struggling to make ends meet, he still delighted in provoking the well-to-do and those in power.

In 1870, in the midst of the Franco-Prussian War, Courbet took a step too far. He proposed that the column honoring Napoleon I in the Place Vendôme be disassembled and reassembled near Napoleon's tomb. The proposal went nowhere and might have been forgotten except for the never-ending political turmoil of Paris. Under siege by Prussian troops for four months, the French government basically skipped town for greener pastures (the city of Tours in this case), and a new government, the radical socialist Paris Commune, took control of the city. Courbet was an active participant in the Commune, and during its brief stay in power (March to May, 1871), the Vendôme Column was toppled and destroyed, with Courbet receiving credit for instigating the act.[27] After the French government retook control of Paris, Courbet was tried and convicted for having encouraged the column's destruction. He was fined and sentenced to six months in prison.

> **The Paris Commune**
>
> The Paris Commune was an extraordinary, if brief, moment in the history of Paris. Born of the fall of the Second Republic and the siege of Paris by the Prussians, it was a radical government that ruled the city of Paris independently from the national government for roughly two months in the spring of 1871. Members were called "communards." It was overthrown by the French army at the end of May 1871, with horrendous bloodshed and executions taking place on both sides.

But his problems were not over. When Patrice de MacMahon was elected president of the Third Republic in 1873, he wanted the column rebuilt and for Courbet to pay the costs. Another trial, another verdict, and Courbet was on the hook for 323,000 francs. Our hero decided to once again relocate, this time to Switzerland.[28]

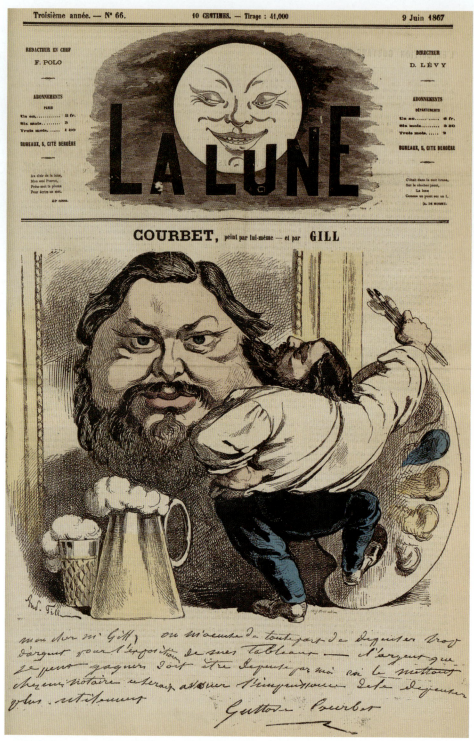

Figure 3.10. *Caricature of Courbet*, Andre Gill, 1867.
https://commons.wikimedia.org/wiki/File:Gill_Courbet.jpg

Courbet fled to Lake Geneva, Switzerland, where he lived the remainder of his life and continued to paint. However, his work took on a distinctly more Impressionist style, just as the Impressionists were making their mark in Paris. They had always looked up to Courbet, admiring his pictorial abilities as well as his antagonism toward the establishment, a posture they found laudable. His influence can be seen throughout Impressionism.

But he longed for Paris, and in his depression, he drank even more heavily than he had in Paris, and took to the popular but dangerous absinthe. He died from liver disease on December 31, 1877, bereft and far from his beloved Paris. His only comfort was that his aged father made the trip from Ornans to be with him when he died. Courbet once argued that the smiling face that the public saw of him was a facade concealing anguish, doubt, and sorrow: "Under the laughing mask that you see I conceal inside me suffering, bitterness and a sadness that clings to my heart like a vampire."[29] A rabble rouser and an anarchist, a rogue and a lout, Gustave Courbet changed the course of art in the way only he could—dramatically.

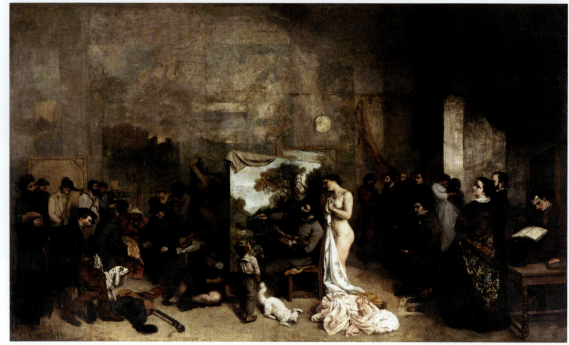

Figure 3.11. *The Painter's Studio: A real allegory summing up seven years of my artistic and moral life*, Gustave Courbet, 1855. Musée d'Orsay, Paris.
https://commons.wikimedia.org/wiki/File:Courbet_LAtelier_du_peintre.jpg

Gustave Courbet made this painting for the Paris World's Fair of 1855 in its Exposition Universelle. Courbet was well-established in the Parisian art scene at this time. The Exposition accepted eleven of Courbet's works, but turned down this one. Outraged, Courbet set up his own, The Pavilion of Realism, near the exposition, but it was not successful. This work conveys the artist's prototypical immodesty, extoling himself above all. He portrays his allies and admirers on the right hand side of the painting, and his rivals and enemies on the left hand side. Courbet sits dead center, not unlike Christ in The Last Supper. *The Painter's Studio is filled with symbolism and not-so-subtle commentary on the artistic, social, and political life of Paris at mid-century. Courbet completed this massive painting in his studio in Ornans (250 miles from Paris), working from previous paintings, sketches, and photographs of his subjects. The painting is almost twelve feet high and twenty feet wide, only slightly smaller than Emanuel Leutze's* Washington Crossing the Delaware, *painted four years earlier. The figures, therefore, are basically life-sized.*

A Closer Look: *The Painter's Studio*

Please take a look at the work featured in figure 3.11 and read the label that accompanies it. Take your time; there is a lot to see!

Welcome back. This is one of Courbet's most famous works. A reasonable first reaction to this work might well be: "Wow, there is a lot of stuff going on in this painting!" And there is. After all, as the title says, it sums up seven years of Courbet's artistic

and moral life. It also declares that it is an allegory, so it is reasonable to look for symbolic items. But let's not start there. Let's start with what hits the eye immediately. In a room filled with dozens of individuals, Courbet has placed a naked model clutching a robe or sheet, watching Courbet paint, absolutely rapt with the wonderfulness of his work. And then one might be tempted to say, "Wait a minute; he isn't even painting her. She's just there naked!?"

A small child and a cat seem to be equally enthralled. In fact, the model, child, and cat seem to be the only ones in the painting attending to what Courbet is doing. In a studio full of individuals and ideas from his life, do these three represent beauty, innocence, and nature, the only things for which Courbet really has time? We also see that even though Courbet is busy painting another masterpiece in the picture, we are able to get an excellent view of the artist at work. Courbet never missed an opportunity to put himself on display, and at the center of attention! It is also interesting to see that Courbet is almost in the painting that he is making. He seems to be coming out of the painting itself, as if to declare, "This is who I am. I am art itself." The boy, cat, and model can be viewed as being part of the painting within the painting as well.

Leaving the focus on the center of the work presents the viewer with over twenty people and a wealth of objects to contemplate, including working people, skulls, one man being crucified, another reading a book, lovers, merchants, what may be a religious figure, a destitute woman, and a man or woman bowing down on a cloth. So what is going on here? Courbet, as was almost always the case, wanted to make a statement. Actually, he wanted to make an assortment of them. In the artist's own description of the work, "It's society at its best, its worst, and its average . . . it's the people who come to my studio to be painted On the right . . . are my friends. On the left . . . are the poor, the wealthy . . . those who thrive on death."[30] Above all, Courbet was not subtle.

The man reading the book on the far right is the poet and art critic, Charles Beaudelaire, author of the scandalous collection of poems *Les Fleurs du mal*. Although he and Courbet were allies, it was a tenuous relationship, and Courbet casts him as off to the side with his head in a book, not noticing what was going on around him. Toward the rear of the right of the painting are Courbet's friends, including the art critic, Champfleury, who coined the term *Realism*. Proudhon, known as the father of anarchism, is there also, as well as various collectors and sellers of art.

On the left, or sinister side ("sinister" is Latin for left-handed), there is a man with hunting dogs who bears a strong resemblance to Napoleon III, who had seized power and declared himself emperor. Courbet despised him and depicts him, appropriately enough, as a poacher. We also see a man crucified, which may represent the death of the Royal Academy of Art. The items lying on the floor have been interpreted as the death of Romanticism and the death of Classicism.

Something for everyone.

WHISTLER

Figure 4.1. *Portrait of Whistler*, William Merritt Chase, 1885. The Metropolitan Museum of Art, New York.
https://commons.wikimedia.org/wiki/File:Chase_William_Merritt_James_Abbott_McNeill_Whistler_1885.jpg

Figure 4.2. *Milly Finch*, James McNeill Whistler, 1884. Freer Gallery of Art and the Arthur M. Sackler Gallery, Washington, DC.

https://commons.wikimedia.org/wiki/File:James_McNeill_Whistler_-_Milly_Finch_-_Google_Art_Project.jpg

CHAPTER 4

Whistler

PEACOCK PUGNACIOUS

If the title of this book had been expanded to *Scoundrels, Cads, Fops, Poseurs, Dandies, and Other Great Artists*, James Abbott McNeill Whistler would have qualified for inclusion under any of the criteria. Once, having accidentally shot a friend's dog on a hunting outing, he proclaimed, "It was a dog without artistic habits, and had placed itself badly in relation to the landscape."[1] The dog and Whistler survived the incident.

Whistler was the living embodiment of the Groucho Marx line, "I wouldn't want to be a member of any country club that would have me as a member." His family pulled strings to get him into West Point, and then his misbehavior got him thrown out (by Robert E. Lee, no less).[2] He was accepted into and then expelled from a number of artists' societies (or left in a huff); he withdrew his paintings from exhibitions when he felt he wasn't being sufficiently respected by the organizers. He was constantly suing and

being sued. He had multiple affairs and children out of wedlock, repeatedly befriended people and then fell out with them, and once, in a fit of pique, threw his brother-in-law through a plate glass window at a café.[3] He continuously outspent his income. But through thick and thin, he was always impeccably well-dressed (see figure 4.1). Resplendent with monocle and cane, and often, a cape, he was an epicurean of *la vie bohème* and a breathtakingly brilliant artist.

Starting Out

Reality had only the lightest of claims on James Abbott McNeill Whistler; he lived as he chose to live, the consequences be damned. He once declared that he was born in St. Petersburg, Russia, but he was actually born in Lowell, Massachusetts, in 1834. As he put it, "I shall be born when and where I want, and I do not choose to be born in Lowell."[4] His father was an internationally renowned builder of railroads, and Whistler indeed lived in high fashion in St. Petersburg, Russia, for roughly five years while his father worked for the Russian government. With Whistler still in his early teens, his father died in a cholera epidemic and the family's fortunes changed dramatically. They moved back to America into very modest quarters and a life of hardship. Great gain and great loss was a theme that played itself out time and again in Whistler's life, most often through his own deeds, but in this critical incident early in his life, it was through fate: his father had wisely sent the family off to London to escape the epidemic but foolishly stayed in St. Petersburg himself, succumbing to the deadly disease and impoverishing his family. Young Jimmy Whistler was forced to trade his art lessons at the Imperial Academy of Fine Arts in St. Petersburg for caring for pigs and chickens in Pomfret, Connecticut.[5]

A Cadet, for a While

After his father died, the question of what should become of Whistler was of great concern to both him and his mother. She initially wanted him to become a minister, but they settled on sending him to the United States Military Academy at West Point, where his father had graduated. To see Whistler in his adult years—the most effete of aesthetes—West Point was an astonishing choice. Getting into the academy was quite difficult, but ultimately, friends of his late father persuaded Millard Fillmore, then president of the United States, to advocate for him. Having been admitted, he promptly set about doing whatever he could to be dismissed, racking up demerits for being late to classes and drills, drinking in town, insulting senior cadets and officers, and abusing the norms of the institution. His mother had admonished him in a letter to "clean your teeth and your musket."[6] He did neither. Also working against him was his consistently poor academic performance, as well as the mistress he had in town (contracting gonorrhea while still a teenager). The final straw was reportedly failing a chemistry test where, when asked what silicon was, he responded, "A gas." In later years he would say, "Had silicon been a gas, I would now be a major general."[7] (For the technically minded reader, silicon *can* exist as a gas, but only at well over 2,000 degrees centigrade.)

Figure 4.3. *Sketches on the Coast Survey Plate*, James McNeill Whistler, 1854–1855. The Metropolitan Museum of Art, New York.
https://digitalcollections.nypl.org/items/510d47e3-ac62-a3d9-e040-e00a18064a99

Whistler pleaded repeatedly to get back into the Academy, appealing to both Lee and Jefferson Davis, but to no avail. Now on his own, he secured a position as a draftsman making maps of coastlines for the Coast Guard. He lost that work for frequently being late or absent. He claimed the problem wasn't that he was late, but that the Coast Guard opened too early.[8] The mapmaking department shipped him off to the etching department, where he developed impressive skills in the two months prior to being fired from there, as well. He was an exceptional etcher, but he felt that coastlines would surely be more interesting if they also contained portraits of interesting people, whales, and mermaids in the borders (see figure 4.3 for an example of Whistler's proclivity to drift off-topic in his etching). In addition to opening too early, it appears that the Coast Guard also had no appreciation for accessorizing.

Although the demands of his job did not fully engage the young James Whistler, he always dressed well and partook of a number of dalliances. He had overcome difficult circumstances to attain what he thought was the chance of a lifetime at West Point. Only wanting what he could not have, he threw that chance away. He left America, never to return, but would always claim to be "a West Point man."[9] Just twenty-one, and having been tossed from West Point and two jobs, adventure beckoned.

Paris and London, Heloise and Jo

In 1855, he left the United States, sailing to Paris to become an artist. And what a Paris it was! Louis-Napoleon Bonaparte (nephew of the great Napoleon I) ruled France and was reinventing the city of Paris. Construction was taking place everywhere, with new

boulevards, infrastructure, and buildings on the rise. There was a sense of progress and change throughout the city. Ingres and Delacroix were leading painters of the time. On the literary front, Jules Verne was perfecting his craft; Gustave Flaubert was writing his scandalous *Madame Bovary*; and Victor Hugo was working on *Les Misérables* (although doing so in exile for having opposed Bonaparte).

> ## Etching and Dry Point
>
> Etching and dry point are related approaches to making an image on a metal plate (often copper) so that the plate could be inked and multiple images produced. In etching, an acid-resistant wax is applied to the plate, and then the image is drawn into the wax with an etching tool. The wax is removed as the lines are drawn. The plate is then submersed in an acid bath. The acid eats into the plate where the wax has been removed, creating an image on the plate ("etch" comes from a German word meaning "to eat"). Ink is applied to the plate and worked into the lines that have been made by the acid. The excess ink is removed from the plate, a clean piece of paper laid on top of it, and then it is run through a press, creating the final image. Dry point differs from etching in that the artist draws directly on the plate with a diamond-tipped needle or similar instrument. The plate is inked, cleaned, and pressed, as in etching. Often the two techniques (and others) are combined in making an image.

In Paris, Whistler focused on etchings, fine clothing, and *grisettes*, the flirtatious and independent working class young women who often served as models and sometimes mistresses for young artists in Paris. Whistler took up with a volatile grisette name Héloise, whom he nicknamed "Fumette," which means "little smoke" in French, but also has a number of less than desirable slang connotations. "Little smoke" seems appropriate here, as she appears almost combustible in Whistler's etching of her in figure 4.4. Whistler also called her "La Tigresse," and indeed, this etching has both captured her striking beauty and suggested her proclivity to strike out from the crouching pose he has chosen for her. She was totally devoted to Whistler, but also wildly jealous. In a fit of rage, she once tore up dozens of his drawings.[10] Whistler moved on to other grisettes, and then on to London.

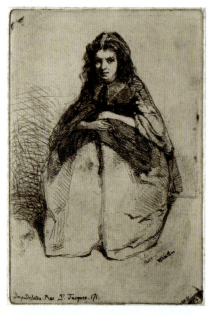

Figure 4.4. *Fumette, etching*, James McNeill Whistler, 1858. The Metropolitan Museum of Art, New York.

https://commons.wikimedia.org/wiki/File: James_McNeill_Whistler_-_Twelve_Etch ings_from_Nature-_Fumette_-_1940 .795.4_-_Cleveland_Museum_of_Art.tif

In London, he lived with his half-sister and brother-in-law, and began to focus on painting as well as etching. In 1860, he met the beautiful and brilliant Joanna Hiffernan. Just seventeen years old, with blue eyes and copper hair, she would become known in Paris as *La Belle Irlandaise* (the beautiful Irish girl). Jo became Whistler's model and mistress, muse and manager.[11] He painted and drew her numerous

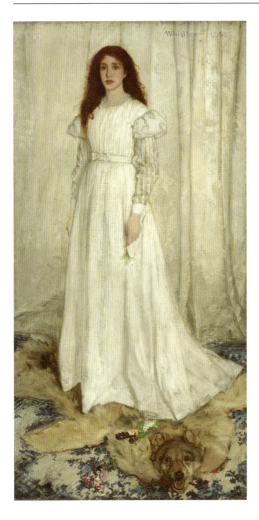

Figure 4.5. *Symphony in White No. 1: The White Girl*, James McNeill Whistler, 1861. National Gallery of Art, Washington, DC.

https://commons.wikimedia.org/wiki/File:Whistler_James_Symphony_in_White_no_1_(The_White_Girl)_1862.jpg

times, but none more stunning than *The White Girl*, later to become known as *Symphony in White No. 1: The White Girl* (figure 4.5).

The reproduction in this book might only be six or seven inches in height, but in real life, the painting is seven feet tall! It is almost overwhelming in person, and it *is* a symphony in white. Her dress is made of different materials, all shades of white; the curtains are a white on white brocade; she stands on a white polar bear rug, holding a white lily in her hand. Whistler argued that the painting did not tell a story, but rather was analogous to a symphony, using white as a theme. Thus, the painting isn't really a portrait of Jo Hiffernan, as beautiful and ethereal as she is in this work. Her face and hair, it might be argued, are unfinished (a common criticism of Whistler's works). But Whistler is saying (my words), "This isn't about her. It's about the colors and their arrangement. It is simply meant to be a beautiful thing to see." But look at the bear at the bottom of the painting. It provides a balance to Jo's head at the top of the painting. It is painted with as much detail and finish as Jo, and perhaps with even more expression. And there are flowers on the bear rug. Is she deflowered? Or, has she conquered the beast (the bear) that she stands upon? If so, the bear doesn't seem upset. Is Whistler toying with us as viewer? Or should we just focus on the white?

Symphony in White No. 1: The White Girl was rejected for the annual exhibition by the Royal Academy of London in 1862, and then by Salon of Paris in 1863. It appeared instead in the infamous *Salon des Refusés*, where, along with Manet's *Le Dejeuner sur l'Herbes*, it stole the show and began Whistler's climb to fame. It also marked the beginning of Whistler entitling his paintings with musical terms, such as symphony, arrangement, and nocturne. He wanted viewers to associate them with the patterns and harmonies of musical movements.

Imagine Whistler's *La Vie Bohème*

A small break in the narrative for a reverie of sorts: It is the early 1860s and you are Jamie Whistler, in your late twenties, in London and Paris, outrageously dressed, and with a stunning young Irish girl as your model and mistress. Not a girl that you could take to meet the family mind you, but one that would be the envy of every one of your young colleagues and compatriots, some of whom would go on to fame and fortune . . . and some who would fade into obscurity. But for now, those fates have not been realized. For now, you are one of a coterie of young rebels and dandies, artists, poets, and aspiring novelists—"cads" some would say—gathering in the bistros and cafes in the evening to discuss the events of the day, certain of your positions even if they were different from last week. You would drink coffee, cheap wine and absinthe, flirt, posture, bluster, and dispute. Of all the clever lads, you were the cleverest. During the day you would struggle with your art—what did it mean, where could you make your mark or at least make a few guineas, where could you proclaim whom you are and not sell out? But then, in the evenings, you have reinvented yourself as a man of somewhat mysterious origin, born in St. Petersburg, Russia (OK, not really, but who knew that?), a West Point man (of sorts), who was occasionally stricken with rheumatic fever that would lay you low and engender sympathy as being tragic in addition to brilliant. Was it as incredibly romantic as it sounds, filled with wild aspirations and hopes, matching wits with the wittiest (including an adoring Oscar Wilde), breaking all the rules of art of the day, and then submitting one's work for the approbation of the very establishment you rejected? It was *La Vie Bohème*. Over a century and a half later, I confess to a bit of envy.

Mother Comes to Visit, and Stays

Perhaps because of his father's early death, or the severe nature of the expectations that the father held for his son, Whistler always maintained a strong attachment to his mother, Anna McNeill Whistler. And so, when in the heart of the Civil War, she left the United States to come live with Whistler in London, he took her in. But this required relocating Jo Hiffernan, as the staunchly religious Anna would not tolerate the immorality of living together out of wedlock, nor his marrying a girl of such low status. Jo had to go, and Whistler set her up in a nearby apartment. For someone as reckless with money as Whistler, this would prove to be difficult. His mother would live with him for most of the rest of her life. This was also difficult.

Whistler's relationship with Hiffernan both baffles and intrigues. She often referred to herself as Mrs. Abbot (Whistler's middle name). They never married nor had children together, but she ran his affairs and promoted his work, and she accepted being usurped by Whistler's mother. In 1865, Jo and Jimmy vacationed in the beautiful French seaside town of Trouville. Gustave Courbet (chapter 3) joined them in this visit, whether by

accident or by plan isn't clear. What *is* clear is that Jo's affections were complicated by this threesome. Courbet painted Jo multiple times in Trouville, but he saw her not as the ethereal waif that we see in *The White Girl* (figure 4.5), but rather as a voluptuous seductress (that's Jo Hiffernan frolicking with a parrot in figure 3.2 in chapter 3). Whether an affair with Courbet started in Trouville or shortly thereafter isn't clear, but it is fairly certain that one did at some point.[12]

Being a spendthrift and a dandy, Whistler was almost always short of money and scheming to solve the problem with one great score. His life was so filled with intrigues, assignations, and imbroglios that to try to list them all would cause them to pile up and fall off the bottom of these pages. But in one truly bizarre episode, Whistler was involved in a scheme to sell torpedoes to the Chilean navy in their battle against Spain.[13] Torpedoes. To the Chilean Navy. In dire financial straits, and supporting his mother and his mistress, in 1866, Whistler decided to join his younger brother Willie (who had been a surgeon in the Confederacy, but had escaped to London just before the end of the war) and head off to Valparaiso as part of a plot to become wealthy as an arms merchant. While there, he played the spy, had an affair with the wife of the man who was running the scheme (well, turns out it wasn't really his wife, but that's a detail), got in multiple fistfights, and painted some stunning pictures (see figure 4.6 for one of his works while in Chile). Whistler often just made preliminary sketches of his works outdoors, leaving the real work to the studio. He argued that "Painting from nature needs to be done at home."[14]

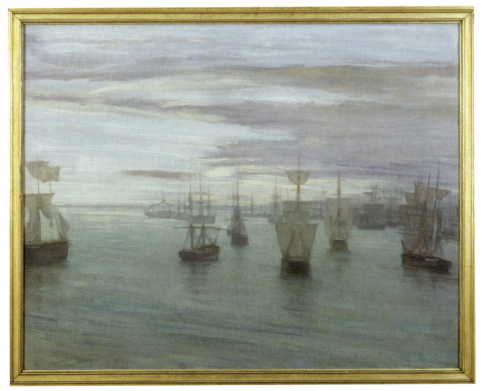

Figure 4.6. *Crepuscule in Flesh Colour and Green—Valpariso*, James McNeill Whistler, 1866. Tate Britain, London.
(C) Tate, London 2019

And work it was. He was never quite satisfied. He worked and reworked paintings, sometimes making changes ten years after a work was "complete." He would work through the night at times, a stunning contrast to the carefree and witty public persona of Whistler. In *Crepuscule in Flesh Colour and Green—Valparaiso* (figure 4.6), we can see the twilight (*crepuscule* means twilight) fading off to the left. Whistler has brought the theme of the light through both the sky *and* the sea. The light reflected in the sea is particularly effective. It seems to gleam from under the water.

While off on his South American intrigue, he left Jo in charge of his affairs. To help balance the accounts, Jo in turn decided to go to Paris and pose incredibly provocatively for Courbet. That marked the beginning of a sea change between Jimmy and Jo. They split not long thereafter, although when Whistler fathered a child with a parlour maid in 1870, Jo took on the role of foster mother in 1872, and raised the boy.[15] Whistler had other matters to attend to.

In 1871, a model failed to show for a scheduled sitting, and Whistler asked his mother if she would pose instead.[16] She was not able to stand for extended periods of time, so he painted her sitting, with a small stool for her feet. This work became the famous "Whistler's Mother," though its true title is *Arrangement in Grey and Black, No. 1: Portrait of the Artist's Mother* (figure 4.7). Whistler argued that the fact that this is his

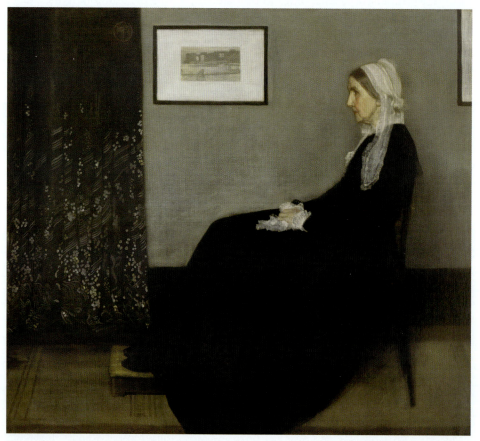

Figure 4.7. *Arrangement in Grey and Black: Portrait of the Artist's Mother,* James McNeill Whistler, 1870. Musée d'Orsay, Paris.
https://commons.wikimedia.org/wiki/File:Whistlers_Mother_high_res.jpg

mother is of no consequence in appreciating the work. It is about the arrangement and the colors. Her black dress comprises smooth lines and curves, in contrast to the rectangles that dominate the work in grey and black. The picture frame on the right shows only the smallest part of a picture, so its presence in the painting is odd, perhaps reflecting a fascination with the developing art of camera work (where small details appear that weren't obvious when a picture was being composed). The closest object to the center of the painting is her wedding ring, a grace note in gold, still worn decades after the passing of her husband. Also, Whistler's mother herself almost seems to be painted on a different plane from the background. She sits closer (too close?) to the viewer than the rest of the work. She seems almost too big for the room. Was that intentional? For me, this is essentially a painting of an old lady. A lace bonnet, a lace kerchief gripped by her hands, and a black mourning dress for a love long departed. Her expression is one of a person who wants to "do this sitting properly" for her boy.

Float Like a Butterfly . . .

Whistler designed a butterfly monogram to use instead of a signature in about 1870, later adding a barbed stinger on it, presaging Muhammad Ali's incredibly poetic quote, "*Float like a butterfly, sting like a bee."* The butterfly contained the W for Whistler as the bottom half of the wings of the butterfly and the M for McNeill as the top half. Although Whistler was born James Abbott Whistler, he added his mother's maiden name to his own as an adult, and eventually dropped Abbott altogether. The J for James formed the stinger (see figure 4.8 for evolution and variations).

The full-length portrait of Whistler in figure 4.1 gives no indication of his height. In that painting, he might be 6'7" or 5'5". In fact, he was 5'3". He was a bantamweight and as pugnacious a one as ever lived. He would take to task anyone who demeaned his work. When a critic argued that one of his *Symphony in White* paintings had colors in addition to white in the painting, Whistler responded, "Does he then . . . believe that a symphony in F contains no other note, but . . . a continued repetition of F F F? Fool!"[17] Whistler had a nasal and high-pitched voice, and he often affected a French, British, or American Southern accent (he had never lived further south than Baltimore, Maryland).

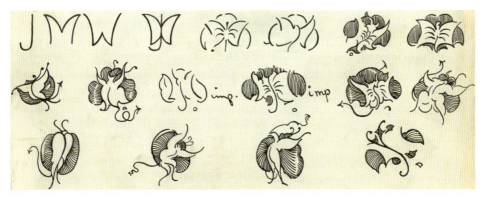

Figure 4.8. *Whistler's butterfly signatures*, James McNeill Whistler. James McNeill Whistler Collection, Boston Public Library.
https://www.digitalcommonwealth.org/search/commonwealth:3r076n81r

Degas once said of his style of speaking, "Whistler, if you were not a genius, you would be the most ridiculous man in Paris."[18]

Whistler also had an interesting view of what purchasing a painting meant. "People imagine that just because they've paid £200 for a picture, it becomes their property. Absurd!"[19] An owner of one of his works returned it to Whistler so that he could make some repairs. When she asked for it back after a reasonable amount of time, Whistler responded in this way:

> Ten years ago this woman bought my picture for a ridiculously small sum, a mere bagatelle, a few pounds. She has had the privilege of living with this masterpiece for ten whole years; and now she has the presumption to ask for it back again. Pshaw! The thing's unspeakable.[20]

The great poet and author, Oscar Wilde, looked upon the older Whistler as a sort of role model for verbal jousting. Wilde and Whistler shared a way with words and an irrepressible need to poke established authority. In fact, the two were the best of friends until they became the best of enemies. Whistler felt that Wilde frequently presented Whistler's views on art as his own. Once, when Whistler had delivered one of his many *bon mots* at a dinner, Wilde pined, "I wish I had said that." Whistler responded, "Oh, you will, Oscar, you will!"[21] But Wilde gave as good as he got. A particularly pointed jab: "Mr. Whistler always spelt art, and I believe still spells it, with a capital 'I.'"[22] Sadly, when Wilde was in the greatest need during his trial for gross indecency, Whistler abandoned his friend, objecting to being associated with "the large, indecent poet."

Leyland, Maud, and the Trial

In the late 1860s, Whistler became acquainted with shipping magnate Frederick Leyland. Leyland liked Whistler's work and in 1872 commissioned him to paint portraits of his family (six in all). Whistler moved into the Leyland mansion and began work on a portrait of the lord of the manor. He stayed there for several months, completing stunning portraits of Leyland and his wife, Frances. He also had an affair with Frances, got engaged to Frances's much younger sister, and shot Leyland's dog.[23] (The one with no artistic sensibilities described in the introduction to the chapter.)

The dog recovered but the engagement died, and by 1876, the woman in Whistler's life was Maud Franklin, basically an English grisette, twenty-three years Whistler's junior. Maud became his new model and muse and had two daughters with Whistler, both of whom, like his son, were sent off to live with foster parents. When Maud was eight months pregnant with their second daughter, Whistler told her that he had to go to Paris on business, and put her up in a local London hotel. This was a charade that allowed him to stay in London and not have to care for his mistress through childbirth.[24]

In 1877, Whistler presented several of his "nocturne" paintings (a term referring to Chopin's musical nocturnes) at an exhibition of the newly constructed Grosvenor Gallery in London. The exhibition was attended by everyone who was anyone, including the

prominent, but somewhat dyspeptic art critic and social reformer, John Ruskin. Ruskin was enamored of the Impressionistic work of J. M. W. Turner, and of the Pre-Raphaelite movement, a rather strange pairing as the styles are dramatically different. Ruskin believed that only the spiritually and morally superior individual can appreciate what is beautiful and transform it into great art.[25] Needless to say, this perspective on life put Ruskin at odds with Whistler.

Whistler exhibited a number of his nocturnes at the Grosvenor Gallery, including one titled *Nocturne in Black and Gold, the Falling Rocket* (figure 4.9). Ruskin savaged the work in a review. Learning that Whistler was asking 200 guineas for the work, Ruskin wrote, "I have seen, and heard, much of Cockney impudence before now; but never expected to hear a coxcomb ask two hundred guineas for flinging a pot of paint in the public's face."[26] Whistler took exception . . . and then took Ruskin to court.

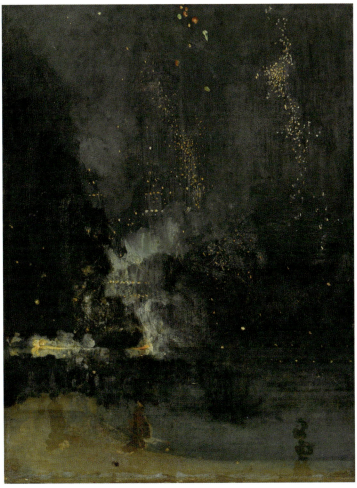

Figure 4.9. *Nocturne in Black and Gold, the Falling Rocket*, James McNeill Whistler, 1875. Detroit Institute of Arts.
https://commons.wikimedia.org/wiki/File:James_Abbot_McNeill_Whistler_012.jpg

The offense that Whistler felt was no doubt real, but it was also convenient. He had spent a small fortune building a new house and studio, and had recently battled with Frederick Leyland over the redecoration of a room in the Leyland's house (apparently Leyland had gotten over the dog incident and only suspected the affair with his wife at the time). A successful libel suit against Ruskin would not only enhance Whistler's social and artistic standing, but it would help keep him in the new abode he was having built, cleverly called by Whistler, "The White House." It was a beautiful building, and the neighborhood included Lillie Langtry, the alluring actress and socialite. There may have been a brief affair, but then Langtry entered into a liaison with Prince Albert (later to become King Edward VII).[27]

The Falling Rocket is really a beautiful painting, capturing a dramatic fireworks display along a seaside with shadowy figures watching from a beach. For a painting so dark, it has tremendous movement and excitement. One can almost hear the explosions that are depicted in the lower left center of the work. I love the way that some of the fireworks are just going off while others (off to the right) are gradually falling back to the earth, having spent their energy. And to the left near the bottom, one can see the reflections of explosions in the sea. The painting has mystery and drama. But it doesn't have the moral underpinning or theme that the social philosopher Ruskin thought should always be present in art. It didn't teach or exemplify the good. It is just a great painting to look at, capturing an exciting, and ultimately fun moment at a park, which is what I think Whistler was after.

The trial was delayed for months due to the failing health of Ruskin. When it was finally held, it lasted only two days, with three witnesses presenting on each side. *Nobody* wanted to testify in the trial for either side. What was needed were "experts" who could speak authoritatively about the quality of the works in question. In an interesting twist, Pre-Raphaelite painters (see box) ended up testifying for each side (Dante Gabriel Rosetti for Whistler, and Edmund Burne-Jones for Ruskin), both doing so highly reluctantly and ultimately, ineffectively. Ruskin had strongly promoted the Pre-Raphaelite painters in his writings, and they did not want to offend him. At the same time, many were friends of Whistler's and did not want to offend him either, nor testify against a fellow artist.[28]

Pre-Raphaelite Brotherhood

The Pre-Raphaelite Brotherhood, now more simply referred to as the Pre-Raphaelites, were a group of artists and art critics in England that started in 1848. Although the original group dissolved in 1853, the ideas continued on into the twentieth century. They called themselves "Pre-Raphaelites," as they felt that painting began a downward turn from Raphael onward. They promoted realism, a return to and study of nature, and the promotion of moral good in art. Founding figures in the movement were art critic and social philosopher John Ruskin, and painters John Everett Millais and Dante Gabriel Rosetti. They tended to use very vivid colors, making their works easy to discern from other work at the time. Figure 4.10, *Marianna*, by Millais, is a classic Pre-Raphaelite painting. It is interesting to note that Whistler was good friends with the Pre-Raphaelite crowd given how starkly different their approaches to art were.

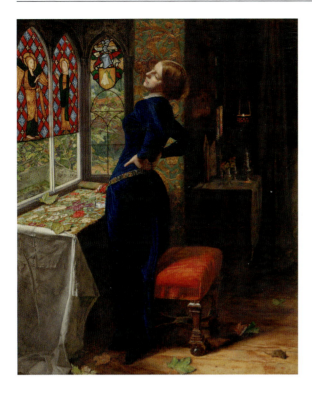

Figure 4.10. *Marianna*, John Everett Millais, 1851. Tate Britain, London. (C) Tate, London 2019

The trial was covered widely in the London press, complete with cartoons and *bon mots* all around. The jury took only two hours to reach a verdict, which was to find in favor of Whistler, but to award him not the £1000 he had sued for, but rather, one farthing, the smallest unit of currency in England at the time.[29] Whistler declared victory, but it was truly pyrrhic in nature. His debts had mounted, and he had to sell the White House after only having lived there for one year. The trial was equally detrimental to his adversary. Already ill, Ruskin, humiliated, gave up his professorship at Oxford, and to a large degree, retreated from public life.

The example of the Pre-Raphaelite work presented in figure 4.10, *Marianna*, taken from a Shakespeare character from *Measure for Measure*, illustrates the stark contrast between Whistler and his friends in the Pre-Raphaelite movement. This painting is all about telling a story, emphasizing detail, precision, and finish in a work of art, and nothing about a simple, beautiful juxtaposition and harmony of colors. This is, by the way, a work that really has to be seen in person to be truly appreciated. The deep blue of Marianna's dress absolutely glows through a technique of painting a translucent glaze directly over a wet, white gesso undercoating. It is highly dramatic.

After Whistler's Mother

It would be argumentative to say that James Abbott McNeill Whistler ever had *mature* years, but the disaster of the trial against Ruskin forced him into bankruptcy, and in

1881, Anna died. Whistler had not visited her in her final days as he had promised, and he was distraught over her passing. Later that year, Maud temporarily "disappeared" amid rumors of another pregnancy. She reappeared three months later without child. Who knows? For most people these events would be traumatizing, but not for Whistler. Now in his forties, Whistler realized two major accomplishments, neither of which was directly related to painting or etching. First, he presented a lecture on his theory of art, known as "The Ten O'Clock," so named because it was delivered at ten in the evening (so that no one would have an excuse for not attending).[30] It was a huge hit and remains to this day a declaration of what is known as the Aesthetic Movement in art (see box for explanation). The second was that he was elected president of the Society of British Artists (primarily due to his packing the membership with supporters). He was then able to get Queen Victoria to endorse the group, making it the Royal Society of British Artists. When he was voted out of office two years later, he promptly quit the organization, claiming, "the 'Artists' have come out and the 'British' remain."[31]

Whistler was no longer struggling to be noticed. He was a known commodity. His literary companions included Oscar Wilde (*The Picture of Dorian Grey*), Henry James (*The Turn of the Screw*), Bram Stoker (*Dracula*), and Beatrix Potter (*Peter Rabbit*). He entertained friends and potential patrons, charmed the ladies, and traded barbs with critics. Whistler was both painting and etching, and producing brilliant results in each. The work at the beginning of the chapter, *Milly Finch* (figure 4.2), was done in 1884, and is a masterpiece of color, composition, and veiled eroticism (although I cannot quite figure out how Milly's stockinged foot and ankle are attached to the rest of her leg). If Whistler is saying that this work isn't "telling a story," I don't believe him. And *The Embroidered Curtain* (figure 4.11) is a creative combination of etching and dry point techniques, at which Whistler excelled. It depicts a street scene in Amsterdam with a wonderful jumble of buildings, wharf, windows, adults, and children.

In 1887, Whistler sent Maud Franklin packing. Maud had posed nude (and probably more) for Whistler's friend, William Stott. She is the model in a Stott painting, *Birth of Venus*. Infidelity was one thing, but the painting was egregiously bad. Maud's crime was similar to Jo Hiffernan's with Gustave Courbet many years earlier, but at least Courbet's work was well-respected. He replaced Maud with the widow of his good friend, Edwin Godwin. Beatrice Godwin, or Trixie as she was known, was twenty-three years Whistler's junior, and better-looking and more talented than Maud. They married in 1888, and so she became the only legal "Mrs. Whistler." But one wonders if she introduced herself as "Trixie Whistler"?

The Aesthetic Movement

The Aesthetic Movement refers to the intellectual, literary, and artistic perception that art should exist for the sake of beauty and not have a deeper intellectual content. "Art for art's sake" was the credo of the aesthetic movement. Whistler, and his friends, poet Algernon Swinburne and poet and author Oscar Wilde, were leading proponents of the Aesthetic Movement. The Metro-Goldwyn-Mayer movie logo, with the roaring lion, contains the slogan, "Ars Gratia Artis," Latin for "Art for art's sake."

Figure 4.11. *The Embroidered Curtain*, James McNeill Whistler, 1889. The Metropolitan Museum of Art, New York.
https://commons.wikimedia.org/wiki/File:The_Embroidered_Curtain_MET_DP813745.jpg

The End Game

Life was lively and productive for James and Trixie Whistler, until she fell ill. They lived in both Paris and London, and he continued to make beautiful paintings and etchings. There was drama, of course, or it wouldn't have been James Abbott McNeill Whistler. Lawsuits, financial difficulties, and acerbic exchanges with critics in the popular press intermingled with successful shows and commissions. As always, the Whistler of the studio, constantly revising and reworking, struggling to make each work perfect and then more perfect, contrasted sharply with the carefree *bon vivant* of his public persona.

In 1896, Trixie died from cancer. Whistler wrote, "The sun has gone out of my sky forever."[32] He rallied back to a degree from the loss of maybe the only woman other than his mother that he truly loved. More paintings were made, more exhibitions organized, more old friends offended, and more lawsuits were filed. But the fire, while not out, was fading. He was continually fighting off illness, now without Trixie as his support. In 1903, he died of a blood clot to his brain just after his sixty-ninth birthday. He wrote of the dual nature of his existence, private struggle and public braggadocio, in what could have been an appropriate epitaph:

> Whistler has for years and years! so leaned on Jimmie that he wore him out! and bore him down to the dust—and took all his joy out of him—and without Jimmie, what is Whistler!—and there you have it![33]

Among the mourners in attendance at his funeral were Maud Franklin and Jo Hiffernan.

Figure 4.12. *Nocturne in Blue and Gold: Old Battersea Bridge*, James McNeill Whistler, 1872–1875. Tate Britain, London.
(C) Tate, London 2019

Nocturne in Blue and Gold: Old Battersea Bridge *was painted as part of Whistler's nocturne series, where he sought to evoke a sense of calm and harmony as opposed to presenting a narrative. As Whistler developed his art, he also developed his theory that art should be about emotions, color, and harmony in painting, which is why he took to naming his pieces after musical terms such as* harmony, composition, arrangement, *and* nocturne. *His efforts were not always well received. Oscar Wilde said of the painting that it was "worth looking at for about as long as one looks at a real rocket, that is, for somewhat less than a quarter of a minute."*[34]

In this work, painted sometime between 1872 and 1875, Whistler has depicted an evening in London at the Old Battersea Bridge, which was made of wood and spanned the Thames River (and has long since been replaced) with fireworks going off in the distance. The height and fragility of the bridge are exaggerated for effect in the painting. The work is very similar to a woodblock print called *Kyobashi Bridge,* by the famous Japanese artist Utagawa Hiroshige, done several decades earlier.

A Closer Look: *Nocturne in Blue and Gold: Old Battersea Bridge*

Once again, have a long look at the painting chosen for this segment, note your reactions to it, and then return for an admittedly one-sided "discussion" of the work.

When I look at art, I sometimes try to focus on who the artist was and what he or she was trying to say in the work. Other times, I simply let myself drift into the painting and see where my reactions take me. *Nocturne in Blue and Gold: Old Battersea Bridge*

definitely provokes the latter option. What strikes me here is that it is cold, misty, and maybe around nine o'clock in the evening. That is, it isn't the dead of night, as it isn't very dark, but lights are on in the distance, and the people, to the degree that they can be made out on the bridge and the boat below it, appear to be wearing coats. In general, I like evening light, mist, and the cold. So my initial reaction to this work is one of connection. I know evenings like this and I enjoy them. I can bundle against the cold, and wonder what is in the distance that I just cannot make out. I also think that the colors of a cloudy evening with mist are beautiful, and Whistler has captured that.

But a bit of a longer look brings another sensation, perhaps surprisingly something of a sense of foreboding. The bridge seems threateningly high and fragile, as if it could collapse or someone could fall off of it. My mood of comfort and connection fades and is replaced with one of danger, even menace. I don't want to be on that bridge, and I don't want those people to be on it either. The concept of a painting inducing a sense of awe that is so extreme that it turns to unease, and even fear, is called, in art, *sublime*. This is a very different usage of the term that in everyday language means something exceedingly excellent or wonderful.

> **The Sublime**
>
> The word *sublime* in common parlance refers to something that is extraordinarily good or beautiful. But in the eighteenth century, philosophers such as Edmund Burke and Immanuel Kant recast the term as referring to artworks that engender fear or even horror through their depiction of nature in a way that is overwhelming to the viewer. Works that make the viewer feel small, or powerless, or ones where the viewer's perspective is dangerous (as in being on cliffside or in a violent sea), can cause a sense of the sublime.

In his series of nocturne paintings, Whistler was trying to change the conversation in art; he was trying to produce works that did not tell a story, essentially were not about anything narrative or accurate, but rather aroused one's sense of beauty, or art for art's sake. In talking about the purpose of art, Whistler said this:

> The desire to see, for the sake of seeing . . . when the evening mist clothes the riverside with poetry, as with a veil, and the poor buildings lose themselves in the dim sky, and the tall chimneys become campanile [bell towers], and the warehouses are palaces in the night, and the whole city hangs in the heavens, and the fairyland is before us then the wayfarer hastens home . . . and Nature, who for once, has sung in tune, sings her exquisite song to the artist alone.[35]

In the midst of this rather melancholy and somewhat disturbing scene, we also see fireworks in the distance. What is this? Are they like a musical "ornament," not part of the main structure of the composition, but added for a bit of flourish in an otherwise monotonic piece?

For me, the picture ends with the figure of the boatman on the bottom. He is a secondary focus of this nocturnal mood piece, and yet I keep coming back to him. It is as if he is saying, "Yes, this is all very interesting and evocative, but I've got a boat to move down the river. I have work to do." Whistler tells us not to focus on the story line, but Whistler is gone, and I'm the one looking at this work. Whistler has had his say. This is *my* aesthetic experience, and I can define it on my own terms.

So can you.

GENTILESCHI

Figure 5.1. *Allegory of Painting*, Artemisia Gentileschi, 1638–1639. Royal Collection, London.
https://commons.wikimedia.org/w/index.php?curid=37146117

Figure 5.2. *Susanna and the Elders*, Artemisia Gentileschi, 1610. Schloss Weißenstein, Pommersfelden. https://commons.wikimedia.org/w/index.php?curid=78391814

CHAPTER 5

Gentileschi

A WOMAN FOR ALL SEASONS

Artemisia Gentileschi watched as the court clerk tightened the metal rings and cords of the torture device called the *sibille* around her slender fingers. Her goal of becoming a painter like her father was unusual for a woman at the turn of the seventeenth century in Rome, but Orazio Gentileschi had encouraged his daughter's passion, hiring his friend, Agostino Tassi, to teach her the finer points of perspective. Tassi had other passions in mind. Tricking her into being alone with him, Tassi raped her. She was seventeen years old. Orazio pressed charges against Tassi, arguing that his daughter was no longer fit for marriage. Below is a small portion of the transcript of the trial of Tassi. As was the custom of the day, Artemisia had volunteered to (some argued "been coerced to") testify while undergoing the finger-crushing torture of the *sibille*.[1]

> Then the judge ordered that the prison guard put on the *sibille* and, having joined her [Gentileschi's] hands before her breast, that he adjust the cords between each finger, according to custom and practice, in the presence of [Agostino]. And while the guard tightened the said cords with a running string, the said woman [Gentileschi] began to say: "*It is true, it is true, it is true*," repeating the above words over and over, and then saying [referring to the *sibille*], "*This is the ring that you give me, and these are your promises.*"[2]

Raped, publicly humiliated, and under torture, Artemisia Gentileschi, barely more than a child, responded with the immense strength, poise, and poetry that would contribute to her becoming one of the truly great painters of the Baroque era, and a heroine for any era.

The "Story" of Artemisia Gentileschi

The story of Artemisia Gentileschi lies somewhere between legend and myth. Born in 1593, her mother died when she was only twelve years old. At seventeen, she was raped by Agostino Tassi, her art tutor who was a friend and collaborator of her father, Orazio Gentileschi. When it became clear that Tassi would not marry Gentileschi, and thus "restore her honor," her father took Tassi to court for damages done to his daughter and to the family's reputation. During the seven month trial, Artemisia was forced to submit to torture via a *sibille*, where metal rings around the fingers are progressively tightened with strings to ensure that she was telling the truth. In the trial, Tassi, who faced no equivalent torture, accused Artemisia of being "an insatiable whore."[3] He was convicted but was sentenced to a mere five years' banishment from Rome, which he never actually served, as he was a favorite of the Pope.[4] Following the literal rape by Tassi, and metaphorical rape of the trial, Artemisia went on to become a world-class painter, extracting symbolic revenge on her tormentors by focusing her art on strong women, often depicted in the act of killing famously despicable men in history (see, for example, *Judith and Holofernes*, figure 5.3, painted shortly after the conclusion of the trial).

Well, that's the story. The truth, as so often is the case in matters historical, is fuzzier and probably less dramatic, but ultimately more interesting.

Gentileschi's Life and Times, Extended, and Somewhat Closer to Reality

Although there is nothing untrue, that I know of, in the brief description of Artemisia Gentileschi above, it doesn't really tell the whole story. The *whole story* will never be known, as she became obscure shortly after her death, her fame not revived until the twentieth century. It is hard to see clearly when looking back 400 years.

Artemisia Gentileschi (1593–1656) was born in Rome to Orazio Gentileschi and Prudentia Montone, the oldest of four children and their only daughter. After giving

Figure 5.3. *Judith and Holofernes*, Artemisia Gentileschi, 1612–1613. Uffizi Gallery, Florence.
https://commons.wikimedia.org/wiki/File:GENTILESCHI_Judith.jpg#/media/File:Artemisia_Gentileschi_-_Giuditta_decapita_Oloferne_-_Google_Art_Project-Adjust.jpg

birth to the three boys, none with artistic inclination, her mother died in childbirth when Artemisia was but twelve years old. Orazio entered into an informal arrangement with the widow next door, Tuzia, to serve as a kind of surrogate mother and female minder for Artemisia. Orazio was a well-established painter, and he trained Artemisia to follow in his footsteps, introducing her to many famous artists including his friend, Caravaggio (the subject of chapter 2). Caravaggio and Orazio had spent a bit of prison time together for jointly having suggested, in a poem no less, that another painter, Giovanni Baglione, was homosexual.[5] Orazio arranged for his friend and collaborator, Agostino Tassi, to tutor Artemisia, and thus Tassi was frequently in the Gentileschi household. Tassi was even thought to be a potential husband for Artemisia.[6]

Artemisia's talent in painting was immediately apparent. *Susanna and the Elders* (figure 5.2, at the opening of this chapter) was painted when she was only seventeen years old, using herself as the model. The work was done under the tutelage of her father. In the painting, Susanna is repulsed by the lecherous elders and attempts to fend them off. One might think that this was strangely prophetic of what was in store for Artemisia, but perhaps Artemisia wasn't prescient. Perhaps she was depicting what was happening in her real life as she was fending off unwanted advances from Tassi prior to the rape. Notice that the elder on the left appears to be not so "elder," and that his face is mostly obscured. Are we seeing Tassi there? Whatever the motivation for the painting, the work is incredible for being executed by the hand of a seventeen-year-old. Speaking of hands, note that in *Susanna*, the hands are central to the work, both physically and in the expressions of

the participants. Five hands in total are right in the heart of the action and help to tell the story. This focus on the hand as a means to convey emotion can be seen throughout Gentileschi's work.

> **Caravaggisti**
>
> Caravaggio (chapter 2) revolutionized painting, not only with his development of chiaroscuro and the simplicity of his compositions, where the background sometimes fades completely into darkness, but also with his emphasis on realism, painting things as he saw them. His followers became known as Caravaggisti, and included Ruebens, Rembrandt, La Tour, Zubaran, and Velaquez, in addition to both Gentileschis.

Just two years later, she painted *Judith and Holofernes* (figure 5.3). *Judith and Holofernes* was crafted in a strongly chiaroscuro fashion, heightening the drama of the already incredibly vivid depiction. Artemisia was the only known female follower of Caravaggio—a *Caravaggista*. In the midst of this intense drama, look at Judith's face. There is consternation there to be sure, but there is also a business-like quality in her expression and her actions. Her sleeves are pushed up (as is her bracelet); her left arm pushes down and away on Holofernes' head, creating tension for the cut; and she is drawing the sword across his neck with her right arm ("Bring sword A through neck B . . ."). These are serious arms, both in their action and in their size. There is nothing dainty about them. This is an amazing painting—Holofernes is in the midst of the agony of being beheaded. Look at his face; he *knows* he is being beheaded, and by a *woman!* And Gentileschi has enshrined that fact for eternity. Holofernes is thus forever being beheaded. One is tempted to say, "Good for you, Judith, and for you as well, Artemisia."

Trial and Tribulation . . . and Torture

The rape and trial of Artemisia Gentileschi are often considered the defining events of her life, and they deserve a more detailed look. We already know that Orazio Gentileschi hired Agostino Tassi as a tutor, and that he hired a woman named Tuzia as a sort of guardian for Artemisia.

Once he was a regular fixture in the Gentileschi household, Agostino Tassi pursued Artemisia relentlessly. Artemisia successfully parried his efforts, but at the same time, Agostino was considered to be a potential husband for her, so it is not certain exactly what the nature of their relationship was. This seems incredible to us now, but maybe not as much in that era. At some point, Agostino enlisted Tuzia's aid in making it possible for him to be alone with Artemisia, and then took advantage of the situation, pushing her into her bedroom and raping her. Artemisia described this in some detail in her court testimony, including her efforts to fight him off, removing a piece of his member in the fracas, and wounding him with a knife after the attack.[7] Whatever their relationship, there is no question that this was rape.

But then the story gets a bit complicated to a modern eye. To begin, rape wasn't exactly against the law at the time. Agostino could be brought to court for having taken

Artemisia's virginity, but not for the rape itself. It seems that not being a virgin impaired her chances of getting married, and therefore, the rape caused damages to the family.

The first effort made by Orazio on his daughter's behalf was to convince Agostino to marry her. He agreed to do so, and Artemisia agreed as well. Whether she did so happily is yet another aspect of the story that we don't know, but whatever the case, according to Artemisia's testimony in the trial, Agostino and Artemisia then engaged in a consensual affair for some time. The only problem was that as months went by, Agostino never got around to actually marrying her. After a while, Orazio had had enough. He took Agostino to the Papal Court and the trial began.[8] Also included in the charges was that Agostino had stolen a painting from the Gentileschis, but it's not certain whether it was a work by Orazio or Artemisia.

A SMALL DIGRESSION

The notion of who painted what is yet another area of contention in the cloudy history of Artemisia Gentileschi. We know that she worked under the tutelage of her father, and then later in life, worked with him on commissions; this kind of collaboration was not uncommon in Renaissance painting. Getting a commission done as well as possible was often more important than who did what. Consider figure 5.4, *Cleopatra*. This painting is unquestionably by Artemisia. Or, it is unquestionably by her father, Orazio. It was definitely painted in 1613, or in 1621–1622. It depends on which art

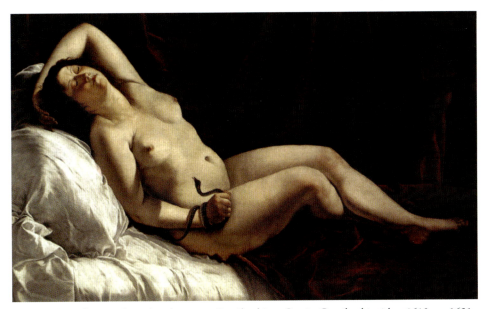

Figure 5.4. *Cleopatra*, by either Artemisia Gentileschi or Orazio Gentileschi, either 1613, or 1621–1622. Amedeo Morandotti Collection, Milan.
https://commons.wikimedia.org/w/index.php?curid=10590596

historian you are talking to and what has been discovered about the work most recently. Art historians argue over the handling of the drapery, the nature of the scene, and so forth.[9] To me, it is more a question of whether I think a man painted the woman in the picture or a woman did. I think the body is painted by a woman. It looks to me to be the kind of real body that would resonate more with a female artist than a male one. But that's just an opinion, one from a psychologist, not an art historian. And—again to me—I don't think either artist would necessarily want to claim the face, as it doesn't really seem all that well done! It looks amateurish compared to the rest of the painting, almost stuck on to an unnaturally elongated neck. What do you think?

BACK TO CRIME AND PUNISHMENT

Trials in the early seventeenth century in Rome were different from how they are today. To begin, Agostino Tassi was thrown into prison at the very start of the trial. Apparently, his reputation was sufficiently sullied that prison seemed like a good place for him to spend the duration of the trial. The first phase of a trial at the time was determining the evidentiary basis for the accusation. This was ascetained by questioning the participants individually. Then, when testimony was in conflict, the two persons presenting contradictory information were questioned together so that they could dispute one another's points. Also, witnesses could be put under torture to enhance the likelihood that they were telling the truth.[10] It was definitely the case that Artemisia was subjected to such torture; what isn't clear is under what circumstances she agreed to it. In some accounts, she volunteered, and in others, she was persuaded or coerced by her father. In any event, she was not yet twenty years old. The torture device used, the sibille, seems particularly cruel to do to a young person who aspired to use her hands as her livelihood. Tassi? Not tortured.

With Tassi present, and as the court officer tightened the sibille on her fingers, squeezing (crushing?) them, Artemisia was steadfast in her testimony. "It is true. It is true. It is true." Holding up her sibille-bound fingers, she cried out at Agostino, "This is the ring you gave me and these are your promises."[11] What a great sense of the moment and flair for the dramatic—and from a teenager! Agostino's defense was laughable. He accused her of sleeping around with most of Rome, including with her father, but not with Tassi. He also claimed she wrote him a letter (she was illiterate at the time). It should also be noted that although the trial was in theory private, in reality it was not. It was absolutely the talk of Rome as both Orazio and Agostino were well-known artists. Artemisia was subjected to the scorn of the city as Agostino's counter accusations, however ridiculous, had credibility in certain quarters. Ultimately, Agostino lost the case, whereupon he was released from prison(!), and sentenced to a choice of either five years at hard labor or banishment from Rome. He chose banishment, but never actually left Rome. His connection to the Pope ultimately led to the commutation of the sentence.[12]

One final irony. Even during the seven months of the trial, a mutual friend continued to try to talk Agostino and Artemisia into marrying to resolve the dispute. He might have succeeded had Agostino been free to marry. Alas, the assassins that he had hired

Allegorical Painting

An allegorical painting is one in which the figure or figures are symbolic or representative of a deeper meaning. Allegory is common throughout the arts and literature. By way of example, the pigs in George Orwell's *Animal Farm* are an allegory for the leaders of the Russian Revolution and the subsequent communist regime. The Salem witch trials in Arthur Miller's *The Crucible* are an allegory for McCarthyism. In painting, it is often the depiction of an idea as a person, such as Delacroix's *Liberty Leading the People* (figure 3.5), where a young woman is depicted as being "Liberty."

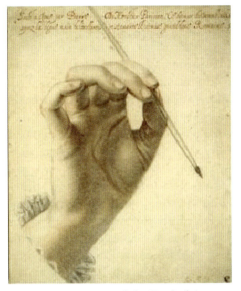

Figure 5.5. *Drawing of the Hand of Artemisia Gentileschi with Paintbrush*, 1625. Pierre Dumonstier le Neveu, British Museum, London.

https://www.britishmuseum.org/join_in/using_digital_images/using_digital_images.aspx?asset_id=92210001&objectId=721808&partId=1

to kill his current wife (a fact unknown to the Gentileschis) had botched the job. She was still alive and he was still married. He had aspired to become a widower. Furthermore, it turns out that he had raped and subsequently married his current wife as well, along with having had a child with her sister (considered to be incest in Rome at the time). Apparently, murder, rape, slander, and incest were well within Agostino's moral code, but he drew the line at bigamy. (Had he been a better artist, he might have had a chapter of his own in this book.)

As to Artemisia's torture, we don't know how severe it was (the very thought of it causes the blood to drain from my head), but we do know that she recovered from it. In a remarkable irony, we have a drawing of Artemisia's hand by Pierre Dumonstier le Neveu (figure 5.5), done in 1625, over a decade later, and it appears to be in quite good shape.

Marriage, Fame, and Florence

Following the rape and the trial, Artemisia was married off to Pietro Antonio Stiattesi, the brother of Giovanni Battista Stiattesi, who testified for Artemisia at the trial and was the friend who tried to arrange a marriage between Artemisia and Agostino.[13] There might have been financial considerations involved for Pietro, who also was an artist, but it would have been a modest amount at best. It appears to be the case that Artemisia did not know Pietro, and even might not have met him prior to their marriage, which occurred the day after the verdict was handed down.

The newlyweds moved to Florence. Despite not being particularly well-matched, they had four or five children over the course of seven years, the first coming a mere ten months after the wedding. One might conclude that the marriage was a happy one, but recent discoveries of love letters by Artemisia show that she had a passionate affair with wealthy nobleman Francesco Maria di Niccolò Maringhi, apparently with the knowledge of Stiattesi. This, of course, raises the question of exactly who was the father of at least some of her children.[14] (If there seems to be frequent hedging on the details of her life, it should be noted that the biography of Artemisia is consistently one of conjecture and revision.)

Tragically, three (or four) of Artemisia's children died at a young age, leaving only one daughter. It is interesting to note that in the scholarship on Gentileschi and the influences on her work, the stress of bearing multiple children, and the tragedy of losing all but one of them in a short period of time is rarely speculated upon. Also rarely mentioned is the admiration that Gentileschi inspired among the literati and the locals, with poems written to her beauty and talent, drawings made of her, and even a coin struck that depicted her as a great beauty. She is also often mentioned in church records as being chosen to be a godmother of a child.[15] On the more salacious side of life, her husband was once arrested for having slashed a man in the face because he was serenading her below her bedroom window.[16] Affairs? Acceptable. Serenading? Outrageous.

The seven years in Florence were highly eventful for Gentileschi on the professional side of her life, as well. To begin, she met (or reconnected with) Michelangelo Buonarroti the Younger, grandnephew of the great Renaissance artist, Michelangelo.[17] She received commissions from him to paint works for the Casa Buonarroti, a palace that Michelangelo the Younger had dedicated to honor the artistic achievements of his family. The younger Michelangelo became a lifelong patron and advocate of Artemisia's, paying her more than other artists for commissioned works, and introducing her to the rich and famous, including Galileo Galilei (yes, *that* Galileo).[18] Galileo was in Florence at the time, at the invitation of Cosimo II de Medici, and on the lam from the Italian Inquisition. In Florence, Galileo was more free to advance the heretical idea of heliocentrism, the notion that the earth revolved around the sun, and not the other way around. The great scientist became a friend of Gentileschi, coming to her aid several times later in life, in particular intervening to get her works seen and sold. The woman who had been illiterate wrote elegant letters to Galileo and to potential patrons.[19] Clearly, Artemisia's ability and disposition to learn, to grow, to do what life required, were remarkable.

The patronage of Michelangelo the Younger led Gentileschi to a remarkably productive period of her life. She was accepted into the highest circles of art in Florence and

Patronage

At a time when there were no art galleries, no grand salons, and so forth, having a patron—or patrons—was critical for artists. Patrons would commission works of art, with contracts sometimes specifying in great detail what would be contained in the work. During the Renaissance and Baroque eras, the Catholic Church was a great source of patronage for artists, as churches needed to be filled with works that would depict the wonders of the Old and New Testament for largely illiterate congregations.

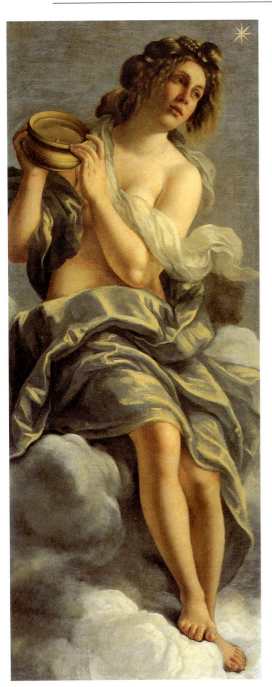

Figure 5.6. *Allegory of Inclination*, Artemisia Gentileschi, 1615–1616. Casa Buonarroti, Florence.
https://commons.wikimedia.org/wiki/File:A_Gentileschi_Allegoria_dell%27inclinazione.jpg

produced works of drama and of elegance, including *Judith and Holofernes* (figure 5.3), *Judith and Her Maidservant* (figure 5.9), and *Allegory of Inclination* (figure 5.6), which was commissioned by Michelangelo the Younger for Casa Buonarroti. "Inclination" here refers to talent, or the "inclination" to be able to do something well. This painting was originally totally nude, but seventy years later, Michelangelo the Younger's great nephew, then in charge of the Casa, had another artist paint over the nudity, finding it too shocking.[20]

On to Genoa, Rome, Venice, Naples, London, and Naples Again

In roughly 1623, Gentileschi transitioned to a new period in her life and in her art. Her chosen style of art, Caravaggism, was losing favor in Florence, and so her patronage was declining. Her husband had left her, both physically and in terrible financial straits by running up debts. Change was needed, but Artemisia was always one who could adapt to new realities. She moved to Rome, with the intent of staying a few months, which turned into six years. In all likelihood, she also travelled during this time to Genoa to work with her father on commissions. But although many of her greatest paintings were done in Rome (see, for example, figure 5.7, *Sleeping Venus*), her stay was not a financial success.

> ### Provenance
>
> The provenance of a painting is the history of its ownership. It is used to document the authenticity of the ownership and can help to determine who painted the work. In recent years, a shaky record of provenance has led many great works of art to be returned to countries of origin by highly respected museums, acknowledging that the work might have come into their possession through a questionable trail of transactions.

Sleeping Venus is another puzzle in the oeuvre of Gentileschi. The gorgeous deep blue in *Sleeping Venus* consisted of two coats of a paint made with the gemstone lapis lazuli, which would have been very expensive. Thus, one would think this would have been done on commission (to cover the costs), but the provenance of the painting is not clear. If she did not have a commission, did she invest her own scarce funds to display her talents to potential patrons? Although the chiaroscuro approach is still clear here, the emotional intensity seen in many of her earlier works has given way to elegance and idealization of the beauty of the female form. Contrast this work to *Cleopatra* in figure 5.4. *Sleeping Venus* is clearly more sensual; is Artemisia playing to an audience or looking for one? Finding little luck with Rome, in 1627, Artemisia moved to Venice, but then quickly thereafter, to Naples.[21]

In 1629, Artemisia was in Naples (then under Spanish rule), where she was more successful in obtaining commissions and was working on paintings collaboratively with other artists. For example, in *Sleeping Venus* (figure 5.7), there is a question as to whether she executed the landscape painting in the upper left of the picture (again, collaboration was common at the time).[22] From Naples, she travelled to London, where she reunited with her father and her brothers. She worked with Orazio and received several commissions of her own, including a stunning work, *Allegory of Painting* (figure 5.1), which is a self-portrait (at the opening of the chapter). It reveals a mature Artemisia, both in style and in subject matter. Although the painting closely follows a description in literature of the allegory of painting in terms of pose, hair style, jewelry, and so forth, it has a vitality that is highly engaging. Artemisia depicted herself leaning into the picture she is painting. It is an interesting contrast to many self-portraits, where the artist is clearly looking into a mirror to get a self-likeness, and where looking distinguished, dashing, or discerning is the goal. And finally, notice the hands. They frame the artist as she works. And then note that her left hand holds the

> ### Oeuvre
>
> *Oeuvre* is a French word meaning "work." In art terms, it usually refers to an artist's entire body of work, but it can also (far less often) refer to a single work. It is also part of the term *hors d'oeuvres*, meaning something offered "outside of the work" of the meal as a whole. Americans pronounce the *oeuvre* part with the /r/ coming before the /v/ in hors d'oeuvres, but not so with oeuvre.

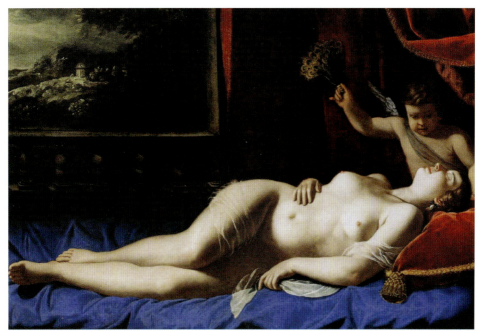

Figure 5.7. *Sleeping Venus,* Artemesia Gentileschi, 1625. Virginia Museum of Fine Arts, Richmond. https://commons.wikimedia.org/wiki/File:Artemisia_Gentileschi_-_Sleeping_Venus.JPG

palette, but the palette also holds her hand. It grips her thumb. Is this a reference to the torture of her youth?

Artemisia Reconsidered

In the end, contemplating Artemisia Gentileschi is complicated, and wonderfully so. So many questions come to mind: How influential were the rape and the trial? How did she become so amazingly accomplished at such a young age? What of the tragedy of bearing and losing so many children? Was she the great beauty that so many wrote about or more the "everywoman" of her paintings? Did the change in her style and subject matter in later life reflect a change of heart, a maturation, or a shift to meet the prevailing taste of the patron class? Who were these Roman men of the seventeenth century who would not consider rape a crime, who would torture victims and not the accused, and who would marry their daughters off to strangers? Who was this woman who was illiterate at age nineteen, yet wrote elegant letters to plead her case to patrons as an adult?[23] Why did women choose her to be godmother to their children? Why did men serenade her outside her window and write love poems to her? What of her love affair with Maringhi?

One thing is certain: Artemisia Gentileschi was infinitely more complex than the rape and torture victim that is her legend. As tightly strictured by society as she was by the sibille, she made her own way in life and defined it on her own terms. She rose above

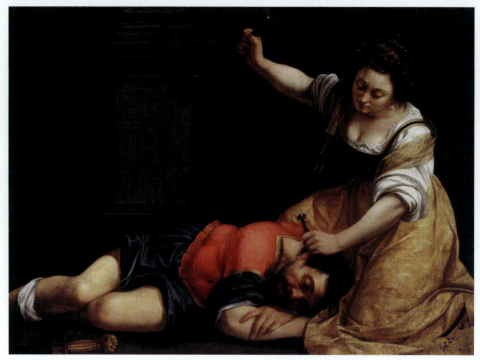

Figure 5.8. *Jael and Sisera*, Artemisia Gentileschi, 1620. Museum of Fine Arts, Budapest.
https://commons.wikimedia.org/wiki/File:Jael_and_Sisera_95fb5c9.jpg

the humiliation and pain of her youth and became a renowned artist in a man's world. She found a lover of her own choosing, and painted through joy and grief.

One more work before we go. She painted scenes from the story of Judith beheading Holofernes multiple times, but she found another heroine in the biblical story of Jael killing the general Sisera (figure 5.8 *Jael and Sisera*). In Gentileschi's depiction, Jael slays the general by calmly driving a tent spike through his skull while he was sleeping. Sisera bears some resemblance to a known self-portrait of Agostino Tassi, and Jael looks a bit like Artemesia. Recent scholarship using X-rays of her work has indicated that Gentileschi used herself as her model frequently in her career. And indeed, there is a similarity of appearance in many of her heroines.

What is to me incredible about *Jael and Sisera* is the manner in which Jael dispatches Sisera. If you cover up Sisera and then look at Jael, she looks like she might be driving that stake to secure a real tent flap rather than into the parietal lobe of Sisera. And note two details that Gentileschi offers. The first is that Sisera's sword lies idle in the bottom left corner of the painting. It is of no avail when he has fallen prey to a determined and intelligent woman. The second is that even in his drunken stupor, his hand is underneath her dress, but not for long. This man is evil and this is a job to be done. Nothing more to it.

A Final Note

Artemisia returned to Naples from London and continued to paint, dying in 1654 or 1656, possibly of the plague, although the causes are unknown. Artemisia Gentileschi was a woman of courage, resilience, and immense talent. She had an incredible "inclination" not just toward the craft of painting but toward creative expression. Her works speak to us, are alive to us, across four centuries. She is Judith and Jael, controlling her life in ways not usually seen in her time. All three woman use the tools available to them. For Judith and Jael, it was the enemy's own sword, or a convenient tent spike. For Artemisia, it was the paintbrush and the palette.

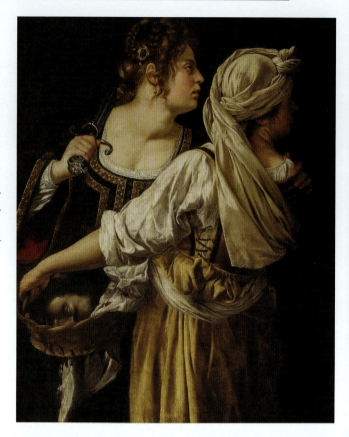

Figure 5.9. *Judith and Her Maidservant*, Artemisia Gentileschi, 1613–1614 (?). Palazzo Pitti, Florence.
https://commons.wikimedia.org/wiki/File:Gentileschi_judith1FXD.jpg#/media/File:Gentileschi_judith1.jpg

This painting depicts the moment after Judith has severed the head of Holofernes with the assistance of her maidservant, Abra. In The Book of Judith, *Holofernes is an Assyrian general who is about to lead his troops to destroy Judith's city of Bethulia, part of Israel. Judith seduced Holofernes, got him inebriated, and then cut off his head with his own sword. When his troops learned of his death, they fled, and Bethulia was saved. In this work, Judith and Abra have completed the task and are taking Holofernes's head back to Bethulia to show the townspeople. It appears that they have heard something and are looking back toward the sound that has caught their attention. This painting is one of a series that Gentileschi painted of this event, including a more gruesome one of the actual beheading (figure 5.3). Her father, Orazio Gentileschi, also painted aspects of the Judith story, and historically there has been some confusion as to who painted which work, which works came first, and which work served as an influence for another. This subject has been a popular theme for painting throughout history, including works by Botticelli, Mantegna, Goya, Titian, Lucas Cranach the Elder, and even Gustav Klimt (see figure 7.4). It is generally considered to be one of Gentileschi's finest pieces, both for its emotional intensity and composition, as well as for the Caravaggesque approach to chiaroscuro and the simple, unadorned design.*

A Closer Look: Gentileschi's *Judith and Her Maidservant*

Once again, take a few minutes to look at Gentileschi's dramatic depiction of *Judith and Her Maidservant* and then return here. As always, please take your time.

Welcome back. In this work, Judith has already beheaded Holofernes; she and her maidservant, Abra, are looking over their shoulders off to our right, obviously distracted by something, perhaps even startled. The pair appears to be joined at the hip, almost in a dance move, with the evidence of their crime hidden off left and low. Judith has a large sword casually resting on her shoulder and the Abra has Holofernes's noggin in a basket, as if it were a large cabbage. They look as if they are encountering an authority, with Judith about to say, "What? This head? The one that is leaking blood out through this basket? We know nothing about it."

The exact date of the painting is in dispute, but there is no question that the rape and trial were still fresh in Artemisia's mind as she made this painting. Look at Judith. Although her hair is braided and bejewelled (consistent with the bible story) and she is wearing finery, she is not really a beauty—not a seductress. Instead, Judith is depicted (to my mind) as a real person and absolutely someone you do not want to mess with right now. She looks like she could, and would, cut your head off. Her look is both inquisitive (What is going on over there?) and malevolent (Is there somebody else who needs killing?).

The maidservant, who occupies the bulk of the painting, is presented in the clothes of a servant. But take a close look at the brushwork of her outfit; it is truly breath-taking. One of the aspects of this work that is particularly appealing to me is that it doesn't appear to me to be posed. It's almost as if Gentileschi were about to paint a different picture of the two women, and then suddenly there was a noise off to the right that caught the two models' attention, and Gentileschi decided to paint that instead. The painting cuts across the canvas diagonally, running from the top right to the bottom left. The protagonists are caught in motion. They are headed left, and then drawn back to the right by the sound, or whatever has caught their attention. Abra's headdress swings back to the right as she changes direction.

Now for a small, but wonderful detail. Look at the hilt of the sword. At first, I was taken by how Gentileschi has made paints that are not silver look like silver. No matter how often I see metal in paintings that is not made by metal paint, I am amazed. But then, look at the pommel (end part) of the hilt of the sword. There is a screaming face on it. And that face appears to be looking down at Holofernes. And then remember, this is Holofernes's sword. His sword basically cries out, "Oh, no! Master! What have they done to us?" I find this detail to be fantastic! And while we are on this point, I realize that the sword is symbolic, showing us who killed Holofernes and how it was done, but I also like to think that Gentileschi, who took a knife to her own rapist, wanted her Judith to be the kind of woman *who kept her wits about her* enough to think, "On the escape . . . let's take the sword."

And then, the final piece, for me, the one that elevates this work to greatness, is another small feature seen on the right side of the painting, about two thirds of the way to the top. Judith is holding Abra's shoulder with her left hand in a protective fashion. She has a sword that has just beheaded an enemy in one hand, and provides a comforting embrace to her servant, her accomplice, her friend, with the other. Amazing. I didn't see that detail until I had looked at this work a dozen times. For me, it brings the entire piece together and takes it a step further; it suggests a relationship between women who have not lost the ability to care, even as they have just become partners in murder.

It is the benefit of taking a longer look.

REMINGTON

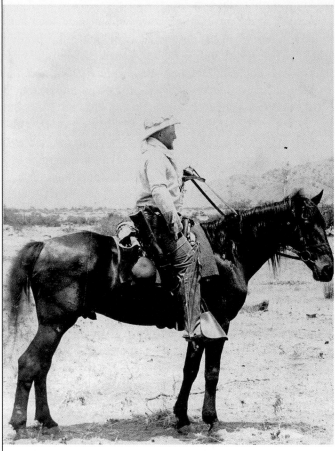

Figure 6.1. Photograph of Remington, 1888. Frederic Remington Art Museum, Ogdensburg, New York.
Courtesy Frederic Remington Art Muesuem, Ogdensburg, New York.

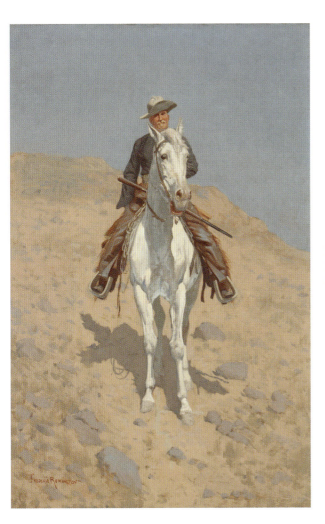

Figure 6.2. *Self-Portrait*, Frederic Remington, 1890. Sid Richardson Museum, Fort Worth, Texas.
Courtesy Sid Richardson Museum, Fort Worth, Texas

CHAPTER 6

Remington

THE COWBOY FROM NEW ROCHELLE

Frederic Sackrider Remington fancied himself a cowpoke. Dipping his toe into the water's edge of the American West in the 1880s (Kansas City), Remington tried his hand at sheep farming, hardware selling, and saloon keeping. He failed miserably at all three. He neglected to tell his wife about the saloon escapade; when she discovered his deception, she packed up and returned to her parents in New York. Although he loved her dearly, it was the best thing that ever happened to him. Having wasted most of the inheritance from his father on these ventures, he took his remaining few dollars, bought a bedraggled horse, and took the advice of Horace Greeley to "Go West, young man."[1]

With his business ineptitude running the gamut from livestock to libation, Remington focused his efforts on something he was actually good at: drawing. He briefly traveled about the Southwest and discovered that he could earn a living selling renderings of cowboys, cavalry, and Native Americans. Returning to the East Coast, Remington reconnected with his wife and started a career as an illustrator and storyteller of the Wild West for *Harper's Weekly, Outing,* and *Century Illustrated Magazine.* Soon he had enough money to buy a big house in New Rochelle, New York, where he would live most of the rest of his life.

There was no question in the mind of Frederic Remington that he was the roughest, toughest cowboy (painter) this side of the Rio Hudson. All you had to do was ask. He most assuredly had the rootin' and tootin' aspects of the old frontier down pat, but whether he actually ever poked a cow in his life . . . is in serious question.

Early Days

Frederic Sackrider Remington was born in Canton, New York, in 1861. His father was a Union Army Civil War hero (known locally as "the Colonel") who owned a newspaper in Canton. His cousin, Eliphalet Remington, was cofounder of the Remington Arms rifle company. In 1872, the family moved to Ogdensburg, New York, on the Saint Lawrence River. His father started a business raising racehorses (trotters). Remington thus developed his love for the horse at an early age. Hoping his son and only child would become a military man, the elder Remington enrolled Frederic in military schools, but it didn't take. Young Remington had no interest in a career in the Army as it seemed hard work; he once wrote to his uncle: "I never intend to do any great amount of labor. I have but one short life and do not aspire to wealth or fame in a degree which could only be obtained by an extraordinary effort on my part."[2]

Yale ultimately won out as a college destination over his father's choice of West Point, where Remington studied art and excelled in football,[3] playing on a team captained by the legendary Walter Camp, who is known as the "Father of Football" for having transformed the game from a version of rugby into what it looks like today.[4] But in 1880, Remington's father died of tuberculosis, and Remington dropped out of Yale. As a respite, he took a trip to the Montana territory, making some sketches of western life and becoming greatly enamored of the all things rugged and rudimentary.[5] While in the West, Remington heard a story of an ambush of a group of cowboys by Mexican "Rurales" (a kind of paramilitary police force) in Guadalupe Canyon, in what is now Baja California, near Arizona. Remington made a rough drawing of the story on wrapping paper and sent it to *Harper's Weekly* for possible publication (figure 6.3, *Cow-boys of Arizona—Roused by a Scout*). It depicts a scene of seven men (one in the distance) just before they were set upon by the Rurales, resulting in the death of all but two of them.[6]

The bearded fellow in the center of the illustration is Newman Haynes Clanton, known as "Old Man" Clanton. He was a cattle rustler by trade and, in all likelihood, was moving ill-gotten stock when the attack occurred in August of 1881. Clanton was

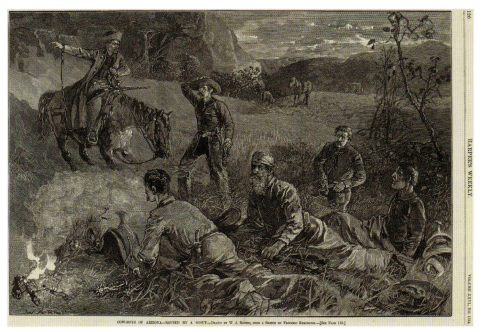

Figure 6.3. *Cow-boys of Arizona—Roused by a Scout,* William Allen Rogers and Frederic Remington, 1882.
The Museum of Fine Arts, Houston, Gift Dr. Mavis P. and Mary Wilson Kelsey, 91.1430.84

making breakfast when he was shot, falling face first into the fire and dying.[7] (Two months later, his son, Billy Clanton, met a similar fate at a place called the "OK Corral" at the hands of Wyatt Earp and Doc Holliday.) Remington's rough and amateurish drawing was engraved in wood by *Harper's* artist, William Allen Rogers, and the black and white illustration and accompanying story raised such a stir that President Chester Arthur commented on the deplorable state of lawlessness in the West.[8] There is some question over whether Remington actually heard the story of multiple killings, or if this drawing is coincidental to that event. It seems far too consistent with the details not to be based on having heard the story. Ironically, the rustlers were almost certainly shot by the Rurales with Remington rifles.

Going to Kansas City

After his Montana trip, Remington worked at various jobs in and around Ogdensburg and Albany, New York, hating them all. In the early 1880s, upon turning twenty-one and receiving his inheritance from his father, Remington decided to head West and do real work. He landed in Kansas and tried sheep farming, selling hardware, and then became a silent partner in a saloon. But, as he had said when he was a young man, he simply wasn't cut out for real work. He had told his new wife, the former Eva Caten, that he was in some sort of iron business, and when she found out that this wasn't the case, she left him.[9]

That is when he bought the bedraggled horse described in the chapter introduction and headed out to seek his fortune. He had already sold a few paintings and was encouraged by the prospect of becoming a chronicler of the Old West. But it was necessary to move quickly, as the Old West was rapidly disappearing.

Brooklyn and Becoming an Illustrator

In 1885, Remington returned to the East Coast, reconciled with Eva, moved to Brooklyn, and took a few classes at the Art Students League in New York City. With a collection of artifacts and photographs from his brief sojourns in the West, Remington became an illustrator for *Collier's* and *Harper's Weekly* (then the premier illustrated periodical in the United States). His work with *Harper's* led him to assignments following the US cavalry's efforts to catch the famous chief Geronimo, and to the Canadian Northwest to visit the Blackfoot and Crow nations. He drew and painted while on these trips. He also took more photographs and purchased more artifacts to bring back to New York.[10] His appetite for memorabilia and photo documentation served him well throughout his career.

Figure 6.4, *In from the Night Herd,* appeared as a *Harper's* cover in 1886. We can see Remington's proclivity toward romanticism, action, and detail as the soldier pulls the horse's reins tight but doesn't lose sight of whatever is going on off to his right. He is lean but well-muscled (even his face is well-muscled!), and kitted out with everything he might have needed for his evening's work. In the distance are dozens of the horses that he has been rounding up. His horse is magnificent but seems none too pleased at the goings-on. It is no wonder that Remington's work gained him immediate fame once it started appearing in national magazines. What ten-year-old sitting in a parlor in Philadelphia and looking at this image wouldn't want to be the soldier riding that horse? Or what fifty-year-old for that matter? In Remington's West, everything is strong, rugged, and ready for action.

Up until about 1890, Remington's pencil drawings and oil paintings done *en grisaille* (in black and white, see box) were redone by anonymous engravers at the major magazines onto wood blocks or metal plates.[11] So, none of the monochromatic final pieces that appeared in the magazines were directly by Remington's hand. In 1890, the engravers were replaced through a process called "half tone" where original images are photographed through screens, which then produce dots that can be used to generate tones and shadings.

Grisaille

Grisaille is a French term referring to a painting that is completely done in gray tones (*gris* is French for gray). Sometimes paintings are intentionally done *en grisaille* for effect, and sometimes they are underpaintings for a painting in color. They can also be used (as Remington did) as the basis for making engravings and using other techniques for black and white reproductions.

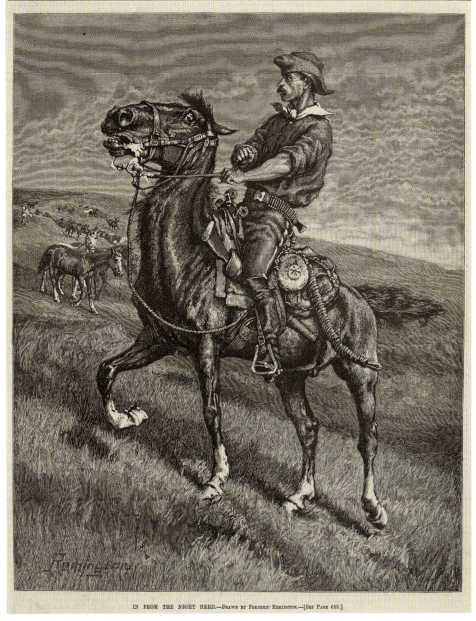

Figure 6.4. *In from the Night Herd*, Frederic Remington, 1886. The Museum of Fine Arts, Houston. Museum of Fine Arts, Houston, Gift Dr. Mavis P. and Mary Wilson Kelsey, 91.1430.106

On the Hunt for Geronimo, Blackfoot, and the Royal Canadian Mounties

In the late 1880s, *Harper's* sent Remington on a number of journeys to gather material for illustrations for them. This included travelling with the US Cavalry in the hunt for Geronimo, who had once again escaped from a reservation. The photograph in figure 6.1 shows Remington during this trip, somewhat less than resplendent, astride his horse and sporting a rifle, a six-shooter, and inexplicably, a pith helmet instead of a cowboy's hat. Contrast this image with the self-portrait he painted in figure 6.2. Remington saw himself as a 6.2, but in reality, he was a 6.1. Perhaps we all see ourselves that way, in our own fashion.

But if Remington cut a less than dashing figure in the West, he could depict it like few others. To be certain, he was "over the top" in many, if not most of his works, but the romance of the old West is what his audience desired and it was where his heart resided—if not his person. He mostly lived in a style somewhere between very comfortable and lavish, in New York.[12] The trips he took to the West allowed him to talk about life with cowboys, cavalry men, and members of a variety of Native American tribes. He collected stories along with photographs, all grist for his artistic and literary mill. But he knew that the West was receding before his eyes. He worried about the incursion of the railroad, the factory, and the fences that came with domestication of the land. He wanted to capture and portray a West that was vibrant, not dying. He loved the West, but not quite enough to actually live there. The calculus was simple: In the West, he was a quirky artist who dressed funny but was a likable guy. In the East, he was a range rider and cowpoke of the first order. Who was there in New Rochelle who could question that? Remington preferred being a rowdy in the East to a rube in the West. Throughout his life, he only spent about three years in the West.

Life in New Rochelle

In 1889–1890, Remington bought a beautiful home in New Rochelle, New York, close to the Long Island Sound to the East, and Manhattan to the Southwest. He named it Endion, a Native American word meaning "the place where I live."[13] He would call this his home for almost all of the rest of his life. Remington became well-known as a storyteller and an illustrator. He nurtured a relationship with Teddy Roosevelt that paid off handsomely. *Century Magazine* commissioned Remington to produce eighty illustrations for Roosevelt's *Ranch Life and the Hunting Trail*, which was serialized in the magazine before being published as a book. Roosevelt, who had also failed at ranching in the West, would say of Remington, "The soldier, the cowboy and rancher, the Indian, the horses and the cattle of the plains, will live in his pictures and bronzes, I verily believe, for all time."[14]

Remington's efforts were not exclusively drawings. He also made paintings, which were then turned into color illustrations for sale. Figure 6.5, *A Dash for the Timber*, represents his early endeavors along these lines. To a degree, one might see this as a "colorized" version of one of his pencil drawings. It is all adventure and action. A group of cowboys are racing at full tilt away from a threatening band of warriors who appear

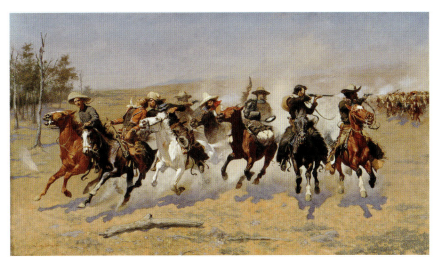

Figure 6.5. *A Dash for the Timber*, Frederic Remington, 1889. Amon Carter Museum of American Art, Fort Worth, Texas.
https://commons.wikimedia.org/w/index.php?curid=44091923

to greatly outnumber them. The cowboys, one of whom has been shot, are returning fire at a full gallop. Will they get away? What have they done to have gotten themselves in such a fix? One aspect of this work that is particularly interesting: the cowboys are kind of roughed in; only one faces the viewer, but the horses are painted in gorgeous detail and are highly expressive. They seem terrified; they are also running for their lives. Remington's ability to depict a horse was incredible and can be seen throughout his career. Note that every one of these horses is airborne. The black one is headed right for you as the viewer; you are less than a gallop away! There were other painters of the Old West, some more contemporary to the times that Remington longed for. Among these were Karl Bodmer and George Catlin. Their work, while probably technically accurate portraits and depictions of Native American dress, were very staid compared to Remington's "guns ablaze" approach.

The Gilded Age

Remington lived much of his adult life in an era of America that Mark Twain (and Charles Dudley) called the "Gilded Age."[15] By that, they meant that poverty, inequality, and a host of social problems were covered over by a light coating of gold, or gilt. The 1890s were basically the culmination of the Gilded Age, and were characterized by rapid growth in America, heavy industrialization, vast differences in wealth, and massive immigration to the United States from Europe, especially from areas with a heavy concentration of "your tired, your poor/Your huddled masses yearning to breathe free."[16] Construction of the Statue of Liberty had been completed and the dedication held in 1886. Unsurprisingly, not everyone really wanted those masses, huddled or otherwise. Immigration from Italy, Poland, and Eastern Europe came to the East Coast, and from China to the West Coast.

> **Post-impressionism**
>
> Post-impressionism is a movement that followed Impressionism, primarily in France, in the 1880s, in part as a reaction to Impressionism. The Post-impressionists rebelled against what they felt was the trivial subject matter of the Impressionists. They used a bolder palette and focused on more basic shapes and structure. Van Gogh and Cézanne are two of the most important figures in Post-impressionism.

It was a time of John D. Rockefeller, Andrew Carnegie, J. P. Morgan, and the rest of the "robber barons." But it was also the time of Eugene V. Debs, Samuel Gompers, and the beginnings of the labor movement. There was the Haymarket Riot and the Pullman Strike, the Panic of 1873, and the Panic of 1893. It was a highly unsettled time. Change was not just economic. Invention and discovery abounded. Automobiles, airplanes, motion pictures, X-rays, and the discovery of argon, neon, and xenon all were part of the change. Sherlock Holmes, Dorian Gray, Tess of the d'Urbervilles, Dracula, Doctor Moreau, and Rikki-Tikki-Tavi were all introduced to the American public in the 1890s.

In art, Impressionism was giving way to Post-impressionism (see textbox); the Hudson River School (see textbox) was still active, although somewhat in decline. But none of these schools or movements were of much interest to Remington. He was much more heavily invested in his subject matter than in artistic movements. He preferred cowboys to Courbet.

> **Hudson River School**
>
> The Hudson River School refers to a group of painters in the middle of the nineteenth century who painted idealized and detailed landscapes of America. It started with work in the general area of the Hudson River Valley, but it expanded out to the American West. Notable members of this school included Thomas Cole, its founder, Asher Durand, Frederic Church, and Albert Bierstadt. Their work was often in large format and captured broad and breathtaking landscapes.

Frederic Remington, Xenophobe

Into the turbulence of America in the 1880s and 1890s came Remington—a bit of a blowhard, a cowboy only in his own mind, and always on the lookout to make connections with those more famous than he. But these less than admirable qualities are not what made him reprehensible. Bluntly put, Frederic Remington was a bigot. The term "xenophobe" might be a bit more accurate, but the message is the same. Not unlike his hero, Teddy Roosevelt, Remington saw people lumped into categories, complete with all the exaggerated characteristics of such categorizations. Apaches were like this; Jews were like that; and Russians were the other thing. And those characterizations were almost always less than becoming. Remington was a prolific writer and not hesitant to express his opinions. He wrote magazine articles, short stories, and novels; he also kept regular correspondence and a journal. His letters and journals reveal a truly ugly side of Remington that appears only occasionally in his more public works.

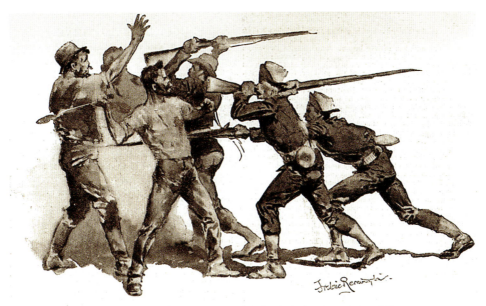

"GIVING THE BUTT"—THE WAY THE "REGULAR" INFANTRY TACKLES A MOB.

Figure 6.6. *Illustration for "Chicago Under the Mob" in Harper's Weekly*, Frederic Remington, 1894. https://en.wikipedia.org/w/index.php?curid=52867290

In an 1892 letter to his lifelong friend, Poultney Bigelow (no stranger himself to controversy over racial and ethnic views), Remington wrote, "I've got some Winchesters and when the massacreing (*sic*) begins, I can get my share of 'em and what's more, I will. Jews, Injuns, Chinamen, Italians, Huns, the rubbish of the Earth—I hate."[17] The "massacreing" that Remington refers to had to do with the general social unrest that he saw all around him. He apparently was convinced that there was serious civil unrest coming, and he had chosen his side. In an 1894 article on the Chicago Pullman strike and riot that he wrote and illustrated for *Harper's Weekly*, he referred to Chicago railway strikers as a "crowd of anarchistic foreign trash"[18] and depicted them as such (figure 6.6).

Although Remington included "Injuns" in the list of foreigners he was going to shoot with his Winchester (not that he would have hit any of them, as he was a terrible shot), he also wrote highly sympathetically of some of the tribes he encountered, in particular, the Blackfoot tribe of Canada: "They are a fine outfit, those Blackfeet. . . . I never tire of looking at the Blackfoot Indian. I believe they are the most picturesque people in the world."[19] His admiration for the Blackfoot can readily be seen in figure 6.7, *An Indian Trapper*. In this compassionate rendering, the trapper looks back from his horse, perhaps at another trapper, perhaps upon hearing a noise, or perhaps on a disappearing way of life.

Remington's attitudes toward African Americans were equally complex. In his trips to the West, he often rode with African American troops and popularized the Native American name for them, "Buffalo Soldiers."[20] Remington praised these troops in an article he wrote for *The Century* magazine, saying that they fought with valor and worked well with white officers. He depicted them in illustrations and paintings in typical Remington heroic poses. In his personal notes, his praise was fulsome and at the same time,

objectionable, "greatly gratified to say that I like the Negro soldiers character as a soldier in almost every particular." And then, "These [_____] are the best d[amned] soldiers in the world."[21] Even when offering praise, he was offensive, and other writings about African Americans were simply harshly derogatory.

It would be easy to say that Remington was a man of his times, no better or worse than, say, his friend Teddy Roosevelt, whose racial attitudes are abhorrent to us today—or publishing magnate William Randolph Hearst (who employed Remington), or Thomas Edison or Henry Ford. The sense of ethnic and national pride, along with unbridled entitlement so common to the time, is exemplified in an exchange between Hearst and Remington. Hearst had sent the artist to Havana in 1897 to cover a developing, but not yet realized Spanish American War that Hearst was promoting. Finding no trouble brewing in Cuba, Remington wrote to Hearst: "Everything is quiet. There is no trouble. There will be no war. I wish to return." Hearst replied, "Please remain. You furnish the pictures and I'll furnish the war"[22] The war was realized in the following year after the Battleship Maine exploded under suspicious circumstances. But at the same time that these men were leading figures in the United States, one could find social reformers and philosophers such as John Dewey, Upton Sinclair, Jane Addams, and Fiorello La Guardia, who passionately fought for the rights of men and women from all races, classes, and ethnic origins. Presented with clear alternatives, Remington chose the powerful and the bigoted.

Figure 6.7. *An Indian Trapper*, Frederic Remington, 1889. Amon Carter Museum of American Art, Fort Worth, Texas. https://commons.wikimedia.org/w/index.php?curid=48222272

Becoming an Artist

His work writing and illustrating stories paid the bills, handsomely, but Remington wanted to be accepted as an artist, not "just" an illustrator. He wanted to be a painter of fine art, and so he expanded his repertoire, moving from watercolors to oils, and to bronze sculpture (which he called "working with mud"). The development of halftone and photogravure printing facilitated this shift, allowing his work to be reproduced in magazines in color. The magazines he worked for offered for sale color reproductions of the works that appeared in the magazine.[23]

In 1905, he stopped writing altogether so that he could focus on painting. The development of his painting proficiency can be seen by looking at his works over time. Consider figures 6.2, 6.5, and 6.7, all painted before 1900. Although they are done well enough, and in 6.5 and 6.7 tell a dramatic story, they are a bit flat and the primary characters are, well, plunked down on the landscape. It is as if Remington only really wanted the main characters but threw in a landscape because one was needed (and indeed, there is a certain generic quality to the three landscapes).

Look at figure 6.7 and focus on the rock pile that sits just above the pony in the painting. These rocks look kind of like gray marshmallows that have been piled one on top of another. There is no weight to them. Now contrast these works to those in figures 6.8, 6.10, and 6.11, all painted in the 1900s. Figure 6.8, *The End of the Day*, takes you into the place of the painting and its atmosphere as well. If you have ever been in a cabin in the woods in winter, this painting will absolutely bring you back to that time. You feel for the man who is breaking down the gear; he isn't dressed warmly enough. He needs to get those horses settled and get back into that cabin with the light on in the distance. This painting, and Figure 6.10 as well, are part of a series of "nocturne" paintings that Remington did late in his career. He took on the challenge of painting night-time scenes and accomplished some truly remarkable and evocative works in doing so.[24]

During this time of dedicating himself to painting, on two different occasions he decided to burn a number of his paintings, over ninety in total. Some of these works still exist in the reproductions that were made by the magazines for which he worked. Although there is a natural tendency to think, "It's a shame that those originals were lost," it is also understandable. In looking at some of those works, it is clear that they were inferior to

Figure 6.8. *The End of the Day*, Frederic Remington, 1904. The Frederic Remington Art Museum, Ogdensburg, New York.
Courtesy Frederic Remington Art Mueseum, Ogdensburg, New York.

what Remington was doing at that time. He didn't want those works to be considered part of his oeuvre. He felt he was doing much better work and didn't want the inferior works to pull down his reputation.

Part of Remington's legacy is his work in bronze. He started this work in the 1890s and would return to it from time to time. His bronze sculptures were well-received and some of them over the years have become iconic representations of "bronco busters," or as he wrote, "broncho busters." (His spelling was atrocious.) Figure 6.9 is perhaps the most famous of these pieces. Three-dimensional work doesn't reproduce well in two dimensions, but figure 6.9 is highly recognizable. It has been reproduced in a host of forms and sizes, as has his work, *Coming through the Rye*, which depicts four cowboys on horseback, all firing their pistols.

Sundown

In 1909, he bought land in Ridgefield, Connecticut and built a dream home for Eva and himself, with a huge studio for his painting. They moved into the house in May of that year and it appeared that Remington was all set for a new phase in his life—a meaningful shift from illustrator to fine artist. But it wasn't to be. Remington's Rooseveltian appetite for life extended readily to food and drink. He battled his weight his whole life, nearing 300 pounds to distribute on a 5'9" frame. At Christmastime in 1909, at age forty-eight, his appendix burst, and he died a few days later.[25]

In the end, what is to be made of Frederic Remington? His reputation as an artist has waxed and waned. Frequently, his artistic abilities are intertwined with his social outlook: those who focused on his objectionable social views also didn't like his compositions or use of color. Others separated the art from the man. The easier assessment is of Remington the artist. His black and white illustrations are what they were intended to be: rousing and emotional depictions of action, adventure, and danger. They appeal to anyone who owned dozens of toy guns as a child, even if they would not own a real one as an adult. It also seems clear that he made remarkable gains as an artist. His later paintings are far superior to his earlier ones. The Impressionistic depiction of a Native American facing away from a setting sun (figure 6.10, *The Outlier*) is highly evocative of the plight of the Native American. But, as is so often the

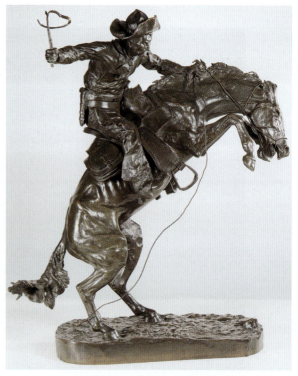

Figure 6.9. *The Bronco Buster*, Frederic Remington, 1895. The Metropolitan Museum of Art, New York.
https://commons.wikimedia.org/w/index.php?curid=68187933

CHAPTER 6: REMINGTON 87

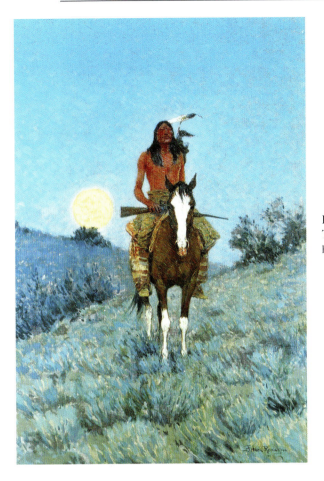

Figure 6.10. *The Outlier,* Frederic Remington, 1909. The Brooklyn Museum, New York.
https://commons.wikimedia.org/wiki/File:Frederic_Sackrider_Remington_-_The_Outlier_-_Google_Art_Project.jpg

case with Remington's work, one's attention is drawn to the horse as well, who occupies as much of the painting as his rider. Remington's horses never take second place in his work; they reaffirm the truth of what Remington wanted his epitaph to be: "He knew the horse."[26] *The Outlier,* along with other works of Remington's final years, reveal a brushwork that is looser, freer, more "painterly" (see box) than his other works. It is a shame that his life ended just as his art was reaching this new phase.

> **Painterly**
>
> Painterly is a term of art that refers to works where the brushstrokes are clearly and easily seen, where the artist has not tried to give the illusion that there was no paintwork involved. Often the goal is a more dynamic, less controlled work of art.

And as to Remington the man? One cannot excuse or forgive his atrocious statements. He grew up in privilege and displayed little sympathy for those less fortunate than he. About the best one can say is that he died young, and perhaps, as his art developed and he reflected more on life, he would have also grown as a human being. It is hard to look at the works depicted in Figures 6.7, 6.10, and 6.11 and not ask the question, "This man hated Native Americans?" They are painted with such empathy, sensitivity, and compassion that one could only hope that the qualities so evident in the works of his hand and eye would, one day, eventually have found their way to his heart and mind.

88 SCOUNDRELS, CADS, AND OTHER GREAT ARTISTS

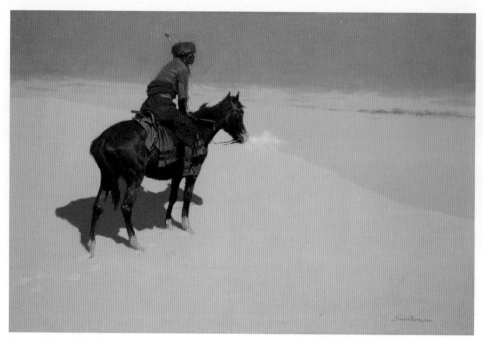

Figure 6.11. *The Scout: Friends or Foes*, Frederic Remington, 1902–1905. Sterling and Francine Clark Art Institute, Williamstown, Massachusetts.
https://commons.wikimedia.org/w/index.php?curid=1022101

In the last decade of his career, Frederic Remington became concerned about being viewed not as an illustrator or storyteller, but as a fine artist. The Scout: Friends or Foes *(figure 6.11) is one of a series of paintings Remington made of a nighttime scene. He referred to these as his "nocturnes," which is a term from music meaning a composition that evokes or is inspired by the night. These works are somewhat reminiscent of the nocturnes of Remington's predecessor, James Abbott McNeill Whistler (see chapter 4). Whether he took the term directly from Whistler is not known. The painting is part of the remarkable collection of the Clark Art Institute in Williamstown, Massachusetts.*

Remington painted several works of Indian scouts in a wide variety of settings and situations. This one depicts a Blackfoot scout; the Blackfoot Nation lived in Canada and the northwestern plains states of the United States. Thus, this scout would be no stranger to extremely cold weather. In the distance, off to the right, is an encampment of some sort with fires going. But whether that encampment is made up of friends or foes is the underlying narrative of the story. Remington sets a mood of solitude, loneliness, and at the same time, the possibility of danger.

A Closer Look: *The Scout: Friends or Foes*

Please take a few minutes to look at figure 6.11 *The Scout: Friends or Foes*. After you've done so, return to this discussion.

This painting is simply beautiful. It catches the eye immediately and holds it. It is hard not to be drawn into it. The colors are amazing: three shades of light blue going

from the snow on the bluff where the scout and his horse stand, to the plain over the bluff, to the night sky. The contrast of the black horse against the darkening sky and the reflection of that sky off the snow are captivating. Next, the moon shadow of the horse and rider come into play, along with the frosty breath of the horse. We are outside on a cold winter's night. And we are alone.

Remington grabs our attention with the stunning colors and composition of the work, and then he pulls us into the narrative, his intention all along. One aspect of looking at a work of art is to be cognizant of where you are as the viewer. Here, our viewpoint suggests that we, too, could be on horseback, slightly to the right and the rear of the scout. Maybe we are his partner in this reconnaissance. If so, what to make of the encampment? It looks warm, invitingly so. There appear to be a number of fires going. There could be food, and hot drink. But we do not carry our rifles for no reason. The encampment itself is too far away to be a danger, but they, too, are likely to have scouts, so there is reason to be cautious. There are no tracks in front of the horse, so this is where the scout has stopped. This vantage point is close enough. Time to make some judgments.

This painting stirs a number of reactions in me. The first reaction I had was this: it is *cold*. We can see the horse's breath, and his extended mane along with the fringe on the scout's sleeve tell us that not only is it cold, there is a breeze, a windchill. The moonlight creates a shadow of horse and rider, and the stars are starting to come out. It is early evening, and it is only going to get colder. We can feel the atmosphere that Remington has provided. Off to the right, the scout, and we as viewers, see the large encampment in the distance. We scan that expanse and see the outline of some sort of fortifications. The campfires are only the very smallest dots of yellow in this painting, and yet they project warmth and protection, human activity and companionship. We can imagine the fires up close even though we can barely see them. We are squinting, just as the scout is.

The next reaction I have is one of loneliness and sympathy for this scout. Unless we are his companions, he is out here by himself. You don't see breath coming from him. Of course, he *has* to breathe at some point, but Remington depicts him as stoic, silent and still on his mount as he peers into the distance trying to settle on whose camp that is. Neither he nor we can quite make out what is going on. Friends or foes?

And then finally, there is a sense of nostalgia and loss. Remington hated the fact that the Old West of romantic tales—"cow-boys and Indians," cavalry coming to the rescue—was all coming to an end. Remington's works were typically narratives; he loved a picture that told a story and he often wanted to not complete the story, but to leave some ambiguity in it. And that is what he has done here. We are given part of the story, but we need to complete it, maybe extend it. Is this simply a moment in the life of a scout in the prairie, or is this warrior metaphorically looking at a way of life that was disappearing before his eyes? Do we dare venture nearer for a closer look, or are we then trying our luck? The ending? Is yours.

SCHIELE

Figure 7.1. *Self-Portrait,* Egon Schiele, 1912. Leopold Museum, Vienna.
https://commons.wikimedia.org/w/index.php?curid=22127540

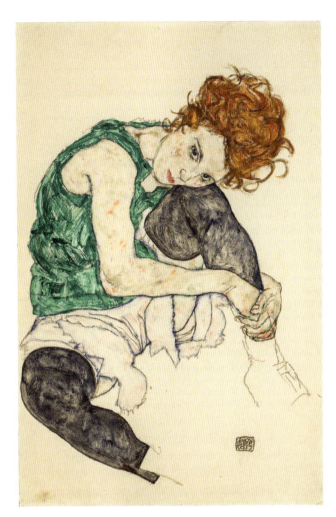

Figure 7.2. *Seated Woman with Bent Knee*, Egon Schiele, 1917. National Gallery, Prague. https://commons.wikimedia.org/w/index.php?curid=46030995

CHAPTER 7

Schiele

MOTH TO THE FLAME

By the time Egon Schiele was thirty, he had been dead for two years. But during his all too brief incandescence on earth, he produced 3,000 works of art, spent time in jail for exposing children to pornography, was part of a new art movement, and served in the Austro-Hungarian Army in the First World War.[1]

Schiele approached his twenty-second birthday making paintings in a prison cell, having been arrested and charged with the kidnapping and statutory rape of a thirteen-year-old girl, and with public immorality for letting minors see erotic paintings and drawings in his apartment.[2] The kidnapping and rape charges were clearly false and quickly

dropped.³ It would be convenient to say that all the charges against him were a terrible misunderstanding, and that he was merely a young man discovering and expressing his sexuality through art in ways that were somewhat unconventional at the time—but essentially harmless. That would, however, fall somewhat short of being true, although the truth of Egon Schiele is murky at best.

Even today, Schiele is a lightning rod for issues of morality and art, with reasonable people holding strongly differing opinions on the argument of the acceptability of his work. His drawings and paintings were often clearly erotic and involved models who would be considered minors in many countries today. He was of questionable character not for his life outside of art, but for the art itself. For Schiele, what is celebrated is also what is censured.

"Here Comes the Divinity!"

Egon Schiele was not a model child. Growing up, he tormented his sisters and felt that as an aspiring artist, the rules and norms of society didn't really apply to him. It turns out that they really did, but that comes later. Schiele was born into an upper-middle-class family in 1890 in Tulln, near Vienna. His father was a railway station master and they lived above the station. Egon had two sisters, and as the only boy, he lorded his status over them. He was known to enter a room by proclaiming, immodestly, "Make way for the Godhead. Here comes the divinity!"⁴ His talent at art was evident at a very early age, along with his distaste for any subject in school other than art and gymnastics. Schiele was very close to his younger sister, Gertrude—some speculate too close as they, at ages sixteen and twelve, took a train to Trieste and spent the night there in a hotel alone together (who rents a hotel room to a sixteen-year-old and a twelve-year-old, whom he claims is his sister?).⁵

Schiele adored his father and was crushed when the elder Schiele died of syphilis in 1905, but not before becoming deranged and burning the stocks and bonds that he owned, thus impoverishing his family. Schiele was sent off to live with his uncle and was accepted into the Academy of Fine Arts at the age of sixteen, a remarkable accomplishment for someone that young. The following year, and the year after, that same academy turned down the application of another aspiring young artist, Adolf Hitler.⁶ He went into politics.

In *Trieste Harbor* (figure 7.3), Schiele displayed his remarkable early talent. This is a beautiful work of art, the contrast of the movement and dreamlike reflections in the water with the weight and stability of the boats foreshadows the insight and sensitivity along with the technical mastery so often seen in Schiele's drawing of human figures. He was able to say what he wanted to say through his art. The composition of this work is also intriguing in that the boats, ostensibly the subject of the painting, occupy less than half of the canvas. The star of the show is the water and the interplay between boat and water. The ripples appear to be objects in their own right. Remarkable for someone so young.

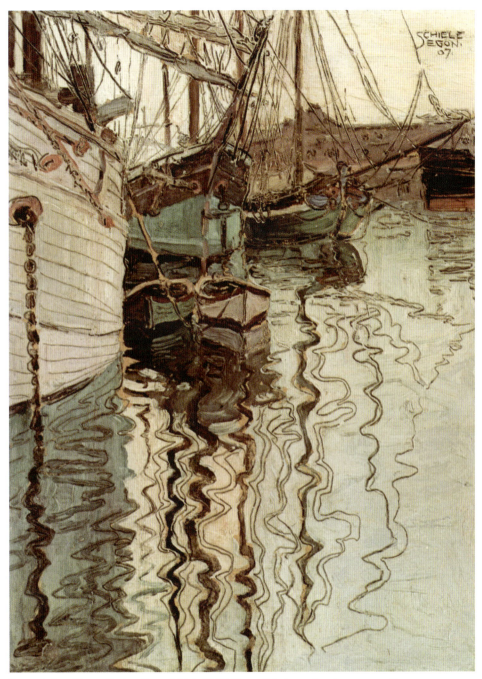

Figure 7.3. *Trieste Harbor*, Egon Schiele 1907. Neue Galerie am Landesmuseum, Graz. https://commons.wikimedia.org/w/index.php?curid=158772

Schiele, the Academy, and Gustav Klimt

Tragically, Egon Schiele never got to see life beyond being a young man. But his twenty-eight years came at a place and time that was critical both in the history of art and the history of the world. Turn-of-the century Vienna included Sigmund Freud and Carl Jung, Johann Strauss and Arnold Schoenberg. Franz Joseph had been emperor for half a century and had his eyes on Serbia. The assassination of his heir, Archduke Franz Ferdinand, would provide the spark for a round of declarations of war that would become the "War to End All Wars."

The leading artist of the day in Vienna was Gustav Klimt, who would become Schiele's mentor.[7] Klimt was a leading proponent of *modernism* and the leading founding member of the Vienna Secession art movement.[8]

> **Modernism**
>
> Modernism is both a term specific to art and to society in general. It has to do with a response to the industrialization and modernization of the late nineteenth and early twentieth centuries. It rejected a classical or conservative approach to art (such as realism) and opened up thinking to changing what was depicted and how it was depicted. Fauvism, Cubism, Constructivism, Surrealism, the Dada movement, and the Vienna Secession are all aspects of Modernism in art.

Elsewhere, Picasso, Matisse, Chagall, Miró, and Duchamp were all starting out or already well-established. Schiele finished three years at the Academy of Fine Arts, leaving in 1909 with a basic qualification, along with a group of students who all felt that the academy was stifling their artistic inclinations.[9] He had met Klimt two years earlier, and drew and painted in Klimt's distinctive style (see figures 7.4 and 7.5). Klimt's painting of the biblical Judith, half naked but fully accessorized, after having beheaded Holofernes (that's him in the bottom right corner), is far more lavish and dramatic than Schiele's *Standing Girl in a Plaid Garment* (figure 7.5), but Schiele was still in his teens, and gold leaf was expensive.

Note the highly stylized and expressive hands in both paintings. Schiele's, in particular, are elongated for effect. What also can be seen here is Schiele's penchant for emphasizing angles and geometric shapes. Follow the left arm from the shoulder all the way to the elbow, back up to the garment the subject is holding, and then follow the garment down to the greatly exaggerated right hand, which comes up at an almost impossible angle. These

> **Vienna Secession**
>
> The Vienna Secession was begun by a group of artists and architects who rejected classical approaches to art and sought to promote an artistic vision more aligned with the nascent but growing notions of Modernism and art nouveau. The group was led by Gustav Klimt and flourished from its formation in 1897 until Klimt and a number of its members split off over a dispute concerning buying a gallery in 1905. The Vienna Secession building remains today, a stunning reminder of the creativity of the movement.

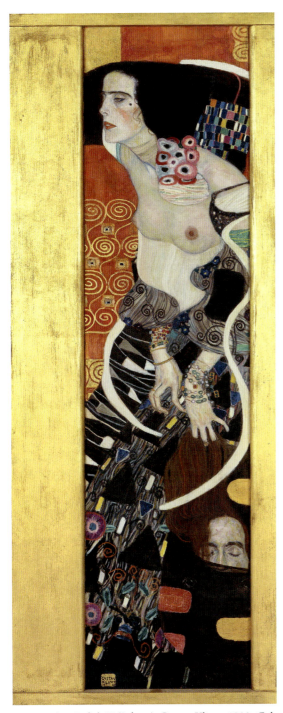

Figure 7.4. *Judith II (Salome)*, Gustav Klimt, 1909. Galleria d'Arte Moderna, Venice.

https://commons.wikimedia.org/w/index.php?curid=47736746

Figure 7.5. *Woman with Black Hat (or Standing Girl in a Plaid Garment)*, Egon Schiele, 1910. Minneapolis Institute of Art, Minneapolis.

https://collections.artsmia.org/art/1743/standing-girl-egon-schiele; https://new.artsmia.org/copyright-and-image-access/; Egon Schiele, Austrian, 1890–1918

Standing Girl, 1910

Conté crayon and tempera wash over black chalk on brown wrapping paper

Minneapolis Institute of Art, The John R. Van Derlip Fund and gift from Dr. Otto Kallir, 69.7

Photo: Minneapolis Institute of Art

figures are close to being grotesque, and yet are alluring. This same kind of treatment can be seen in the second image (figure 7.2) in this chapter. The model's head and right arm form a nearly perfect square, and her pose is all angles. Two other things about these two images: the clothing emphasizes the sensuality in the pictures, and the faces of both models, although fairly simply depicted (especially in figure 7.5), are incredibly beautiful. The other introductory image, figure 7.1, is Schiele himself. If you trace his face, you'll see it is an almost perfect rectangle at about a thirty-degree tilt to the right. His shoulders and chin are sharp; it is hard to tell whether his gaze out at the viewer is one of indifference, disdain, or curiosity. In any case, Schiele does not present himself as the hero of this painting, as one so often sees in self-portraits by young artists.

Figure 7.6. *Standing Nude with Large Hat (Gertrude Schiele)*, Egon Schiele, 1910. Private Collection.

wikiart.org/en/egon-schiele/standing-nude-with-large-hat-gertrude-schiele-1910

Schiele soon broke out on his own stylistically, although Klimt remained a mentor, friend, and supporter throughout Schiele's brief life. Schiele focused much of his attention on painting nudes and self-portraits (most of which were also nude). He painted himself and his sister, Gertrude, more than anyone else, but also painted portraits of friends and of models when he could get them. Figure 7.6, *Standing Nude with Large Hat*, is an example of one of his portraits of Gertrude. Again, we see a strong focus on angles, but in this work, we once again see Schiele's fascination with hands and with sensuality, heightened by Gertrude being half-clothed. It must have been a tough drawing to have posed for as her position is so contorted. But even with minimal detail, we see a woman who is alluring and aware of that fact. As was the case with most of his drawings, there is nothing here but the model—no background, no context. Schiele focuses intently on his subject, capturing her with an economy of line, and yet communicating fully a sense of the erotic in the position, pose, and attitude of the model and the relationship between the image and the viewer. She is looking at the viewer and aware that the viewer is looking back, admiring her beauty and sensuality; she is in control of the interaction.

Egon Meets Wally

In 1911, Schiele met Valerie Neuzil, four years his junior and a former model and probably mistress of Klimt. She became Schiele's mistress, muse, and something of a business manager for the next four years. Although their relationship was almost certainly romantic, they did not live together for most of their relationship, and he once made her sign

Figure 7.7. *Portrait of Wally*, Egon Schiele, 1912. Leopold Museum, Vienna. https://commons.wikimedia.org/w/index.php?curid=22127442

a quasilegal document stating that she was not in love with him.[10] It is a very difficult liaison to figure out looking back at it a century later. At that time in Vienna, being a model was somewhat akin to being a prostitute, and there is some indication that Neuzil had been both before meeting Schiele. His nickname for her was "Wally" (as a diminutive for Valerie), and he painted her regularly from 1911 to 1915, including the beautiful *Portrait of Wally* (figure 7.7) in 1912. This work is a companion piece to the self-portrait at the beginning of the chapter (figure 7.1).

Wally was totally devoted to Schiele and stood by him during his arrest and his time in prison.[11] She worked to support him while he was struggling financially. Ultimately, her devotion was misplaced. Schiele probably loved her, but she was simply not a person a young Viennese man married at the time. She came from a different class and ultimately "class" won out. He treated her miserably at the end, as we shall see.

Prison

After a series of moves in and out of Vienna, Egon and Wally settled in a small community near Vienna called Neulengbach and appear to have been living together there.

Their house became something of a hangout for adolescents with nothing better to do, just the crowd you wouldn't want your child to be associated with. Schiele would draw or paint them, in various stages of dress or undress. In 1912, when Schiele was twenty-one years old, and Wally was seventeen, a thirteen-year-old local girl came to them and asked for help in going from Neulengbach to Vienna so that she could run away from her father and live with her grandmother.[12] They agreed to help her, but upon arriving in Vienna, the girl changed her mind and wanted to return home. Egon and Wally brought her back to Neulengbach. The event took several days. While they were traveling, the girl's father pressed kidnapping and statutory rape charges against Schiele. Schiele was arrested, jailed, and an investigation was begun. The police found drawings of nude children in his apartment, one aparently tacked to Schiele's bedroom wall, and thus an additional charge of exposing children to lewd artwork (public immorality) was filed. The kidnapping and rape charges were dropped, but the public immorality charges were upheld, and Schiele was sentenced to twenty-four days in jail, twenty-one of which were already served.[13] The judge apparently burned the offending drawing from the bedroom in court, and hundreds more were confiscated.[14]

Although the stay in prison was brief, it was traumatic for Schiele and had a dramatic influence on him and his art. After his time in prison, his art changed. He rarely painted or drew children nude after that, did not depict them erotically, and appears to have gotten parental consent to work with them. Also, his nudes in general gradually became somewhat less explicity erotic—more focused on the human form and perhaps a bit less on what that form was doing. In *Reclining Woman* (figure 7.8), Schiele captured his model (his sister-in-law, Adele Harms) gazing out at the viewer, although still in undergarments as opposed to everyday dress.

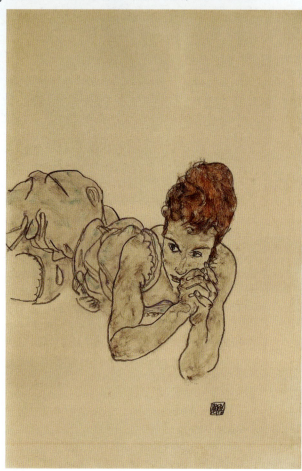

Figure 7.8. *Reclining Woman*, Egon Schiele, 1917. Private Collection.

Egon Meets the Harms Girls, Leaves Wally, and Joins the Army

In 1913, the Neulengbach debacle behind him, Schiele was back living in Vienna with Wally, when a family moved in across the street, complete with their two lovely and marriageable daughters, Adele and Edith Harms. Either Edith or Adele is depicted in figure 7.2 at the opening of the chapter; there is lack of agreement among scholars as to which sister it is. Schiele was smitten with both of them at first and took to communicating with them through the windows of their two houses. He would pose for them or show them his works at his window, and they would giggle looking back across the street through their window.[15] He then took to writing them letters and having Wally deliver them! Their father was not amused. But Schiele convinced them to see him, arguing it would be proper because they would be escorted by Wally. Eventually, Schiele decided that Edith, the younger of the two Harms girls, was the one for him, and he proposed to her. As he wrote to a friend, "I intend to get married . . . advantageously, not to Wally!"[16] But Edith, who was going against the strong wishes of her father, insisted that Wally be completely out of the picture. Schiele agreed, to a degree.

Having decided to leave Wally for Edith Harms, he informed Wally of his decision by meeting her in one of the cafés Vienna was famous for at the time (see box) and handing her a note saying that she would have to remove herself from his life, but that they could have a vacation together each year without Edith. It is difficult to imagine that he thought she would accept. She did not and left the café never to see Schiele again.[17] She not only left Schiele, she left her life as a model and everything associated with art. She trained as a nurse and volunteered for service in World War I. While working as an army nurse, she died of scarlet fever at age twenty-three, in Dalmatia on Christmas Day, 1917.[18]

> **Café Society**
>
> Café Society is a term referring to the practice in the late nineteenth and early twentieth centuries of gathering in elegant coffee houses in major cities in Europe and the United States, to discuss the events of the day. The concept extended to be a derogatory term encompassing the idea of those who were able to engage in such luxuries, along with evening soirées and the like. Vienna has always been known for its excellent coffees and pastries.

Schiele's issues with children and erotic art aside, his behavior toward Wally Neuzil would seem to qualify him as a cad of the first order. One never knows what really goes on with two people in a relationship, and possibly he was doing the best that he thought he could, but from a twenty-first-century perspective, it is hard to be anything but critical of him, perhaps even damning. In early 1915, Schiele had an exhibition at the Galerie Arnot, and made a poster advertising the show (figure 7.9). This work, depicting the artist as a modern-day St. Francis of Assisi, may have expressed Schiele's emotions as he recovered from his jail escapade and contemplated the prospect of how to leave Wally for Edith. The angularity of the pose and strange arrangement of fingers that Schiele typically employed are again seen here. The artist as victim: slings and arrows.

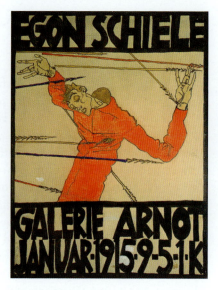

Figure 7.9. *Galerie Arnot Poster*, Egon Schiele, 1914.
https://commons.wikimedia.org/w/index.php?curid=33580962

Schiele and Edith Harms were married in 1915, just before he was drafted and went to serve in the Austrian army in World War I. He received a number of posts during the war, but never one that involved fighting, and several that allowed him to work on his art.[19] Near the end of the war, he returned to Vienna and had only minimal duties for the army. During this time, his work showed the beginnings of a maturity that was sadly never fully realized. Among other work, he painted some stunningly beautiful landscapes and cityscapes. Figure 7.10, *Four Trees*, shows one of his landscapes. The painting abso-

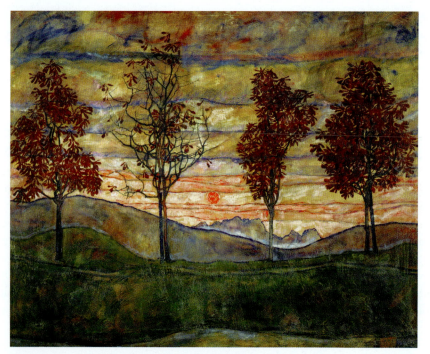

Figure 7.10. *Four Trees*, Egon Schiele, 1917. Belvedere Gallery, Vienna.
https://commons.wikimedia.org/w/index.php?curid=158794

lutely glows, reminiscent of a Tiffany stained glass window. Also of interest is the state of the trees, seeming to indicate the passage of time, or perhaps the stages of a lifetime.

The Tragic End of Egon and Edith

The marriage of Egon and Edith was either blissful or rocky; it depends on which account one reads.[20] But looking at his work after he married Edith Schiele, it appears that she had an effect, perhaps profound, on his work. As mentioned, the beautiful and evocative female portrait at the beginning of the chapter (figure 7.2) is reportedly of either Edith Schiele or her sister Adele Harms. In part, it is hard to know because Edith would often require Egon to put a different face on a work if she had posed for it in a sensual fashion.[21] It was painted in 1917, as was figure 7.10, *Four Trees*, and *Reclining Woman* (figure 7.8). Looking at Schiele's work after he married Edith, and while he was still in the army (the war being another possible influence on Schiele), reveals a departure from the type of "in your face" eroticism of his teens and early twenties toward a more introspective expression of who he was becoming. Figure 7.11, *Summer Landscape, Krumau*, provides another example of this shift; there were still nudes, and erotic ones to be sure, but they were becoming more clearly what would be considered art in a more mainstream understanding of the term.

The year 1918 brought the end of the first world war, but it also brought the Spanish flu. The Spanish flu got its name not because it started in Spain, or was concentrated

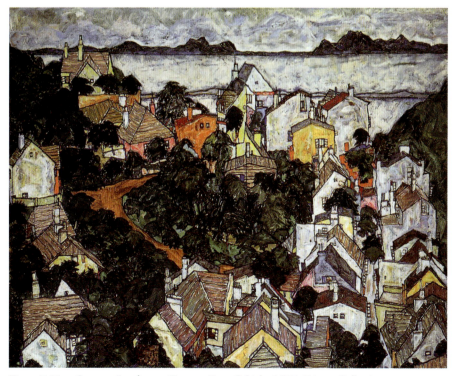

Figure 7.11. *Summer Landscape, Krumau*, Egon Schiele, 1917. Private Collection.
https://uploads2.wikiart.org/images/egon-schiele/summer-landscape-krumau-1917.jpg

there, but rather because wartime censorship would not let it be reported on in countries engaged in the war (because of concern that it would hurt morale). Instead, news focused on neutral Spain, and so the influenza pandemic became "the Spanish flu," fundamentally due to false reporting.[22] It came in two waves. The first, at the beginning of 1918, contributed (along with circulatory problems) to Gustav Klimt's death in February 1918. The second, much more severe outbreak, occurred in autumn of 1918. It was acutely deadly, surprisingly enough, to people in their twenties and thirties, making the Schieles, tragically, particularly vulnerable.

Six months pregnant, young Edith Schiele caught the flu and died of it on October 28, 1918. Schiele cared for her during her illness and caught the flu himself, as a consequence. It is likely that he understood the danger and cared for her anyway. Three days after Edith's death, at age twenty-eight, Egon Schiele succumbed to the same disease. Research on the career trajectories of great artists often show that their most productive years are in their thirties and forties.[23] Schiele appeared headed toward a major shift in his art and expression. The beginnings could be seen. And then he was gone.

What to Do with Egon Schiele?

Schiele undoubtedly behaved in a reprehensible manner toward Wally Neuzil, but that isn't the fundamental problem with Egon Schiele. The issue is, and there is no way around this, Egon Schiele drew and painted nude pictures of underage children, both boys and girls, but mostly girls. To be sure, the "age of consent" in Austria (for sexual relations at least) was fourteen at the time (as it is today!), but some of the children depicted nude are even younger than that, and fourteen is an unacceptable age in any case.[24] He would paint or draw them, sometimes clothed, sometimes in various levels of undress, often explicitly. None of those works are presented in this book. Figure 7.12, painted in 1911, is of an adult model, and is suggestive of the fundamentally erotic nature of the works that Schiele made.

There is no suggestion that Schiele ever behaved inappropriately, in an intimate fashion, with underage children (other than, of course, depicting them, and the strange trip to the hotel with his sister). But unlike some of the other scoundrels and cads presented in this book, who tended to separate their art from their unsavory behavior, in the case of Schiele, the unsavory behavior *is* the art. It is the very act of making the art that also leads to his condemnation. What is particularly perplexing is that the problem isn't with Schiele. For one thing, he is a hundred years dead, and for another, he made no apologies. He proclaimed that eroticism had its rightful place in art. No, the problem of Egon Schiele is not *his*, it is *ours*. What are *we* to make of Egon, today, a century later?

What are we to do with a man who painted young children nude, often in poses that are unambiguously suggestive? How does that behavior affect our judgment of other works by him that are clearly artistically exceptional, even brilliant? Is his behavior more condemnable than Caravaggio killing a man while trying to emasculate him? Than Remington's racism (chapter 6), or Yoshitoshi selling his wife to a brothel, twice (chapter 8)?

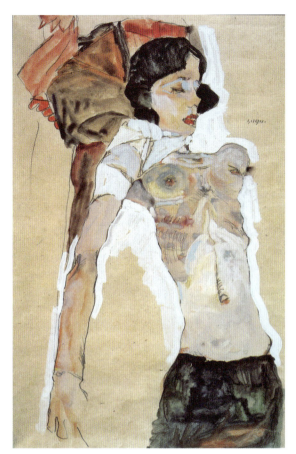

Figure 7.12. *Reclining Nude*, Egon Schiele, 1911. Albertina Museum, Vienna.
https://commons.wikimedia.org/w/index.php?curid=10285708

Than the photographs of Lewis Carroll (of Alice Liddell and others)? Can we separate the personal behavior from artistic genius, and if so, can we even do it when the two can be argued to be one and the same?

Arguing for Egon Schiele, and many art historians and commentators do so,[25] he was a product of his time, a very young man when he engaged in this behavior, who appears to have abandoned such activities after he was released from jail. Additionally, he did not depict his subjects doing anything other than what some children of that age do. His pictures of children tend to be in natural poses as opposed to the contorted poses of much of his adult work. Arguing against Schiele are those who believe that any form of acceptance of what should be considered pornography concerning children, and those who engaged in its production, should not have a public outlet. Full stop.

What the problem of Egon Schiele does, in part, is bring into painfully sharp focus the theme of the book as a whole: the consideration of great art created by people who are less than great representatives of humanity. Why is Schiele more (or less) reprehensible? Can we separate the art from the artist? Or does the nature of the artist inform and illuminate the art we see and how we see it?

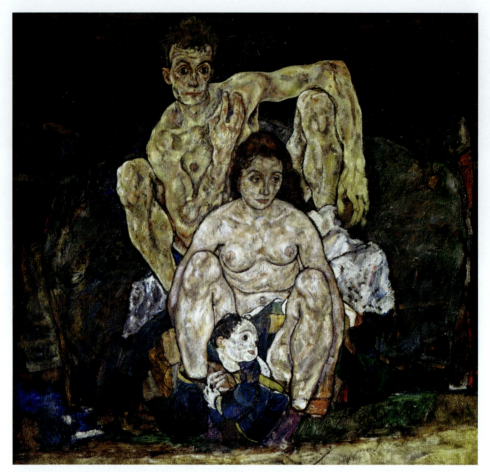

Figure 7.13. *The Family*, Egon Schiele, 1918. Belvedere Gallery, Vienna.
https://commons.wikimedia.org/w/index.php?curid=53397976

The Family *(figure 7.13)* is one of Schiele's last works, and is said not to have been completed when the Spanish influenza epidemic took his life, three days after his wife, Edith, had succumbed to the same disease. She was six months pregnant at the time. The painting was originally titled Crouching Couple, *with the baby added somewhat later than the original work.*[26] *It depicts Schiele and Edith, with the baby being modelled by Schiele's nephew. In fact, the name of the work was changed to* The Family *after Schiele's death, by a friend of his.*

The Family *is one of the last paintings Schiele made. It is not known whether he knew Edith was pregnant when he painted it. Although similar in some aspects to his earlier works, particularly in the angular positioning of his arms and fingers, there are also marked differences between* The Family *and earlier works. It is richly painted, with a full background that puts the sitters into a chiaroscuro prominence. Also note that the sitters are not striking an especially awkward or confrontational pose with regard to the viewer, as is so often the case with Schiele portraits.*

A Closer Look

It is once again time to have a closer look at a work, this time *The Family* (figure 7.13). Please read the label material on the previous page, and have a close look.

In considering this self-portrait of a family that never came to be, it is hard not to be struck with a sense of melancholy. In real life, the baby imagined in this portrait died in utero, along with his mother, and the father/artist three days later. Although the tones are warm in this work, the pose of the sitters seems unsettled. The father (Schiele) is not really embracing the mother or child, and none of the three is looking at one another. In fact, they all look in different directions. The mother and the child are connected in two fashions. First, the swaddling the baby is wrapped in also goes through and around the mother's legs. And they are painted in the same palette, more pink tones than the brown and yellow used to depict the father. But she does not embrace the child when clearly she could. Her arms instead are at her sides and her hands are hidden from view.

What is going on here? What is Schiele trying to say? This may be reading too much into the work, but then again, that is part of what makes looking at art so interesting. I think Schiele is saying, "This is who I have been—the guy who makes funny angular gestures and who has always been a bit strange—but look at what has happened now! I'm a married man, not an adolescent, and about to be a father. My life has changed; I'm not sure what to make of it all, but I look (I think) toward the future." Such an interpretation would require Schiele knowing that Edith was pregnant, or perhaps just anticipating that she might become pregnant.

It is likely the case that Edith was not ill when Schiele was making this painting. The Spanish influenza could kill within days of striking. Both Schiele and Edith were probably perfectly healthy when this picture was painted. But the scourge of the Spanish flu pandemic was well-known and the first wave of it, in early 1918, had already taken the life of Schiele's mentor, Gustav Klimt. Also, in 1918, the horrors of World War I were just coming to an end, with Schiele's Austria on the losing side. And so, this portrait of an anticipated family depicts the anxiety of an uncertain future alongside the hopefulness of new beginnings.

It is also interesting to see that although both the mother and father are naked here, there is no notion of the eroticism that marked so many of Schiele's earlier works. Nor are the figures contorted or confrontational to the viewer. This is a gentler and kinder Schiele, perhaps anticipating fatherhood, and one who is successfully combining his drawing with his painting. And although the figures are presented with multiple colors and hues, they seem more natural than some of his dramatic earlier work. In fact, the colors here are luminous, the glow emanating out from the picture to the viewer, as many of his landscapes do. Although there is nothing markedly attractive about the three figures in this work, their warmth and fundamental humanity call out to us. "Here we are—a family—what is to become of us?"

This work, one of his last, brings the tragedy of his early death into sharp focus. When we look at the other artists in this book, we can see that the late twenties often were a time of change and a move into a new approach to their work, more skilled, more confident. And Schiele certainly seemed headed in that direction. But we are robbed of that era for Egon Schiele. Imagine what would be lost if the great artists of the world all had their work stop at age twenty-eight. We can only speculate on the Schiele that was never to be as we take a closer look and contemplate the possible trajectories for this astonishing talent who blazed brilliantly and then was gone as quickly as a meteor in the night sky.

YOSHITOSHI

Figure 8.1. *Portrait of Yoshitoshi*, Tanaki Toshikage, 1894. Art Gallery of New South Wales.

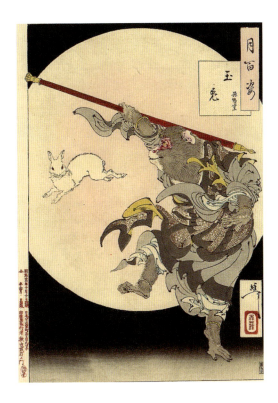

Figure 8.2. *Jade Rabbit—Sun Wukong*, Tsukioka Yoshitoshi, 1889. Art Gallery of New South Wales. https://commons.wikimedia.org/w/index.php?curid=11999288

CHAPTER 8

Yoshitoshi

HOLDING BACK THE NIGHT

In 1878, a young geisha sold all of her worldly possessions, including her clothes, and then sold *herself* to a brothel in order to garner funds to give to her poverty-stricken paramour, the great *ukiyo-e* artist, Tsukioka Yoshitoshi. It would seem a singular act of devotion, but she was actually the second woman to have done so. Her loyalty was not reciprocated; Yoshitoshi had several wives and many mistresses throughout his life and was almost never monogamous during those relationships. His was a life filled with geishas, *yūjo* (women of pleasure), brothels, Kabuki theater—all the pleasures and passions of what was known in mid-nineteenth-century Edo (now Tokyo) as *ukiyo* ("the floating world"). Indeed, he was an illustrator and chronicler of the sensibilities of that existence in his incredible woodblock printings, ukiyo-e.[1]

Exploring the life of Yoshitoshi requires unfastening the seatbelt of twenty-first-century society and journeying to a place and time so different from the West today that one risks whiplash from the tosses and turns. But if you are willing to play a modern day "Alice," and follow a nineteenth-century white jade rabbit across the moon (figure 8.2) and then down a metaphorical and historical rabbit hole into the Japan of the Tokugawa Shogunate and the delicate sensitivities and dispositions of the floating world of Edo, you might find the excursion well worth the price of passage.

Starting Out

Yoshitoshi had many names throughout his life, the first being Owariya Yōnejiro. He was born in Edo in 1839. His father was wealthy and had bought his way into samurai status. His mother was a different story. Nothing is known for certain about her, but the best speculation is that she was a mistress who fell out of favor when Yoshitoshi's father found a new mistress.[2] Yoshitoshi was three when his mother was sent away and Yoshitoshi was packed off to live with an uncle. Not the best of beginnings, but his uncle had recently lost a child of roughly the same age, and formed a loving relationship with Yoshitoshi. Sadly, there is no mention of Yoshitoshi ever having had someone who took a maternal interest in him past the age of three. Throughout his life, Yoshitoshi's relationships with women could be most kindly put as "complicated," although "reprehensible" might be a more accurate term.

Ukiyo

Ukiyo literally translates to "floating world," but the term is much richer with meaning and subtlety than such a simple definition can offer. It refers to a time in Edo (later Tokyo) where samurai, businessmen, nobles, artists, artisans, and others would gather in tea houses, brothels, theaters, and restaurants to engage in intellectual discussions, view plays (Kabuki theater), recite poetry, listen to music, and partake of sexual adventures with geisha. Ukiyo also is a homonym (pronounced the same, spelled differently) for the "world of sorrow" that is part of Buddhist belief of the cycle of rebirth, suffering, and death, from which one tries to escape. It might be thought of as a disposition, or sensibility, rather than a specific time and place.

Owariya Yōnejiro developed an interest in art at a very early age, and at eleven went to study under ukiyo-e master Kuniyoshi. As was the practice at the time, he was given a new name consisting of the "Yoshi" part of Kuniyoshi's name, and then one of his own, becoming Yoshitoshi. (*His* students would then start their name with "Toshi.")[3] Yoshitoshi produced his first print (that still exists) at age fourteen, a triptych of a frantic sea battle filled with giant crabs, rays, and other denizens of the deep, that is not particularly memorable. The next print of his that still exists was not made until he was in his twenties.

Triptych

A triptych is a work of art in three pieces. It is very common in European religious paintings where they are brought together with hinges and used as part of an altarpiece. The three pieces are sometimes one picture that spans the three separate pieces (as is the case typically in Yoshitoshi's works), or they might be three related works that tell a story (often what is seen in European religious paintings). A diptych would be two works brought together. The use of multiple pieces to form a work was common in ukiyo-e printing because it was difficult to make a print from a single, large block of wood.

Hard Times and Strange Work

Yoshitoshi lived in highly unsettled times. The Tokugawa Shogunate that had ruled Japan for hundreds of years would fall in 1868, and Japan would return to rule by the emperor (the Meiji Restoration). The capital city, "Edo," became "Tokyo." The fall of the shogunate would not be realized without incredible strife and chaotic societal change.[4] There were crop failures, riots in Tokyo over the lack of food, arson that destroyed much of Kyoto, and constant disruptive interventions from the West. On a personal level, in 1861, Kuniyoshi died, leaving Yoshitoshi to fend for himself both artistically and financially.[5] For an ukiyo-e artist, survival meant selling prints—in bulk—but for a newcomer to the field, and one whose mentor had passed on, this could be challenging. How to make a name for oneself? And how to do so while enjoying the costly nightlife of ukiyo, which was essential to being its visual chronicler?

> **Ukiyo-e**
>
> The addition of "-e" means depictions or pictures of something. Hence, ukiyo-e are pictures of the floating world (see ukiyo box). Ukiyo-e could be paintings or other forms of two-dimensional art, but they were typically woodblock prints. The woodblock technique offered both possibilities and constraints. Ukiyo-e were noted for the line drawings that would form the initial basis of the picture and then blocks of color added by subsequent stages in the printing. Ukiyo-e tended to be asymmetrical in structure, with a "flat" appearance, without a reliance on depth. Often the subjects would be presented with no particular background at all (see figures 8.3, 8.5, and 8.6). Ukiyo-e prints tend to have a lot going on in them, to be dense in information, and to frequently depict something on the border of the erotic, violent, or outside the general bounds of acceptable behavior.

Yoshitoshi scrambled to earn a living making prints. One avenue for this was to depict his actor friends. This benefitted both Yoshitoshi as well as the actors, in that the prints would serve as publicity for them. They could be collected by fans of the artists, much as baseball cards would be collected later and in a different place. Another option was gory depictions of the general lawlessness of the times. Yoshitoshi developed two series in this vein, one called "*Twenty-eight Murders with Verse*," followed by "*Yoshitoshi's Selection of One Hundred Warriors*."[6] Both sets of prints included many works that were incredibly bloody and violent, particularly in the "murder" series. By bloody and violent, what is meant here is "naked-very-pregnant-women-being-hung-upside-down-by-a-rope-and-attacked-with-swords" violent. Figure 8.3, *The Woman Kansuke Slaying an Assailant with a Sword* represents one of the milder scenes from this era. Here we see a woman driving a sword through the ear of an assailant while casually glancing off to her left. Figures 8.5 and 8.6, which illustrate the process of making Japanese woodblock prints, also depict a woman dispatching a foe, but many of the works involved violence not by, but against women.

It is argued by some that these gruesome works were not without artistic merit, but there was also a "pulp fiction/play to the lowest common denominator" quality to them that is difficult to deny. These works and ones similar to them came to be known as *ero goru*, or the erotic grotesque.[7] The popularity of these works was not part of some sort of subculture, or cult-following phenomenon; "Bloody Yoshitoshi" became internationally famous with these prints, and they were widely sought after. Also, it was not simply the case that Yoshitoshi was providing the public with what they wanted. It appears that he was working out some inner demons through this art. Whatever the underlying motivation, as woodblock prints, they could be generated in large numbers—and they sold. For a brief time, ero goru kept him financially secure.

To get an idea of the truly strange individual Yoshitoshi was, consider a sampling of titles from his works:

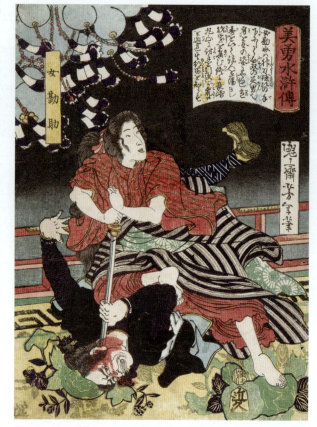

Figure 8.3. *The Woman Kansuke Slaying an Assailant with a Sword*, Tsukioka Yoshitoshi, 1866. Los Angeles County Museum of Art, Los Angeles.
https://commons.wikimedia.org/w/index.php?curid=27343652

- *Lady Kayō, Consort of Prince Hanzoku of India, Holding a Severed Head*
- *The Wicked Thoughts of the Priest Raigō of Miidera Transform Him into a Rat*
- *The Demon of Rashōmon Visits Watanabe no Tsuna Disguised as an Old Woman to Retrieve Her Severed Arm*
- *Heads of Two Foxes Decapitated for Too Much Merrymaking*
- *A Cat Interrupts a Dogfight to Avenge the Death of Her Mother*[8]

Some of these titles come from Japanese myth and tradition, and some may not translate all that well into English, but one hopes that the demon lady was reunited with her arm.

As it turned out, the public taste for blood and gore could not keep pace with Yoshitoshi's taste for the good life of ukiyo. With sales dropping off, Yoshitoshi found himself in financial trouble. He did not complete the *One Hundred Warriors* series due to lack of demand. With the final fall of the shogunate after many years of battle, the public had turned their attention to matters less severe, and no longer desired bloody depictions of

battles. Yoshitoshi's personal life also went through dramatic change at this time. During the 1860s, he is reported to have married but not stayed with his wife, and to have had a child who died, the mother unknown.⁹ Life was becoming difficult.

Descent

To complicate his financial woes, Yoshitoshi's mental health declined dramatically at this time. He became severely depressed, was unable to work regularly, and consequently, was essentially poverty-stricken in the late 1860s and early 1870s. He had complete nervous breakdowns in 1872 and 1873 and was occasionally institutionalized. Although there were times when he could not work at all, at other times he produced stunning works, such as *The Wrestler Chōgorō Throwing a Devil*, figure 8.4. During this time, he was living with a woman named Okoto, who steadfastly attended to his needs and nursed him through his bouts with depression. Eventually, their poverty became so extreme that she sold all of her possessions, including her clothes. His financial fortunes improved briefly, and then again took a turn for the worse. The couple took to tearing up floorboards to burn for heat. The breaking point came in 1876, when Okoto left Yoshitoshi and sold herself to a brothel to raise money for her lover!¹⁰

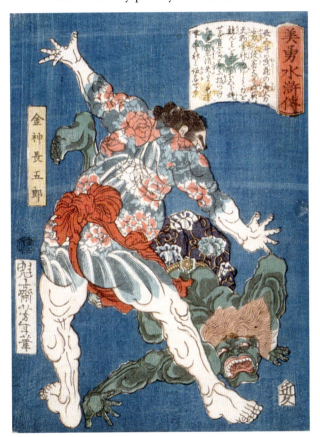

Figure 8.4. *The Wrestler Chōgorō Throwing a Devil*, Tsukioka Yoshitoshi, 1866. Los Angeles County Museum of Art, Los Angeles. https://commons.wikimedia.org/w/index.php?curid=27343652

Political instability continued to wrack Japan throughout the 1860s and 1870s. Oddly enough, Yoshitoshi was ultimately to benefit from this turmoil. Newspapers were thriving by reporting the conflicts and struggles for power, and they wanted woodblock prints of the events of the day. He was able to produce depictions of scenes that were popular with the public, even though he had no first-hand knowledge of the events when he made the prints. In 1877, he developed a relationship with a geisha named Oraku, which, while not technically a marriage, essentially functioned as one. Yoshitoshi treated this relationship in the same shameful fashion as he had others in the past, by developing

side relationships with other women and spending extravagant sums on courtesans. It is hard to imagine a family budget with a line item for brothels! Within a year, during yet another period of financial distress, Oraku took the same route that Okoto had earlier, selling her worldly possessions and then herself to a brothel, all in support of Yoshitoshi.[11]

Not yet forty years old, Yoshitoshi had made a name for himself as Japan's leading ukiyo-e artist, had established financial security and lost it several times, had several nervous breakdowns and recoveries, and had won the devotion of numerous women whom he in turn treated exceptionally poorly. Along the way, he had made a number of beautiful ukiyo-e, but also a number of exceedingly highly disturbing works.

From Sketch to Final Print: The Woodblock Print Process

Japanese woodblock printing involved multiple processes and typically four different professionals: the artist, the printer, the engraver or woodcutter, and the publisher. The publisher would assess the market, coordinate activities, and work with the artist to produce what would typically be a series of prints. The design of the print would be the responsibility of the artist, who would work through sketches to produce a line drawing of the work that would form the basis for the final product. Once the line drawing was made, it would be glued ink side down on a wooden block (usually cherry wood). Then oil would be rubbed on the paper. The woodcutter would carve away wood until just the line drawing was remaining at the initial top level of the wood. Remaining paper would be scrubbed off the wood. At that point, the printer took over, hand inking the wood and creating the prints.[12]

Of course, this would leave just a black and white line drawing, but that is what the original ukiyo-e prints were. Color was added later, and experimentation in the use of colors, inks, and techniques led to a variety of approaches being taken and effects being produced. Interestingly, a new wood block would have to be created for each color to be added (sometimes several for each color), and very careful alignment of the blocks to the existing version of the print had to be assured. A block with lettering could be added as well. Often, ukiyo-e came with poems, moral lessons, or commentary.[13] Figures 8.5 and 8.6 show a preliminary sketch and then a final version of a print of *Hanai Oume Killing Minekichi*. There is a strong fidelity between Yoshitoshi's initial sketch and the final version. Some aspects have clearly been changed (such as the writing in the lower right and the belt and undrawn knife of the victim), but for the most part, the consistency is impressive.

Ukiyo-e was not limited to woodblock prints; there are also ukiyo-e paintings and works on scrolls. And woodblock printing techniques were used in other genres and subgenres, such as *bijin-e*, paintings of beautiful women. An intriguing aspect of the initial drawing (figure 8.5) is its similarity to an unpainted cartoon cell of the 1930s to 1970s, or a storyboard sheet for a movie scene. Also, the similarity to anime or manga popular in Japan today is clear.

CHAPTER 8: YOSHITOSHI 113

> ## Writing and Marks on the Woodblock Prints
>
> Woodblock prints often contain writing and marks on them, much as one might see on posters today. The title of the series and the work itself might be included, along with a poem or story about the work. The artist's signature and mark would be on the work, perhaps with the publisher's name and address, and even the engraver's name. In figure 8.10, *Cooling off at Shijō by the Kamo River*, the series title (One Hundred Moons) is at the top right, with the title of this particular work just inside that to the left. Yoshitoshi's signature and mark are at the bottom left, and the publisher and artist information is in the left margin. There is no engraver's name here, but had there been, it might have been at the bottom right. If there were more of a story that the artist wanted to tell, in all likelihood it would be at the top of the work.

Figure 8.5. *Sketch of Hanai Oume Killing*, Tsukioka Yoshitoshi, c. 1887. Los Angeles County Museum of Art, Los Angeles.

Image: http://collections.lacma.org/sites/default/files/remote_images/piction/ma-317 97745-O3.jpg

Gallery: http://collections.lacma.org/node/191612 archive copy at the Wayback Machine (archived on 28 March 2015), Public Domain, https://commons.wikimedia .org/w/index.php?curid=27345127

In looking at Japanese woodblock prints, one can see wide variation in the appearance and condition of two copies of the same print. Multiple copies will exist of any popular print, and they will have been subject to variations in environmental conditions, handling, and exposure to sunlight. Also, prints taken at different times in the "run" can vary as well. These can give the same work very different appearances.

Finding Stability

In 1880, life took a dramatic turn for the better for Yoshitoshi when he met a former geisha with two children, named Sakamaki Taiko. He had been doing fairly well with his work, producing a series of famous generals and an illustrated history of Japan. Sakamaki seemed to understand how to deal with someone who was often volatile, frequently drunk, and regularly to be found in a brothel. She was incredibly tolerant of Yoshitoshi's staggering character flaws. Sakamaki and Yoshitoshi married in 1884, and lived in a large house with a half dozen of Yoshitoshi's students, the two children, and Sakamaki's mother.[14]

Yoshitoshi's philandering apparently

Figure 8.6. *Hanai Oume Killing Minekichi*, Tsukioka Yoshitoshi, 1887. Los Angeles County Museum of Art, Los Angeles.

Image: http://collections.lacma.org/sites/default/files/remote_images/piction/ma-31806481-O3.jpg Gallery: http://collections.lacma.org/node/191213 archive copy at the Wayback Machine (archived on 20 March 2013), Public Domain, https://commons.wikimedia.org/w/index.php?curid=27339984

never abated throughout his life. In Sakamaki, he had found someone who wasn't bothered by this. It is reported that he once engaged in a sexual act with his favorite prostitute, a woman called "the Phantom Lady," that was so . . . the appropriate adjective is hard to find . . . that he paid her 100 yen the next morning, equivalent to an entire year's salary (during a time when he was making good money).[15] Now apparently, the brothels of the ukiyo-e were known for being extravagantly expensive, and it was necessary to court a courtesan prior to intercourse, but still.

In his mid-forties, Yoshitoshi's life and art matured. Or at least, aspects of them. He apparently was a good stepfather for Sakamaki's children, and he was able to keep the financial wolves at bay. In the late 1880s, he developed two series of prints that are generally thought to be among his best, *One Hundred Aspects of the Moon*, and *Thirty-two Aspects of Customs and Manners*. In each of these, he left behind the gore and violence found in his earlier work, developed a sensitivity with respect for his subjects, and occasionally exhibited a playfulness that is not seen in his earlier work. Figure 8.2, *Jade Rabbit*, is part of the *One Hundred Moons* series. (*Jade Rabbit—Sun Wukong* is also referred to as

Moon Rabbit, The Rabbit in the Moon, and *Moon Rabbit—Monkey. Sun Wukong* is the monkey.) The work depicts two mythical creatures from Chinese and Indian literature, bringing them together in a scene rich with imagery.¹⁶ The rabbit is related to the waxing and waning of the moon, and to death and rebirth. The monkey holds a staff made of iron and gold that was used to beat on the Milky Way until it was flat. So, it's not just any rabbit or monkey. The beautiful print used in the "A Closer Look" part of the chapter, figure 8.10, is also part of the *One Hundred Aspects of the Moon* series. Not only are these works exquisite and engaging, the stories behind them illustrate the incredibly complex play of language, history, and culture that were so important in the time of ukiyo.

Figure 8.7, *Wanting to Meet Someone: A Courtesan of the Kaei Period (1848–1853)*, is part of the *Thirty-Two Aspects of Customs and Manners* series. The series depicts a Japan that was essentially disappearing before Yoshitoshi's eyes, one he desperately wanted to hold onto. These works are generally considered to be among his best. A personal note here: When I first saw this work, I misread the title as ". . .Waiting to Meet Someone" The difference between "waiting" and "wanting," for me, changes the entire tone of the picture. It makes the depiction of this young courtesan tragic instead of hopeful. And it brings up another issue: it is often difficult to discern the emotion of the subject in Yoshitoshi's early works, especially in those of women. The faces are all fairly

Figure 8.7. *Wanting to Meet Someone: A Courtesan of the Kaei Period (1848–1853)*, Tsukioka Yoshitoshi, 1888. Los Angeles County Museum of Art, Los Angeles.

Image: http://collections.lacma.org/sites/default/files/remote_images/piction/ma-31814675-O3.jpg

Gallery: http://collections.lacma.org/node/191623 archive copy at the Wayback Machine (archived on 22 January 2019), Public Domain, https://commons.wikimedia.org/w/index.php?curid=27343582

similar, and somewhat neutral in expression. But here, Yoshitoshi has made his subject a real person, one worthy of our shared joy or sympathy, depending on whether the title is read properly. As is true of many of these works and those of the *One Hundred Aspects of the Moon* series, the subject is brought very close to the viewer; the action, or portrayal, fills the frame, often with few background details. The wisps of hair suggest that a breeze is blowing. The falling cherry blossom petals tell us that it is spring and remind us that the beauty of the cherry blossom tree—and of the young courtesan—is transient. Her costume depicts six different patterns of fabric. It is a touching and lovely composition.

The Final Act

As Yoshitoshi approached what would be the last years of his life, his focus was on the past. He wanted to preserve the traditional aspects of the art of woodblock print, and he longed for a Japanese way of life that was disappearing.[17] In this respect, he was not dissimilar to Frederic Remington and his longing for the Old West (chapter 6). He worked on Kabuki theatre performances and made prints of the more formal Noh dramatic productions. The late 1880s were a time of copying Western ideas, but Yoshitoshi stayed with the old ways, essentially becoming the last, great, ukiyo-e artist.

One of the final series he produced was called "*New Forms of Thirty-Six Ghosts.*" Yoshitoshi believed that he had had several encounters with ghosts earlier in his life, and he believed that they were real.[18] These are a sensitive series of works, capturing the emotions of the humans in them more than simply displaying bizarre ghosts. This is a different Yoshitoshi than the one of his youth. In *Bōtarō's Nurse Otsuji Prays to the God of Konpira for His Success* (figure 8.8), we see a woman in a waterfall, in distress, praying that she can sacrifice her life in exchange for that of the child she nurses, Bōtarō, whose life is currently under threat. Fortunately for Bōtarō, but sadly for Otsuji, she succeeds in her aspiration.

Although Yoshitoshi's work at this time was occasionally quite good, his health was not. In 1891, his mental health had deteriorated once again, and he was hospitalized on several occasions over the next two years.[19] He worked very little during this last period of his life, and needed help to do what work he could.

Figure 8.9, *The Old Warrior Tomobayashi Rokuro Mitsuhira*, done as a newspaper supplement in 1888 during a time when Yoshitoshi's skills were at their peak (before his last bout of mental illness), might be a fitting memorial to this very talented and very strange man. It is a picture of an old priest and scholar, Tomobayashi Rokuro Mitsuhira, dressed in his finest warrior garb. He is looking as fierce as he can be, and he

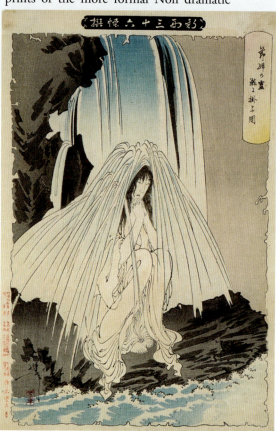

Figure 8.8. *Bōtarō's Nurse Otsuji Prays to the God of Konpira for His Success,* Tsukioka Yoshitoshi, 1892. Los Angeles County Museum of Art, Los Angeles.

http://collections.lacma.org/sites/default/files/remote_images/piction/ma-31806495-O3.jpg Gallery: http://collections.lacma.org/node/191264 archive copy at the Wayback Machine (archived on 20 March 2013), Public Domain, https://commons.wikimedia.org/w/index.php?curid=27340100

Figure 8.9. *The Old Warrior Tomobayashi Rokuro Mitsuhira,* Tsukioka Yoshitoshi, 1888. Los Angeles County Museum of Art, Los Angeles.

Image: http://collections.lacma.org/sites/default/files/remote_images/piction/ma-31814596-O3.jpg Gallery: http://collections.lacma.org/node/191400 archive copy at the Wayback Machine (archived on 22 January 2019), Public Domain, https://commons.wikimedia.org/w/index.php?curid=27343025

is practically stepping out of the picture to confront us. In real life, the shogunate saw Mitsuhira as a threat and had him beheaded. His dress and pose make him look like an Edo version of Don Quixote, tilting at the windmills of his time, much as Yoshitoshi came to be, longing for the ukiyo that was fading as rapidly as his ability to comprehend the loss. In 1892, at the age of fifty-three, he died of a cerebral hemorrhage.

In literary and artistic circles in Japan, one often writes a "death poem" with respect to one's life. This is how Yoshitoshi saw his life:

> holding back the night
> with its increasing brilliance
> the summer moon[20]

Figure 8.10. *Cooling off at Shijō by the Kamo River,* Tsukioka Yoshitoshi, 1885. Philadelphia Museum of Art, Philadelphia.
By Yoshitoshi–http://www.muian.com/muian04/04yoshitoshi05070.jpg
Public Domain, https://commons.wikimedia.org/w/index.php?curid= 12138389

Cooling off at Shijō depicts *a young waitress from a restaurant taking a break from her work and cooling her feet in the Kamo River. The Kamo River would become dry for several months a year and temporary structures and activities would take place on the riverbed; it was here that Kabuki theatre started.* Cooling off at Shijō is taken from Yoshitoshi's highly successful One Hundred Aspects of the Moon *series done by the artist later in his life. It reflects a more mature and sensitive style in comparison to his earlier, frequently violent and gruesome work.*

As is often the case with ukiyo-e, and with Japanese art in general, there are subtleties and commentaries in this work beyond what initially meets the eye.[21] This work makes a sly suggestion of a linkage between the brothel district of Gion, adjacent to Shijō, and a former emperor of Japan, whose name was also Shijō, and his family. The nature of the linkage is complicated, but the message is that the distance between court (as in royal court) and courtesan (as in companion for hire) is not always that great.

A Closer Look

Once again, take a look at the work above, and then return.

In contrast to a battle scene, or a murder, or prohibited lovers meeting in secret, this ukiyo-e portrays a waitress taking a break and cooling a foot in a river. Her dress is somewhat dishevelled, and her red undergarment is visible; she holds her garments up from getting wet in the water. She is in her own world and we are voyeurs, looking not lewdly but sympathetically, sharing her moment of respite from work. Yoshitoshi has captured

that moment. But, I wonder, does this moment exist for the viewer or for the waitress? Is this a real person he knew? Was it a sketch made from real life, or in a studio? Did Yoshitoshi just want to present a beautiful girl with a bare foot in a cool river—a simple visual treat for the subscribers to the series of which this is part? Or was he depicting a young woman he knew, one who is taking a pause in her duties and wondering what the rest of the evening will hold, or the rest of her life? What options are there for her? What would become of her? We know that Yoshitoshi was not the most compassionate of individuals when it came to his relationships with women. But this work was done later in his life, when he had his most stable and enduring relationship, with Sakamaki. Maybe it is emblematic of an artist who is maturing.

Color and composition are often the first things that strike the eye in ukiyo-e prints. Woodblock prints are typically fairly flat. The action is up front; there is little going on in the background. We see that in this print. The waitress here wears a dress that is full of volume. There are folds and puffs. It is impossible to get a sense of her body underneath the dress, even to tell exactly where her left leg is. At the same time, she doesn't seem settled onto the dock; she seems more placed gently on top of it than actually sitting on it. And then there is the pattern of her dress. The odd white figures on the print frequently maintain their form across folds of the dress. Occasionally they respect the folds, but more often, not.

Also, because of the nature of woodblock printing, the colors are typically solid, without gradation. But here we see the sky as it meets the water fading from blue to white. How was that achieved? Why wasn't it used elsewhere? These prints were intended for large productions. Each color seen is a separately drawn block that needs to be precisely registered (placed) for purposes of printing. Thus, the remarkable volume of the dress really has to be captured by the drawing alone. One cannot use the incredible brushstroke techniques of painters like Ingres or David to accomplish this.

The young waitress cuts a diagonal from upper left to lower right in the print. Her porcelain face catches our eye, and then we pan down and see the foot in the water, but only as an outline. The contrast of the pale blues with the white of her face, the moon, the figures on her dress, the commentary in the box, the lantern, and the horizon provide multiple opportunities to see how well these colors work together. And then the deep red on her dress and jet black of her hair punctuate our view of this ostensibly simple scene.

This print is part of a series on aspects (or views) of the moon. I can't help but think that Yoshitoshi is contrasting the beauty of the waitress with the moon that sits just above her. Both are in their full beauty, but that beauty, for both of them, is about to begin to wane. In the series, Yoshitoshi cleverly presented the moon in different phases and with different meanings, always marking the passage of time. To me, I think what he is saying here is that, yes, there is the moon and it is beautiful, but it is no contest for the beauty of a young girl, who is lost in her thoughts, paying attention neither to the moon nor to any of us.

POLLOCK/KRASNER

Figure 9.1. *Portrait and a Dream,* Jackson Pollock, 1953. Dallas Museum of Art, Dallas. Dallas Museum of Art, gift of Mr. and Mrs. Algur H. Meadows and the Meadows Foundation, Incorporated 1967.8. © Pollock-Krasner Foundation/ARS. Copyright Agency, 2020.

Figure 9.2. *Lee Krasner and Jackson Pollock in their garden, Springs, East Hampton*, 1949. Photograph by Wilfrid Zogbaum. Courtesy Pollock-Krasner House and Study Center, East Hampton, NY.

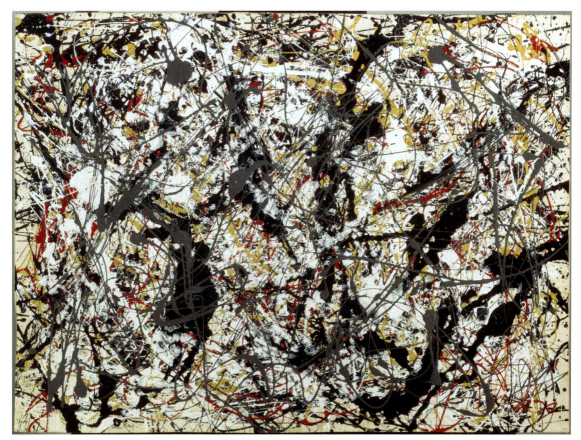

Figure 9.3. *Silver over Black, White, Yellow and Red,* Jackson Pollock, 1948. Centre Pompidou, Musée national d'art moderne, Paris
CNZC/MNAM/Dist, RMN-Grand Palais / Art Resource, NY. © Pollock-Krasner Foundation/ARS. Copyright Agency, 2020.

CHAPTER 9

Pollock/Krasner

COLLISION COURSE

We all have friends whom we cannot explain to our other friends—people who are unkind, self-centered, boorish, likely to lash out at any moment for any reason, or for no reason at all. And yet, they are our friends. Jackson Pollock would have been such a friend, and his wife and fellow abstract expressionist painter, Lee Krasner, would not have been far behind. Pollock is reported to have once stripped naked at a party given by his patron, and New York City socialite, Peggy Guggenheim, and urinated in her fireplace.[1] It put a strain on their relationship.

In addition to being a generally unpleasant person, Pollock was an alcoholic for almost all his life. The disease conquered him at age forty-four when he ran his Oldsmobile

convertible into the woods near his house, at high speed, drunk and angry at his two traveling companions, one of whom was his mistress. Pollock's drinking and depression took much of Lee Krasner's life as well, although in a very different fashion. She had sublimated her desires to become a great artist to promote his artistic vision and career, only reaching her real potential late in life, after his death.

But before the crash, before depression and alcoholism took final control of his life, Jackson Pollock changed the very nature of painting. It is easy to look at a da Vinci, a Reubens, or a Monet and see the beauty and wonder therein. A half century after his tragic death, it is still much more of a challenge with a Pollock. He would have liked that.

The Boy Who Couldn't Draw

Jackson Pollock loved to point out that he was born in Cody, Wyoming, thus distancing himself from the New York City crowd of artists with whom he hung out. Perhaps he saw being from the Plains states as a sign of authenticity. The fifth of five boys, he was born in 1912, and lived in Wyoming for all of ten months before the family began a series of moves around the western United States, rarely settling, and spending only for a few years above the poverty level.

Being the fifth of five in a poor family could not have been easy for Pollock, whose birth name was Paul Jackson Pollock and whose middle name apparently came from his mother's affinity for the town of Jackson, Wyoming. They called him Jack. Pollock's childhood was unhappy; he was isolated, lonely, a disaffected student who failed consistently in school. At age eleven, he suffered the loss of a third of his right index finger when a neighbor boy accidently cut it off with an axe.[2] When asked what he wanted to do with his life, he would claim that he was going to be an artist like his brother Charles, ten years older, and filled with artistic talent.

Unlike many famous artists, Pollock showed no particular inclination toward art as a child. Being one third deficient in the index finger of his dominant hand couldn't have helped. This would be the ideal spot in this chapter to present a precocious work from his teen years. There are none. His brother Sande once said that his early work would have suggested that "he should go into tennis, or plumbing."[3] His social skills were no better. A high school friend said that Pollock seemed "more at ease with a rock than a human being."[4] Nonetheless, at age sixteen he enrolled in Manual Arts High School in Los Angeles, grew his hair long, and briefly changed his first name to Hugo, after writer

Abstract Expressionism

Abstract Expressionism is a term that is applied primarily to a group of New York City artists in the 1940s. It is a combination of the Expressionism school, primarily German, that emphasized a desire for self-expression and emotional intensity in painting (think Edvard Munch's *The Scream*) with the desire to be non-objective in one's work. That is, to not paint from nature or even identifiable objects. Hence, an abstract and emotionally intense form of self-expression in art.

Victor Hugo. It didn't help. He still couldn't draw. In fact, in a letter to his idolized and talented brother Charles, he stated that his drawing wasn't "worth the postage to send it."[5] At least he was looking the part. He was well on his way to "being" an artist; it was just the "doing" part that was getting in his way.

Thomas Hart Benton and the WPA

Bull-headed, mean-spirited, wracked with self-doubt, and on the road to depression and alcoholism, Jackson Pollock moved to New York City to join his brothers in studying at the Art Students League with the great American Regionalist mural painter, Thomas Hart Benton.[6] It was 1930. The stock market crash of 1929 and the coming dust bowl droughts of the mid-1930s would send America, and the world, reeling into depression.

Benton is often considered the quintessential Works Progress Administration (WPA) muralist, which is ironic as he never worked for the program.[7] He was successful enough on commissions to not need to do so. However, he was America's premier mural painter, and his influence on Pollock is evident, if subtle. Figure 9.4 is one panel of a room-sized Benton mural called *America Today*. He was working on it when Pollock came to study with him. Part of Benton's legacy to Pollock was painting in large format; Pollock's work was often massive in scope. Another part was what Pollock would call the "all over" style of painting, where every corner of the work contains something of interest.[8] Here, Benton has depicted jazz, the stock market, Prohibition, the circus, labor relations, the cinema, and what appears to be a modern Jesus, Mary, and Joseph along the bottom edge. A lot to take in and all dramatically and colorfully depicted.

> **Regionalism**
>
> Regionalism, sometimes known as American Regionalism, was an art movement in the 1930s and 1940s focused on rural and small town American, depicted in a somewhat heroic fashion. Farm scenes, country fairs, people heading West to settle new land are all typical of American Regionalism, which was led by Thomas Hart Benton, Grant Wood, and John Steuart Curry.

The 1930s were a strange time for the advent of abstract art in America. In an era where bread lines and foreclosures occupied much of the public concern, few individuals were thinking, "*Now* would be a great time to invest in art that I don't like and fundamentally can't understand!" As it turns out, of course, it would have been, but hindsight has always been an exact science. Franklin D. Roosevelt and the WPA, an integral part of the New Deal, came to the rescue.[9] The artists' component of the WPA experienced a rocky start. Part of the problem was that, when it first became known that one could get paid simply for producing art, self-assessed artistic ability flourished. "Artist? Why, yes I am! Sign me up!" But the program was brought under control and provided income for Jackson, his brothers, and Lee Krasner for years. Pollock was tossed from the program on more than one occasion due to his inability to meet even the modest behavioral requirements laid down for employment (like showing up or making paintings). *Going West*, figure 9.5, is one of the works that Pollock produced during this time. Although very

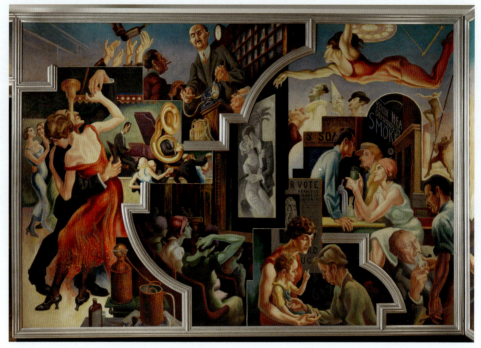

Figure 9.4. *America Today*, Thomas Hart Benton, 1930–1931. The Metropolitan Museum of Art, New York.
Image copyright: © The Metropolitan Museum of Art. Gift of AVA Equitable, 2012 (2012.478a-j) © The Metropolitan Museum of Art Image source: Art Resource, NY.

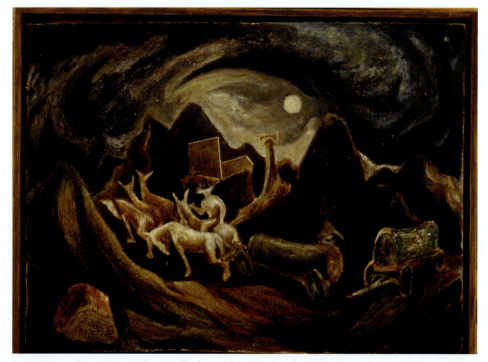

Figure 9.5. *Going West*, Jackson Pollock, 1934–1935. Smithsonion American Art Museum, Washington, DC.
Image copyright: © Smithsonian American Art Museum, Washington, DC/Art Resource, NY.
© Pollack-Krasner Foundation/ARS. Copyright Agency, 2020.

modest in size (roughly 15" × 21"), in this gloomy depiction of a brave soul heading west into a most uncertain future, the "all over" style is apparent, as is Pollock's affinity for depression and danger. (And incidentally, those are supposed to be donkeys.) In 1941, Pollock met Lee Krasner, and life changed.

Lee Krasner

Without Lee Krasner, there never would have been a Jackson Pollock. Pollock was like a set of spinning plates in a vaudeville act, and Lee Krasner was the performer running back and forth, keeping them, always at the last second, from crashing to the stage. But Lee Krasner is a conundrum. It is easy to see her as a conniving and duplicitous individual whose art was simply a series of imitations of the work of other artists, and who used Jackson Pollock to enhance her own position in life. But it is equally possible to see her as a fighter against the poverty she grew up in and the discrimination she faced as a woman, a Jew, and a person who was considered less than beautiful in a world where beauty was prized, and whose art deeply engaged in and commented on the work going on around her. *And* that her devotion to Jackson Pollock, staying with him through his immensely objectionable behavior, should make Krasner a candidate for canonization instead of condemnation (well, that and not being Catholic). To a degree, all these perspectives are true. Figure 9.2 at the opening of the chapter depicts Krasner and Pollock in 1949. He was in the middle of his longest period of sobriety and most productive era of his career. It shows.

Krasner was born Leonore Krassner in New York City in 1908 to Jewish immigrants from Ukraine. She later went by Lee and dropped one of the s's in her last name. Like Pollock, she idolized her older brother and had a difficult relationship with her father. Her early training in art was fraught with sexism; she was, throughout her career, told that she painted well "for a woman." She trained with a variety of abstract expressionist and surrealist artists, and their influence can be seen throughout her early work. In going through her catalogue raisonné, the reader sees one work that is surrealist, one cubist, and the next one a blend of Mondrian and Kandinsky.

In the mid-1930s, she took up with a Russian painter named Igor Pantuhoff. He was an alcoholic and abusive of her. She idolized him. Nothing he could do was wrong. Her friends could not understand the relationship. One day, he simply up and left her. No notice, no note, no forwarding address. In 1943, four years after her parting with Pantuhoff, she painted *Igor* (figure 9.6). *Igor* is particularly interesting in that in some major reference works on Krasner, it is presented upside down from what is presented in figure 9.6. But the orientation here is the one that appears in the Pollock-Krasner House and Study Center website. Furthermore, if presented upside down from this, it simply looks like some shapes. Here it looks like a blue chicken, which seems appropriate.

> **Catalogue Raisonné**
>
> A compendium of all the work of an artist combined with scholarly commentary on the works.

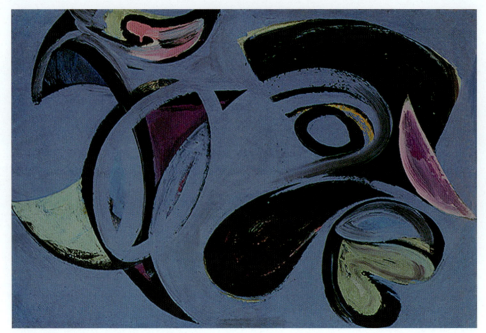

Figure 9.6. *Igor,* Lee Krasner, 1943. Private Collection.
© Lee Krasner/ARS. Copyright Agency, 2020.

In 1941, Krasner met Pollock when they were presenting in the same show. Just how their relationship came to be depends on which story one listens to. Krasner claims she fell in love with the art and then the man. Others say that she pursued him after hearing that he was the best painter of the generation. After living in New York City, they moved out to Long Island, to a hamlet called Springs in the town of East Hampton in 1945. Springs was not too far from New York City, and not too expensive. De Kooning also worked nearby, and later writers Kurt Vonnegut, John Steinbeck, and Joseph Heller were residents.[10] Pollock became popular with the local farmers and grocers, but Krasner never fit it. The local police became accustomed to Pollock appearing hungover somewhere in town. But Krasner's aspirations rose higher than the locals of Springs, New York, and all her efforts were focused on the development and promotion of Pollock's career. She once said, "I stepped on everybody's toes—right up and down the line, because they deserved it. And even then, I could have been a lot bitchier."[11]

Volatility was the hallmark of the Pollock/Krasner partnership. When he was drinking, which was nearly all the time, Pollock was a nasty drunk. Krasner would claim in interviews well after Pollock's death that he was never a violent drunk, but there are too many stories of his brawling and being abusive of her to fully take her word for it. Protecting and promoting Pollock while he was alive, and burnishing his image after his passing, were paramount to Krasner. It seems to have been part of her personality as she had done the same thing for Pantuhoff during their relationship. She also idolized de Kooning until he rejected her.[12] She then became vehemently opposed to any aspect of him and his art. Pollock saw de Kooning more as a competitor but also

as a colleague. He once told de Kooning, "You know more, but I feel more."[13] Apparently, Jackson felt that was a real shot at de Kooning.

When Hans Hoffman, an accomplished painter and Krasner's teacher, once asked Pollock if he worked from nature, Pollock responded, "I *am* nature."[14] At least that is the story according to Lee Krasner. Another local abstract expressionist, Peter Busa (who was there during the exchange), recalls Pollock replying, "I work from myself."[15] That seems a more reasonable, but less dramatic response. Krasner never let an opportunity for a good embellishment of the myth pass unrealized.

Krasner has become much more recognized in recent years for her own efforts as an artist. She has, to a degree, finally come out from under Pollock's shadow. *Imperative* (figure 9.7), painted twenty years after Pollock's death is indicative of the change and development of her oeuvre. It has strong movement and energy, with the white cut outs indicating a sense of urgency among the people and activities in the piece. One of

Figure 9.7. *Imperative*, Lee Krasner, 1976. National Gallery of Art, Washington, DC.
© Lee Krasner/ARS. Copyright Agency, 2020.

the fascinating aspects of her work, and one that is appreciated more than denigrated in recent scholarship, is that she continually changed her style and approach. *Imperative* is one of many collages she did later in life, frequently repurposing bits of old paintings and occasionally cutting up one of Pollock's old works to include in her collages. Although this work is monochromatic, much of her work that followed Pollock's death was highly colorful and very bold.

Back to Jackson: Peggy and Piet

The World War II years were actually very good to Jackson Pollock. He got a sought-after deferment from the draft for having been admitted to a psychiatric hospital for his severe depression; he got a job at the Museum of Non-Objective Art, which gave him a salary and free art supplies; he met Lee Krasner and he also met Peggy Guggenheim, who would become his first serious patron. She ran a gallery called "Art of This Century" and included a work by Pollock in a show she had organized there. The painting Pollock chose to contribute to the exhibition was, at the time, called *Painting* (so as not to confuse it with . . . ?), but later became *Stenographic Figure* (figure 9.8).

Peggy Guggenheim was the daughter of a wealthy copper magnate and the niece of Solomon R. Guggenheim, who turned the Museum of Non-objective Art into the Solomon R. Guggenheim Museum of New York City, with its famed circular Frank Lloyd Wright home building. Prior to the opening of the show, Guggenheim ridiculed Pollock's work to none other than Piet Mondrian, whose status in the art world at the time was close to legendary (he would die of pneumonia within a year). She commented, "Pretty awful, isn't it? . . . This young man has serious problems . . . and painting is one of them. I don't think he is going to be included."[16] Mondrian offered a gentle rebuke, "Peggy . . . I don't know. I have a feeling that this may be the most exciting painting that I have seen in a long, long time, here or in Europe."[17] That brief comment changed the course of Pollock's life (and Krasner's as well). Writing to his brother, Pollock said, "Things really broke with the showing of that painting."[18]

> ### Non-objective Art
>
> Non-objective art is fundamentally abstract in form and does not intend to represent objects found in the real world. Pollock's drip paintings are quintessentially non-objective as there is no intent to depict anything other than what is seen in the painting. Pollock once said, "If you want to see a face, go look at a face."

Mondrian's word was good enough for Guggenheim, who immediately turned 180 degrees on the painting and on Pollock. She arranged to meet Pollock at his home and studio to offer him a one-man show at her gallery. When appointment time arrived, Pollock was drunk and passed out at a friend's wedding.[19] Lee rallied him and they caught Guggenheim as she was leaving their apartment in a huff. They talked her into going back in. The living room was filled with work by Lee. Guggenheim went ballistic, screaming about not wanting to see the work of whoever Lee Krasner was. She and Krasner never really hit it off after that, but Guggenheim stayed long enough to see Pollock's work and was smitten with Pollock. She gave him a fixed contract of employment to work exclusively for her, including doing a huge mural for her apartment in New York.

Figure 9.8. *Stenographic Figure*, Jackson Pollock, 1942. Museum of Modern Art, New York.
New York Museum of Modern Art (MoMA). Mr. and Mrs. Walter Bareiss Fund. 428.1980 © 2020. Digital image, The Museum of Modern Art, New York/Scala, Florence.
© Pollock-Krasner Foundation/ARS. Copyright Agency, 2020.

Much has been written about *Stenographic Figure* (figure 9.8). It has been likened to Matisse and Picasso.[20] It stands about three feet four inches high and four feet eight inches wide. As Pollock often let others suggest titles for his works, *Stenographic Figure* might have been a word play on "figure" suggesting both the person on the left and the markings of a stenographer, which can be seen all over the painting. Some have suggested that there are two figures here, a woman on the left and a man on the right (with a small, weasel-like head, smiling). That seems right to me. I would go a bit further on this. The woman has a head, which is outlined in the letter L. Her nose is prominent and a kind of fish-like structure. And her hair is clipped short, with a suggestion of bangs. I think it is Lee Krasner. They had just met the year before, and I think this is a portrait of the happy couple, with Pollock on the right. Their arms are connected with a U-shaped black line, and the man is smiling. Furthermore, and this will stretch credulity, but is fun nonetheless, I think this might be a take on Grant Wood's *American Gothic* (figure 9.9). Wood painted *American Gothic* in 1930, and it immediately became very popular, appearing in many publications. There is no doubt Pollock could have seen it and read about it. In fact, Wood was closely associated with Pollock's old mentor, Thomas Hart Benton.

Of course, the dissimilarities between the two works are manifold, but note that the man in each painting is tall and thin (exaggerated by Pollock), and has eyes that are somewhat buggy (accentuated by the glasses in *American Gothic*). They both look straight ahead. The woman looks off to the right in each painting. And finally, there is a large red W right in the center of Pollock's work, just as there is one (the pitchfork) in *American*

Gothic. Could it be? Who knows, but the speculation is entertaining.

One more item before leaving this work. There are squiggles all over the top of this work. Some are numbers, some are letters, and some look like stenographic figures. But all of them tend to obscure, to a degree, what we see beneath. This painting shows the root of two ideas that Pollock employed throughout his career. One is again his "all over" approach to painting, where every part of the work has something of interest. The man's head, for example, is in the farthest top right part of the painting possible. The second is what Pollock called "veiling the image." He often painted images or figures in his work, and then obscured, or "veiled" them with squiggly lines—later to become the pours and drips of his most famous works (see figure 9.3 and figure 9.10).

Guggenheim was to become Pollock's staunch and influential advocate

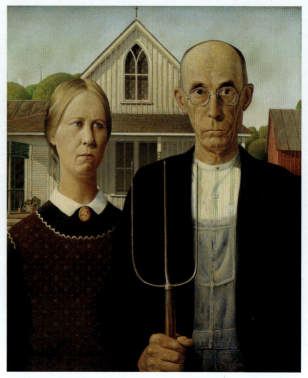

Figure 9.9. *American Gothic*, Grant Wood, 1930. Art Institute of Chicago.

© Figge Art Museum, successors to the estate of Nan Wood Graham/ARS. Copyright Agency, 2020.

for years, until she left New York to move to Paris, basically "turning him over" to his next patron, Betty Parsons. As much as they both adored Pollock and tolerated his outrageous behavior (Guggenheim once called him a trapped animal who never should have left Wyoming),[21] the two women could not stand one another. As to the incident where Pollock stripped naked and urinated into Peggy Guggenheim's fireplace during a party, there are some who say he wasn't naked.

Sobriety and the Drip Paintings

After having tried any number of therapies to conquer alcoholism, Pollock started seeing a local general practitioner, Edwin Heller, with whom he felt comfortable and who helped him get straight. At the same time, Pollock truly found himself artistically. He began work on what was to become known as the "drip paintings." These received strong (and usually positive) critical responses, leading to a major article about the artist in what was then the premier American weekly magazine, *Life*, which asked the rhetorical question of Pollock, "Is this America's greatest living painter?" Of course, the irony of asking such a question next to a photograph of a canvas filled to the brim with squiggly lines, and no subject matter, was not lost on the editors of *Life*. Pollock was sober, successful, and famous. He was producing drip paintings prodigiously; they were selling, and his star never shone brighter.

Figure 9.10. *No. 1A*, Jackson Pollock, 1948. Museum of Modern Art, New York.
Digital image, The Museum of Modern Art, New York/Scala, Florence.
© Pollock-Krasner Foundation/ARS. Copyright Agency, 2020.

Figure 9.10, *No. 1A*, is typical of this period of Pollock's life. It is boldly painted, with layers of paint flung across the canvas, evoking a sense of energy while at the same time forming intricate patterns that are almost lacelike in their delicacy. In the upper right of the painting are a series of handprints. Note that when the right hand is presented, the index finger is of full length, which must have been an adjustment made by Pollock.

Drinking, Ruth Kligman, and the Accident

It couldn't last. In 1950, he was working with a photographer who had been documenting his painting style for months. After the photographer recorded a movie of his "action painting" style in his studio in Springs, Pollock and the photographer returned to his house where a dinner party was getting started. He poured himself a large glass of bourbon, downed it, and then another. He then sat down at the head of the dinner table, made some nasty comments to the photographer, and hoisted his end of the table into the air, breaking dishes and flinging a roast beef onto the floor. Lee Krasner responded to this tantrum with, "Coffee will be served in the living room."[22] He was off the wagon. Forever, but not for good.

Life then simply spun out of control for Pollock. His productivity dropped off dramatically, eventually completely coming to a stop. He drank constantly, and his behavior reflected his drinking. Relations between Pollock and Krasner deteriorated as well. They had moved back into New York City, and Pollock would drink every day, typically ending up in an artists' hangout called the Cedar Street Tavern where he would grope and proposition

> ### Action Painting
>
> A term coined by art critic Harold Rosenberg in 1952, action painting refers to works of art where one can argue that the painting itself is a trace of the activity that went into its creation. The act or acts of making the painting are the artistic event, and the painting itself a reflection of that event.

women, get in fights with men, and be abusive to everyone. As his fame grew, his life diminished. He often talked about life not being worth it. There were brief respites from the decline, but always followed by a relapse.

A 1953 painting called *The Deep* (figure 9.11) seems to presage the fog that Pollock gradually found himself in. Various interpretations of this work have been presented. I see a man all in black, with his right hand in his pocket (which was standard for Pollock in photos), leaning forward and looking down at the ground. His left hand is in front of him near his waist, maybe holding a cigarette. To me, it is a self-portrait. The artist is enveloped by a white and yellow fog or cloud that appears to be grasping him (note what would be his shoulders and right arm), and about to swallow him whole. *He* is the image that is being veiled in this work, and it appears as if he fears that he is about to disappear.

In 1956, amid his most severe problems with drinking, he met Ruth Kligman, beautiful and nineteen years his junior, at the Cedar. They immediately began an affair. Pollock delighted in the alliance, showing Kligman off to anyone who would pay attention. He once said of her that she was a "late model cream puff . . . barely broken in and loaded with extras."²³

At first, Krasner ignored the infidelity, but when Kligman moved to Sag Harbor to be closer to Pollock, things got tense. Finally, Krasner told Pollock that she was going to Europe by herself and that when she returned, "that the girl had better be gone."²⁴ She left for Europe in July of 1956, but her heart remained with Pollock, and she sent him postcards and letters almost every day. Less than a month later, highly inebriated, Pollock crashed his Oldsmobile convertible into the woods near his house, killing himself and a friend of Kligman's who had just come out to visit for the day. Kligman was badly injured but survived and recovered fully. Lee Krasner, and the world of art—worldwide—were in shock. She had not been there to keep the plates spinning, and they came crashing down.

Ironically, the person who informed Pollock's old mentor, Thomas Hart Benton, of his death was Pollock's rival, Willem de Kooning. They were both summering in Chilmark, Massachusetts (near Martha's Vineyard), at the time. Benton did not attend the funeral, feeling that he could not take the pain. There was no eulogy at the funeral, and Krasner sat alone, refusing to sit with Pol-

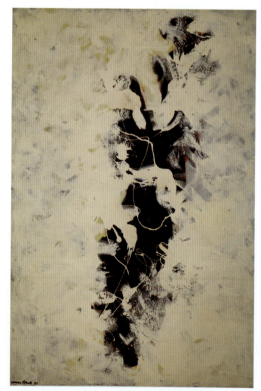

Figure 9.11. *The Deep*, Jackson Pollock, 1953. Centre Pompidou, Paris.
© Pollock-Krasner Foundation/ARS. Copyright Agency, 2020.

lock's family. De Kooning was also in attendance, later saying of the event, "I saw him in his grave, and he's dead, it's over—I'm number 1."[25] He then started dating Ruth Kligman.

Lee Carries On

There is a coda to the Jackson Pollock biography, and it is Lee Krasner's life after his death. She not only continued to paint, but she did so with a productivity and brilliance she never had while married to Pollock. And even though she did cut up some of his old works to include in her collages, she didn't abandon Pollock. She continued to promote an image of Pollock that often did not align with the facts as others saw them. But she was now free to pursue her own art with a vigor and freedom that did not exist for her before. *Right Bird Left* (figure 9.12) and *Imperative* (figure 9.7) are examples of Krasner's post-Pollock work. In essence, Krasner found herself as an artist after Pollock's death. She put it best: "I happened to be Mrs. Jackson Pollock and that's a mouthful. I was a woman, Jewish, a widow, a damn good painter, thank you, and a little too independent."[26]

Jackson Pollock's Influence on Art

Pollock's influence on modern art was immense. It took someone who didn't care about societal norms, proper behavior, standards for paintings—and maybe someone who couldn't draw—to change how we look at art. His work required not only daring, but courage. He knew he would not be well-received by much of the public. He knew he would be misunderstood, ridiculed, even mocked. It wasn't that he didn't care. He cared deeply, often weeping uncontrollably over a slight or a negative review, and often lashing out brutishly against those from whom he perceived slights. He understood the consequences of his approach, and he did it anyway. He simply had to. He knew no other way. De Kooning aptly summarized Pollock's influence on the art of his time. Pollock, he said, "broke the ice for all of us."[27]

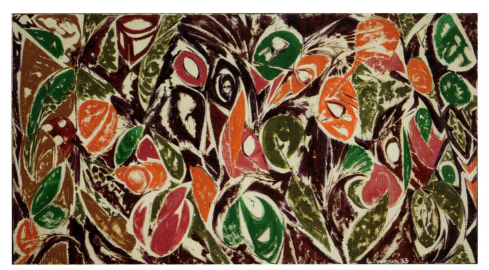

Figure 9.12. *Right Bird Left*, Lee Krasner, 1965. David Owsley Museum of Art, Muncie.
David Owsley Museum of Art, Muncie, Indiana; Gift of David T. Owsley 2006.020.001.
© Lee Krasner/ARS. Copyright Agency, 2020.

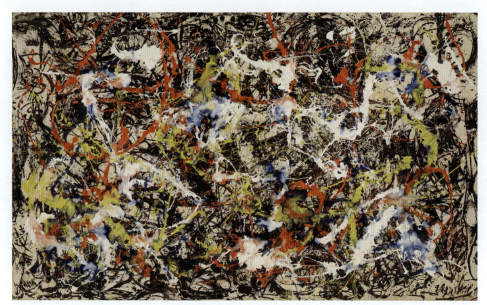

Figure 9.13. *Convergence*, Jackson Pollock, 1952. Albright–Knox Art Gallery, Buffalo.
Photo Credit: Albright-Knox Art Gallery/Art Resource, NY.
© Pollock-Krasner Foundation/ARS. Copyright Agency, 2020.

Convergence is a large, mural-type painting done by Jackson Pollock in 1952. It began as one of his "black paintings" that used black paint on untreated canvas, but he wasn't happy with the result, and added layers of color to it. It was displayed at the Janis Gallery in New York City along with eleven other works, and received wide critical acclaim. It did not sell, however. Only one of the paintings in the exhibition sold, and Pollock was terribly disappointed.

Pollock often walked around the edges of a massive work like Convergence, *allowing him to throw, drip, dribble, and pour paint from all sides of the work. Occasionally, objects from his workshop ended up in his works; there is apparently a match in the center of* Convergence.

Convergence is a controversial work, even for Pollock. It has been argued that it is a bold expression of freedom of speech, standing in stark contrast to the oppression of the Soviet Union. Critics of the time were divided in their opinion of the work, as they are today, but many consider it one of his finest pieces.

A Closer Look: *Convergence*

Once again, please have a long look at figure 9.13, *Convergence*. It may be helpful to find the image online and get a larger view of it than is presented here. It is roughly eight feet high and thirteen feet wide in real life.

Welcome back. *Convergence* may be a bit of a difficult task to take in if one is not an afficionado of Pollock's work. I have to admit that I was not for many years, until one day I was looking at one of his works at the Guggenheim Museum, and thought, "I do *not* get this work. I *never* get Pollock. Well, I really do like the colors and the patterns, and how it is so full of energy, and it looks like there are things going on that I can't even

see because they are covered up. That's all pretty cool and it is engaging to look at." And then it dawned on me that I was enjoying this work, appreciating it, liking it even, just not in ways I typically expected to enjoy a work of art.

My recommendation is to not worry about *getting* anything about this work. Don't try to figure it out. As Pollock once said, you "should not look *for*, but look passively—and try to receive what the painting has to offer."[28] He argued that he is expressing feelings, rather than objects. Also, with Pollock's "all over" approach, there is something going on in every nook and cranny of the painting. This may have been unintentional, but with the black paint in the background, and the white and blue almost floating on top of the other colors, there is a fascinating three-dimensionality to this work. Just focus on the white and you can see how it stands above the rest of the work, the blue with it. Pollock and the other abstract expressionists are noted for flattening the work of art, bringing everything to the same plane, not one on top of another. But, to me, that is not what is going on here. I see depth, and enjoy that depth. The other thing that strikes me in a very pleasant fashion is the color scheme. I enjoy the juxtaposition of the colors and how vibrant they are.

If you look back at figure 9.3 in the introduction to the chapter, many of these same elements exist, except that in figure 9.3, it is the black that seems to float on top, and other than black and white on the unprimed canvas, there are only hints of other colors appearing. Although similar from an initial, surface perspective, if you go back and forth between the two, they are very different from one another. Both are striking, and I hope you will find, enjoyable to view. I might point out that there are critics who very much like figure 9.3 at the beginning of the chapter and who feel that figure 9.13 here is a near total failure. Such critics possess a sense of perceptual sublety, or perhaps personal grandiosity, that I have yet to achieve.

An interesting aspect of this work, and others by Pollock, is that they were positively received by conservative organizations and outlets. Apparently, those groups liked the stark contrast that this "wild West cowboy" of a painter presented in contrast to the stodgy propanganda work extolling the proletariat favored in the Soviet Union.

One more aspect to consider. This painting is huge. Pollock would get depressed when his works wouldn't sell, but who has over 100 square feet of free wall space?

If there is something I might leave you with here, it is to try to be open to new kinds of work, whether they are abstract, Baroque, Realist, or what my son refers to as "Bad Days in the Lives of the Saints." Sometimes an artist needs a second chance, or a third or fourth one. And sometimes, it's fine to say, "Ah yes. Now that I have reconsidered this, I still don't like it." But do give it a longer look.

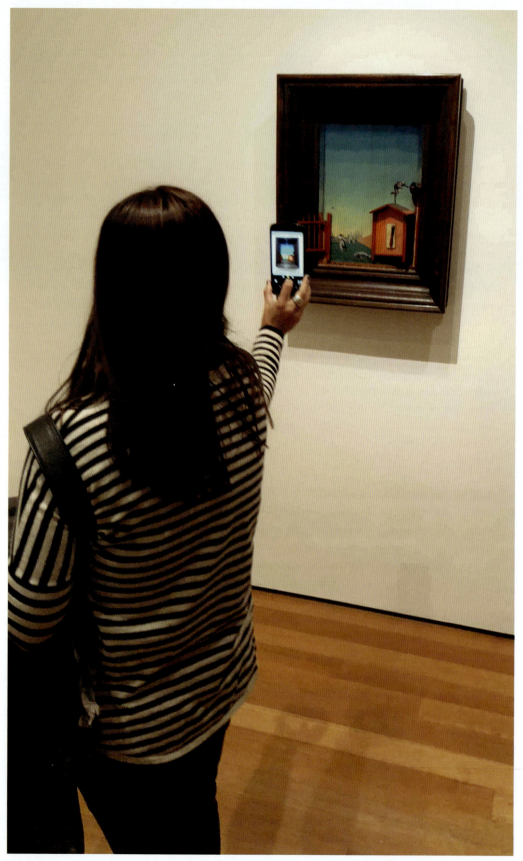

Figure 10.1. Visitor to Museum of Modern Art, New York City, 2019, Photograph by Jeffrey K. Smith.

Figure 10.2. *The Shoe Shop*, Elizabeth Sparhawk-Jones, 1911. The Art Institute of Chicago. Permission for use granted by the Elizabeth Sparhawk Jones estate.

CHAPTER 10

Conclusion

FINDING YOUR OWN SCOUNDREL

In the early 1900s, Elizabeth Sparhawk-Jones was a phenomenon in the world of American art, and justifiably so. Figure 10.2, *The Shoe Shop*, exemplifies the vibrant brushwork, engaging composition, and sense of openness and lightness that led her to winning awards and rave reviews in major newspapers and art journals. Her work was a chronicle and commentary on the lives of women, particularly young women, at the turn of the century in America. She was a rising star, her work reminiscent of Manet, Cassatt, Degas, and Tissot.

Figure 10.3. *The Dreamer*, Elizabeth Sparhawk-Jones, c. 1942. Delaware Art Museum, Wilmington. Watercolor on linen attached to board, 24½ × 28½ in. (62.2 × 72.4 cm). Bequest of John L. Sexton, 1955 © Elizabeth Sparhawk Jones Estate

And then it all turned to custard. Her emotional stability faltered, and in 1913, she had herself committed to a mental institution where she would spend three years, and then an additional twelve years in recovery, abandoning her painting. But she made a comeback, returning to work as a remarkably reinvented artist. Her work was still striking, but it is clear from figure 10.3, that it had changed dramatically.

What happened to this artist? What demons were there in her life? I happened upon the painting in figure 10.2 while visiting the Art Institute of Chicago. I had never seen the work before nor heard of the artist, but the bright and airy shoe shop, with saleswomen in crisp shirtwaists and Gibson-girl hairdos, and shoppers with elaborate hats getting new shoes was captivating. The painting is rapidly and confidently done, filled with lace, frills, and sunshine. I needed to know more. And in exploring her life, I came across *The Dreamer*, equally confident in execution, but filled with evil spirits, flying monsters, and skeletons. Could this really be the same artist? Is she the woman on the rock in *The Dreamer*? Are these her demons? As mentioned, she was once a prodigy, and then a tragedy, and finally she reincarnated into a new and distinctive artist. Her life and work have been, just within the past decade or so, discovered again, and happily so.[1]

Discovering Art and Artists: Nurturing an Open and Receptive Mind

This is the magic of art. Around any corner of an art museum might lie a work of art that is breathtaking. It might be the colors, the composition, the personal or political statement underlying the work, or an enigmatic smile on the face of a woman from five centuries ago. Art allows us to stand directly in the presence of genius, in the same relation to a work of art as the artist who made it. In figure 10.1 at the opening of the chapter, we see a visitor to the Museum of Modern Art in New York City who is captivated enough by a Max Ernst painting to capture it on her cell phone. Ernst would have contemplated whether the work was completed from roughly the same perspective.

The personal discovery of an artist might be someone whose work is well-known and universally revered, or someone obscure and unknown, and that artist's life might be scandalous, immoral, or outrageous, or it might be one of modesty, kindness, and generosity. Viewing art is a process of exploration: of museums, of websites with art reproductions, or of galleries and exhibitions with works of art for sale, but it is also a personal exploration. When you explore art, you also explore yourself. What is it that you react to? What holds your attention, causes you to want to look longer and learn about the art you are viewing, and the artist who made it? How does the work make you feel and what does it make you think?

In over thirty years of museum researching, my wife and I have come to some general recommendations about viewing art. The first is to have a healthy level of trust in people who put together exhibitions for a living. Even when an initial trip through an exhibition is less than enthralling, it can be useful to give the works a second chance. Try to be open to what is new and different to you. The second recommendation concerns learning about art and appreciating it at the same time. Making sense of art is a highly cognitive endeavor, and it can get in the way of letting yourself go and appreciating what you are encountering. But both sense-making and appreciating are worthwhile. One does not take precedence over the other, but they are hard to do simultaneously, and it is important not to get frustrated when trying to do so. The third recommendation is to take your time. Our research shows that even masterpieces get less than a thirty second look from a typical visitor, and rarely does anyone in a museum spend as much as five minutes looking at a work. But there are things to see in that third or fourth, or tenth minute that aren't apparent to the eye on a thirty-second viewing. So for at least a couple of works in a museum visit, spend some extra time. The fourth recommendation is that your appreciation will grow with your knowledge about a work and the artist who made it, but you can thoroughly enjoy a work of art the first time you see it. In fact, there is something special about first-time viewing.

Creativity and Art Viewing

Viewing art is essentially a creative process.[2] What you see depends not only on what appears before you, but also on what you choose to see and how you choose to see it. At

first, you can simply take a work in. Let it wash over you and see how you are reacting to it. If you think it has something to offer, something that has captured your attention, you can go into a second sense of viewing. This is where you become a more active viewer, spending more time on the work. In doing so, you invent a meaning that is yours alone, that you can savor, or share if you are viewing with someone else. And a great work of art will invite you back time and again, allowing you to discover something new about the work, or about yourself, each time you visit.

Figure 10.4, *Paris Street; Rainy Day*, is a stunning painting by French Impressionist Gustave Caillebotte. It is a very large work, seven feet high and nine feet wide. When first seen, it is truly impressive and attractive. It puts you into a cold, wet Parisian day of the nineteenth century. But then where do you go from there? Does this work strike a chord for you? Are you scanning it to see what all Caillebotte has included? For me, I am intrigued by the idea that the travelers on this street seem to be almost "dotted in" in various places. They don't seem "in" the scene as much as "on" it. And they all seem to have purchased their umbrellas from the same store. As many times as I look at this work, I am always drawn to the water on the paving stones. I love looking at the reflection of water in streets, and in my estimation, Caillebotte has captured that brilliantly. I want to see that place on a rainy day. I want to visit the shops, have a coffee to warm up, and maybe splash in a puddle.

And Caillebotte? Fascinating gentleman. This isn't his only brilliant work. Independently wealthy, he didn't have to sell his works, and in his thirties, he began to focus

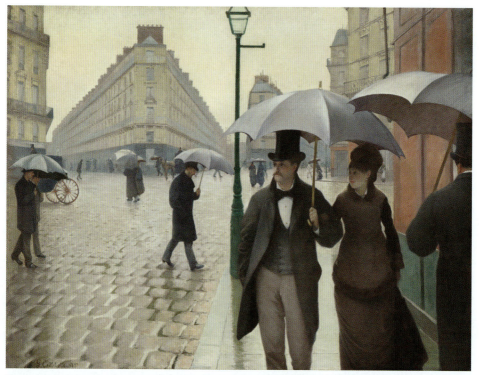

Figure 10.4. *Paris Street; Rainy Day*, Gustave Caillebotte, 1877. The Art Institute of Chicago.

more on gardening and building racing yachts. He also supported other Impressionists by buying their works and organizing exhibitions for them. He was very much interested in photography, and I wonder if he painted this in part, from a photo. Note that there are two people in the distance behind the main gentleman's umbrella stem. That looks to me like a result of a happenstance from a photo. Dying of a heart condition at forty-five, Caillebotte was only twenty-nine when he painted *Paris Street; Rainy Day*.

Scoundrels, Cads, and the Art That They Create

The lives of nine artists are presented in this book (counting Jackson Pollock and Lee Krasner separately), and for all but Artemisia Gentileschi, it is reasonable to describe them as scoundrels and cads. So, at the end of the day and at the end of the book, what are we to make of these people? How should we consider their art? Do we enjoy it, find deep personal meaning in it, or reject it because of the nature of the lives of the people who made it? This is currently a very hot topic in the popular press, but it is not a simple one upon which to make a judgment.

To start, there is no excusing bad behavior. To be sure, most of our scoundrels lived in unsettled, turbulent times, and most of them lost their fathers (or their fathers left their lives) when they were young. But that doesn't justify philandering, brawling, bigotry, or murder. Nor can we excuse their behavior by saying, "Well, they are artists, so we have to treat them differently."

Where does that leave us? Because I am a psychologist and not a philosopher, I tend to focus on questions of what people *actually* do as opposed to what they *ought* to do. So let me address the "actually" question first. I think for the most part, that people looking at art do not know what offenses the artist made in his life, or if they have a general sense of them, they do not enter into their viewing. This seems to be true with regard to famous people in all walks of life. We don't think of Henry Ford's political views when we turn on the ignition of our cars or Thomas Edison's business practices when we turn on a lightbulb. Charles Lindbergh, Woodrow Wilson, Richard Wagner, Charles Dickens, Ernest Hemingway—all had dark sides. I think that when we consider their contributions to society, we do so independently of personal failings. We can truly enjoy light in the darkness and still think Edison the man was not so great. Dickens inspires us today to fight for social justice even if he was a terrible husband. We separate the good from the bad.

So that is what I think we actually do, but should we? The *ought* question is much tougher. To begin, I would separate living artists (and scientists, politicians, etc.) from those of the past. Living artists are profiting from their popularity, and if their behavior offends you, by all means, reject them. But here is what I think about artists from earlier times. Simply put, "Take the good. There is nothing to be done about the bad." The key here is that these people are dead. They wouldn't have cared about your censure when they were alive, and they certainly don't now. This work of art is no longer theirs; they are gone. It is now ours. If you wish to focus on the bad deeds of people, their objectionable opinions and attitudes, and blend that into your viewing mix, it is

your choice. If you believe that their lives disqualify them from your viewing, by all means, go on to the next artist.

I always take what I know into account when viewing. For example, when I look at Caravaggio's *The Beheading of Saint John the Baptist* (figure 2.2), I always put it in context. I know that what Caravaggio has done here is to put his murder in our face, in the guise of a religious scene. I know that this painting is an altarpiece in a religious chapel today. I know that he did more than half a dozen other paintings of John the Baptist, some of them erotic in nature. That is the context for viewing for me, and there is no escaping it. But, and this is my point, there is no need to escape it. This is a murderer depicting a murder, symbolically, the one he committed. The mix of his personal malevolence with his artistic magnificence sets my head spinning.

A Final Artist

There are so many great artists to discover; here is one more with a fascinating life story. Rosa Bonheur was a nineteenth-century French painter and sculptor of animals. Her father was a painter, and her three siblings all became painters or sculptors of animals. Since she had done poorly in school and failed at an initial attempt to become a seamstress, her father decided to try to train her to become an artist. I can imagine her father thinking, "She can't sew; maybe she can paint." And she could. At age twenty-seven, she painted the dazzling *Ploughing in the Nivernais* (figure 10.5); such a bright and airy day, such massive oxen! In her personal life, Bonheur was as open a lesbian as one could safely be in the France of her time. Her fierce independence and uncompromising nature broke ground for female artists who followed her. She had great success as a painter during her lifetime, but recent scholarship has been less kind to her, arguing that her work did not develop, becoming repetitive and mundane.[3] But that does not mean that we cannot revel

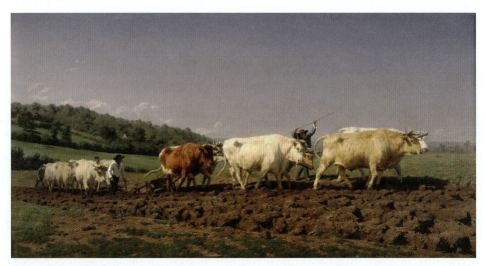

Figure 10.5. *Ploughing in the Nivernais,* Rosa Bonheur, 1849. Musée d'Orsay, Paris.

in *Ploughing in the Nivernais*. Note that there are men in this painting, but they are trivial. Bonheur had little use for men in general. "The fact is, in the way of males, I like only the bulls I paint."[4] (I'll bet it sounds even more derogatory in French.)

The Coda

Part of what I wanted to accomplish with this book was to introduce readers to a rogues' gallery of artists past. I hope that you have been inspired to look more deeply into the lives of these fascinating people, to see what else they have painted, and to seek out their work in museums. But even more than that, I hope that you will search for your own set of artful dodgers (and nondodgers), whose work is moving, beautiful, spectacular, thought-provoking, startling, or endearing. We can each take a lifetime to discover the art that illuminates and enlightens our lives.

Notes

CHAPTER 1. INTRODUCTION: THE ROGUES' GALLERY

1. Georgio Vasari, *The Lives of the Artists*. Oxford: Oxford University Press, 1998.
2. Charles Dempsey, *The Portrayal of Love. Botticelli's* Primavera *and Humanist Culture at the Time of Lorenzo the Magnificent* (Princeton, NJ: Princeton University Press, 1992); Philip McNair, "The Bed of Venus: Key to Poliziano's Stanze," *Italian Studies* 25, no. 1 (1970); 40–48, https://doi.org/10.1179/its.1970.25.1.40
3. Alyssa Palombo, "An Ode to Florence: The Church of the Ognissanti," in *The Spellbook of Katrina Van Tassel*. https://alyssapalombo.com/2017/06/08/an-ode-to-florence-the-church-of-the-ognissanti/
4. F. Scott Fitzgerald, "The Rich Boy," in *The Short Stories of F. Scott Fitzgerald*, ed. Matthew J. Bruccoli (New York: Scribner's, 1989): 335.
5. "El Greco Quotes." El Greco: Paintings, Biography, and Quotes, accessed October 7, 2019, https://www.elgreco.net/el-greco-quotes.jsp
6. Emma Garmen, "Beauty Marks," *The Paris Review*, September 1, 2016, https://www.theparisreview.org/blog/2016/09/01/beauty-marks/
7. "Musa Mayer and Anders Bergstrom on Philip Guston," Hauser & Wirth, accessed October 9, 2019, https://www.hauserwirth.com/stories/24740-conversation-musa-mayer-anders-bergstrom
8. Jeffrey K. Smith, Lisa F. Smith, and Pablo Tinio, "Rogues Gallery: Why We Like Art from Bad People" (Paper presented at annual meeting of American Psychological Association, Chicago, IL, 2019).
9. Smith, Smith, and Tinio, "Rogues Gallery."

CHAPTER 2. CARAVAGGIO: A LIFE IN CHIAROSCURO

1. Andrew Graham-Dixon, *Caravaggio: A Life Sacred and Profane* (New York: Norton, 2010).
2. Patrick Hunt, *Caravaggio* (London: Haus Publishing Limited, 2004).
3. Roderick C. Morris, "Caravaggio's Revolution in Light and Dark," *The New York Times*, November 9, 2016, https://www.nytimes.com/2016/11/09/arts/design/caravaggios-revolution-in-light-and-dark.html

4. Paul J. Locher, "Empirical Investigation of an Aesthetic Experience with Art," in *Aesthetic Science: Connecting Minds, Brains, and Experience*, ed. Arthur P. Shimamura and Stephanie E. Palmer, 163–88 (New York: Oxford University Press, 2012); Jeffrey K. Smith. *The Museum Effect: How Museums, Libraries, and Cultural Institutions Educate and Civilize Society* (New York: Rowman & Littlefield, 2014).

5. Tom Lubbock, "Caravaggio: Cardsharps (1595)," *Independent*, September 26, 2008, https://www.independent.co.uk/arts-entertainment/art/great-works/caravaggio-cardsharps-1595-942660.html

6. David Willey, "Caravaggio's Crimes Exposed in Rome's Police Files," *BBC News*, February 18, 2011, https://www.bbc.com/news/world-europe-12497978

7. Helen Langdon, *Caravaggio: A Life* (New York: Farrar, Straus and Giroux, 2012).

8. Graham-Dixon, *Caravaggio*.

CHAPTER 3. COURBET: THE MOST ARROGANT MAN IN THE WORLD

1. James H. Rubin, *Courbet* (London: Phaidon Press, Inc., 2013).

2. Petra ten-Doesschate Chu, *The Most Arrogant Man in France: Gustave Courbet and the Nineteenth-Century Media Culture* (Princeton, NJ: Princeton University Press, 2007), 106.

3. Ross King, *The Judgment of Paris: The Revolutionary Decade that Gave the World Impressionism* (London: Pimlico, 2007), 83.

4. Jack Lindsay, *Gustave Courbet: His Life and Art* (London: Jupiter Books Ltd., 1977), 9.

5. Lindsay, *Gustave Courbet*.

6. Lindsay, *Gustave Courbet*.

7. ten-Doesschate Chu, *The Most Arrogant Man in France*.

8. Fred S. Kleiner, *Gardener's Art Through the Ages: The Western Perspective* (Boston: Wadsworth, 2010), 631.

9. Tom Lubbock, "Why Gustave Courbet Still Has the Power to Shock," *The Independent*, 29 October, 2007, https://www.independent.co.uk/arts-entertainment/art/features/why-gustave-courbetstill-has-the-power-to-shock-744386.html

10. Lindsay, *Gustave Courbet*.

11. Lindsay, *Gustave Courbet*.

12. Lindsay, *Gustave Courbet*, 56.

13. Lindsay, *Gustave Courbet*, 56.

14. Timothy J. Clark, *Image of the People: Gustave Courbet and the 1848 Revolution* (London: Thames & Hudson, 1999), 69.

15. Clark, *Image of the People*, 69.

16. Lindsay, *Gustave Courbet*.

17. Lindsay, *Gustave Courbet*, 76.

18. ten-Doesschate, *The Most Arrogant Man in France*, 85.

19. ten-Doesschate, *The Most Arrogant Man in France*, 86.

20. ten-Doesschate, *The Most Arrogant Man in France*, 106.

21. Lindsay, *Gustave Courbet*.

22. Lindsay, *Gustave Courbet*, 90.

23. Avis Berman, "Larger Than Life," *Smithsonian Magazine*, April, 2008. https://www.smithsonianmag.com/arts-culture/larger-than-life-31654689/

24. Rubin, *Courbet*, 287.
25. ten-Doesschate, *The Most Arrogant Man in France*.
26. Rubin, *Courbet*.
27. Rubin, *Courbet*.
28. Rubin, *Courbet*.
29. Lindsay, *Gustave Courbet*, 127.
30. Lindsay, *Gustave Courbet*, 127–28.

CHAPTER 4. WHISTLER: PEACOCK PUGNACIOUS

1. Mortimer Menpes, *Whistler as I Knew Him* (Tucson, AZ: Hol Art Books, 2009).
2. Daniel E. Sutherland, *Whistler: A Life for Art's Sake* (New Haven, CT: Yale University Press, 2014).
3. Sutherland, *Whistler*.
4. Lisa N. Peters, *James McNeil Whistler* (New York, NY: Smithmark, 1996), 11.
5. Sutherland, *Whistler*.
6. Sutherland, *Whistler*, 22.
7. William H. Baumer, *Not All Warriors* (New York: Smith & Durrell, 1941), 229.
8. Sutherland, *Whistler*.
9. Elizabeth Robins Pennell and Joseph Pennell, *The Life of James McNeill Whistler*, 6th ed. (London: W. Heinemann, 1920), 38.
10. Sutherland, *Whistler*.
11. Sutherland, *Whistler*.
12. Ross King, *The Judgment of Paris: The Revolutionary Decade that Gave the World Impressionism* (London: Pimlico, 2007).
13. Sutherland, *Whistler*.
14. Sutherland, *Whistler*, 73.
15. Sutherland, *Whistler*.
16. Sutherland, *Whistler*.
17. James McNeill Whistler, *The Gentle Art of Making Enemies* (New York: Dover Publications, Inc., 1967; London: William Heinemann 1892), 45. Citations refer to the Dover Publications edition.
18. Whistler, *The Gentle Art of Making Enemies*, x.
19. Hesketh Pearson, *The Man Whistler* (New York: Harper & Row, 1952), 77.
20. Menpes, *Whistler as I Knew Him*, 58.
21. Frank Harris, *Oscar Wilde* (London: Wordsworth Editions, 2007), 41.
22. Stanley Weintraub, *Whistler: A Biography* (New York: Weybright and Talley, 1974), 304.
23. Sutherland, *Whistler*.
24. Sutherland, *Whistler*.
25. Sutherland, *Whistler*.
26. Whistler, *The Gentle Art of Making Enemies*, 1.
27. Sutherland, *Whistler*.
28. Sutherland, *Whistler*.
29. Whistler, *The Gentle Art of Making Enemies*.
30. Sutherland, *Whistler*.

31. Anne Koval, "The 'Artists' Have Come Out and the 'British' Remain," in *After the Pre-Raphaelites: Art and Aestheticism in Victorian England,* ed. Elizabeth Prettejohn (Manchester: Manchester University Press, 1999), 92.

32. Sutherland, *Whistler,* 294.

33. Sutherland, *Whistler,* 326.

34. Adam Parks, *A Sense of Shock: The Impact of Impressionism on Modern British and Irish Writing* (New York: Oxford University Press, 2011), 45.

35. Whistler, *The Gentle Art of Making Enemies,* 144.

CHAPTER 5. GENTILESCHI: A WOMAN FOR ALL SEASONS

1. Mary D. Garrard, *Artemisia Gentileschi: The Image of the Female Hero in Italian Baroque Art* (Princeton, NJ: Princeton University Press, 1989).

2. Garrard, 1989, 462.

3. Garrard, 1989, 447.

4. Garrard, 1989.

5. Jesse M. Locker, *Artemisia Gentileschi: The Language of Painting* (New Haven, CT: Yale University Press, 2015).

6. R. Ward Bissell, *Artemisia Gentileschi and the Authority of Art: Critical Reading and Catalogue Raisonne* (University Park: Pennsylvania State University Press, 1999).

7. Garrard, 1989.

8. Bissell, 1999.

9. Keith Christiansen and Judith Walker Mann, *Orazio and Artemisia Gentileschi* (New Haven, CT: Yale University Press, 2001).

10. Garrard, 1989.

11. Garrard, 1989, 462.

12. Garrard, 1989.

13. Locker, 2015.

14. Bissell, 1999.

15. Christiansen and Mann, 2001.

16. Bissell, 1999.

17. Bissell, 1999.

18. Babette Bohn, "Death, Dispassion, and the Female Hero: Artemisia Genileschi's *Judiths,* In *The Artemisia Files,* ed. Mieke Bal (Chicago: University of Chicago Press, 2005).

19. Bissell, 1999.

20. Bissell, 1999.

21. Garrard, 1989.

22. Bissell, 1999.

23. Locker, 2015.

CHAPTER 6. REMINGTON: THE COWBOY FROM NEW ROCHELLE

1. Robert Williams, *Horace Greeley: Champion of American Freedom* (New York: NYU Press, 2006), 41.

2. Peggy Samuels and Harold Samuels, *Remington: A Biography* (Doubleday & Co., Garden City, NY, 1982), 21.

3. Thayer Tolles, "Frederic Remington (1861–1909)," Heilbrunn Timeline of Art History, The Metropolitan Museum of Art, 2010, http://www.metmuseum.org/toah/hd/remi/hd_remi.htm

4. Brian W. Dippie, "Frederic Remington's Wild West," *American Heritage* 26, no. 3 (1975). https://www.americanheritage.com/frederic-remingtons-wild-west

5. Tolles, "Frederic Remington."

6. Dippie, "Frederic Remington's Wild West."

7. Paul Cool, "Did Remington Capture Clanton's Last Breath?" *True West*, May 20, 2016. https://truewestmagazine.com/did-remington-capture-clantons-last-breath/.

8. Cool, "Did Remington Capture Clanton's Last Breath?"

9. Samuels & Samuels, *Remington*.

10. Tolles, "Frederic Remington."

11. Laura Foster, "Frederic Remington: Treasures from the Frederic Remington Art Museum," *Resource Library* (July 11, 2007), http://www.tfaoi.com/aa/7aa/7aa796.htm

12. Samuels & Samuels, *Remington*.

13. Samuels & Samuels, *Remington*.

14. Patricia O'Tool, ed., *In the Words of Theodore Roosevelt: Quotations from the Man in the Arena* (Ithaca, NY: Cornell University Press, 2012), 51.

15. Mark Twain and Charles Dudley Warner, *The Gilded Age: A Tale of Today* (New York: Penguin Books, 2001; American Publishing Company, 1873).

16. Emma Lazarus, "The New Colossus." National Park Service, 1883. https://www.nps.gov/stli/learn/historyculture/colossus.htm

17. Poultney Bigelow, "Frederic Remington; with extracts from unpublished letters," *The Quarterly Journal of the New York State Historical Association*, 10, no. 1 (January, 1929), 46.

18. Joseph C. Biggott, *From Cottage to Bungalow: Houses and the Working Class in Metropolitan Chicago, 1869–1929* (Chicago: University of Chicago Press, 2001), 100.

19. Peter H. Hassrick, "'They Are a Fine Outfit: Those Blackfeet': Frederic Remington in Western Canada," *Alberta History*, 52, no. 2 (Spring, 2004).

20. Frank N. Schubert, *Voices of the Buffalo Soldier: Records, Reports, and Recollections of Military Life and Service in the West* (Albuquerque: University of New Mexico Press, 2003), 47.

21. John Langellir, "Remington's Buffalo Soldiers: Frederic Remington and His Groundbreaking Illustrations of the 10th Cavalry in Arizona," *True West: History of the American Frontier*, September 4, 2011. https://truewestmagazine.com/remingtons-buffalo-soldiers-2/

22. David G. McCullough, *Brave Companions: Portraits in History* (New York: Touchstone, 1992), 80.

23. Samuels & Samuels, *Remington*.

24. Nancy K. Anderson, William Sharpe, and Alexander Nemerov, *Frederic Remington: The Color of Night* (Washington, DC: National Academy of Art/Princeton University Press, 2003).

25. Samuels & Samuels, *Remington*.

26. James D. Balestrieri, "The Horse in Time," *Western Art Collector*, 1 October, 2018. https://www.pressreader.com/usa/western-art-collector/20181001/282578788965120

CHAPTER 7. SCHIELE: MOTH TO THE FLAME

1. Frank Whitford, *Egon Schiele* (London: Thames & Hudson, 1981).

2. Jane Kallir, *Egon Schiele: The Complete Works* (New York: Harry N. Abrams Incorporated, 1990).

3. Kallir, *Egon Schiele*.
4. Kallir, *Egon Schiele*, 41.
5. Whitford, *Egon Schiele*.
6. Sarah Pruitt, "When Hitler Tried (and Failed) to Be an Artist," *History Stories*, September 13, 2019. https://www.history.com/news/adolf-hitler-artist-paintings-vienna
7. Reinhard Steiner, *Schiele* (Cologne, Germany: Taschen, 2017).
8. Kallir, *Egon Schiele*.
9. Frank Whitford, *Egon Schiele*.
10. Kallir, *Egon Schiele*.
11. Whitford, *Egon Schiele*.
12. Whitford, *Egon Schiele*.
13. Kallir, *Egon Schiele*.
14. Whitford, *Egon Schiele*.
15. Whitford, *Egon Schiele*.
16. Whitford, *Egon Schiele*.
17. Whitford, *Egon Schiele*.
18. Whitford, *Egon Schiele*.
19. Steiner, *Schiele*.
20. Whitford, *Egon Schiele*; Kallir, *Egon Schiele*.
21. Whitford, *Egon Schiele*.
22. John M. Barry, *The Great Influenza: The Epic Story of the Greatest Plague in History* (New York: Viking Penguin, 2004).
23. Dean K. Simonton, "Creative Genius in Literature, Music, and the Visual Arts," in *Handbook of the Economics of Art and Culture*, ed. Victor Ginsburgh and David Throsby, vol. 2 (Oxford: Elsevier, 2014), 15–48.
24. Jane Kallir, "Egon Schiele Was Not a Sex Offender," *The Art Newspaper* June 1, 2018. https://www.theartnewspaper.com/comment/egon-schiele-was-not-a-sex-offender
25. Ann Binlot, "A Century After His Death, Egon Schiele's Nudes Still Provoke Controversy," *Forbes*. July 31, 2018, https://www.forbes.com/sites/abinlot/2018/07/31/a-century-after-his-death-egon-schieles-nudes-still-provoke-controversy/#61dd0d7c6ac5; Kimberley Bradley, "Egon Schiele Is Still too Racy for Some, Nearly 100 Years after His Death," *The New York Times*, November 10. 2017, https://www.nytimes.com/2017/11/10/arts/design/egon-shiele-ads-london-tube.html; Kallir, "Egon Schiele Was Not a Sex Offender."
26. Kallir, *Egon Schiele*.

CHAPTER 8. YOSHITOSHI: HOLDING BACK THE NIGHT

1. David Bell, "Explaining Ukiyo-e." Unpublished PhD thesis (University of Otago, 2004). Retrieved from http://hdl.handle.net/10523/598
2. John Stevenson, *Yoshitoshi's One Hundred Aspects of the Moon* (Leiden, The Netherlands: Hotei Publishing, 2001).
3. Stevenson, *Yoshitoshi's One Hundred Aspects of the Moon*.
4. John Stevenson, *Yoshitoshi's Women: The Woodblock-Print Series* (Seattle, WA: The University of Washington Press, 1995).
5. Stevenson, *Yoshitoshi's One Hundred Aspects of the Moon*.
6. Stevenson, *Yoshitoshi's One Hundred Aspects of the Moon*.
7. Bell, "Explaining Ukiyo-e."

8. Stevenson, *Yoshitoshi's One Hundred Aspects of the Moon*.
9. Stevenson, *Yoshitoshi's Women*.
10. Stevenson, *Yoshitoshi's Women*.
11. Stevenson, *Yoshitoshi's Women*.
12. Bell, "Explaining Ukiyo-e."
13. Bell, "Explaining Ukiyo-e."
14. Stevenson, *Yoshitoshi's Women*.
15. Stevenson, *Yoshitoshi's Women*.
16. David Bell, personal conversation, August 4, 2019.
17. Stevenson, *Yoshitoshi's Women*.
18. John Stevenson, *Yoshitoshi's Strange Tales* (Amersterdam: Hotei Publishing, 2005).
19. Stevenson, *Yoshitoshi's Women*.
20. Stevenson, *Yoshitoshi's Strange Tales*, 51.
21. David Bell, personal conversation, August 7, 2019.

CHAPTER 9. POLLOCK/KRASNER: COLLISION COURSE

1. Deborah Solomon, *Jackson Pollock: A Biography* (New York: Cooper Square Press, 2001).
2. Solomon, *Jackson Pollock*.
3. Sebastian Smee, *The Art of Rivalry: Four Friendships, Betrayals, and Breakthroughs in Modern Art* (New York: Random House, 2016), 273.
4. Solomon, *Jackson Pollock*, 41.
5. Smee, *The Art of Rivalry*, 273.
6. Solomon, *Jackson Pollock*, 48.
7. Elizabeth Broun, "Thomas Hart Benton: A Politician in Art," *Smithsonian Studies in American Art*, 1, no. 1 (1987).
8. Solomon, *Jackson Pollock*.
9. Jillian Russo, "The Works Progress Administration Federal Art Project reconsidered," *Visual Resources,* 34, no. 1–2 (2018).
10. Solomon, *Jackson Pollock*.
11. M. G. Lord, "Art; Lee Krasner, Before and After the Ball Was Over," *New York Times,* August 27, 1995. https://www.nytimes.com/1995/08/27/arts/art-lee-krasner-before-and-after-the-ball-was-over.html
12. Solomon, *Jackson Pollock,* 201.
13. Solomon, *Jackson Pollock,* 201.
14. Pepe Karmel, *Jackson Pollock: Interviews, Articles and Reviews* (New York: The Museum of Modern Art, 1999), 28.
15. Lucinda Barnes, ed., *Hans Hoffman: The Nature of Abstraction* (Berkley, CA: University of California Press, 2019).
16. Solomon, *Jackson Pollock,* 132.
17. Solomon, *Jackson Pollock,* 132.
18. Sylvia Winter Pollock, ed., *American Letters 1927–1947: Jackson Pollock & Family*. Malden, MA: Polity Press, 2011), 186.
19. Solomon, *Jackson Pollock*.
20. Will Gompertz, *What Are You Looking At? 150 Years of Modern Art in the Blink of An Eye* (London: Penguin Books, 2016),

21. Solomon, *Jackson Pollock*.
22. Karmel, *Jackson Pollock*, 32.
23. Steven Niafeh and Gregory Smith, *Jackson Pollock: An American Saga* (London: Barrie & Jenkins, 1989), 777.
24. April Kingsley, *The Turning Point: The Abstract Expressionists and the Transformation of American Art* (New York: Simon & Schuster, 1992), 358.
25. Smee, *The Art of Rivalry*, 349.
26. Katie Ronzio, "Jackson Pollock's Wife? You Mean Lee Krasner." Accessed September 25, 2019, https://domainsiderbsu.wordpress.com/2016/11/08/jackson-pollocks-wife-you-mean-lee-krasner/
27. "Willem de Kooning," *The Telegraph*, March 20, 1997, https://www.telegraph.co.uk/news/obituaries/7441670/Willem-de-Kooning.html
28. Karmel, *Jackson Pollock*, 20.

CHAPTER 10. CONCLUSION: FINDING YOUR OWN SCOUNDREL

1. Barbara Lehman Smith, *Elizabeth Sparhawk-Jones: The Artist Who Lived Twice* (Parker, CO: Outskirts Press, 2010).
2. Jeffrey K. Smith, "Art as Mirror: Creativity and Communication in Aesthetics," *Psychology of Aesthetics, Creativity, and the Arts* 8, no. 1 (2014).
3. Mary Blume, "The Rise and Fall of Rosa Bonheur," *The New York Times*, October 4, 1997, https://www.nytimes.com/1997/10/04/style/IHT-the-rise-and-fall-of-rosa-bonheur.html
4. Blume, "The Rise and Fall of Rosa Bonheur."

Recommended Readings

INTRODUCTION

How Art Works: A Psychological Exploration, Ellen Winner. Oxford: Oxford University Press, 2019. Winner presents an excellent and accessible explanation of how art (in all forms) influences our lives and how psychologists study the field of psychology of aesthetics.

The Judgment of Paris: The Revolutionary Decade that Gave the World Impressionism, Ross King. New York City: Walker Publishing Company, 2006. Focusing on Édouard Manet and Ernest Meissonier, King explores Paris duing the advent of Impressionism in a fact-filled, but readable book.

CARAVAGGIO

Caravaggio: A Life Sacred and Profane, Andrew Graham-Dixon. London: Penguin, 2010. An excellent and highly readable biography of Caravaggio's life and analysis of his work.

Caravaggio: A Life, Helen Langdon. New York City: Farrar, Strauss, and Giroux, 2012. Langdon's work is a more academic presentation of the life of Caravaggio, with all of the details, and perhaps a bit less sensational in approach.

COURBET

Courbet, James H. Rubin. London: Phaidon Press, Inc., 1997. Rubin presents an engaging biography of the life of the great artist and the turbulent times in which he lived.

The Most Arrogant Man in France, Petra ten-Doesschate Chu. Princeton, NJ: Princeton University Press, 2007. Chu looks at the life and times of Courbet from the perspective of his relationship with the media of his time, and how he cleverly promoted himself as an artist.

WHISTLER

Whistler: A Life for Art's Sake, Daniel. E. Sutherland. New Haven, CT: Yale University Press, 2014. Sutherland's work is a definitive and highly readable biography of Whistler.

The Gentle Art of Making Enemies, James McNeill Whistler. New York: Dover Publications, Inc., 1967. First published 1892, William Heinemann (London). This is a collection of the writings of Whistler and responses to his work, published by Whistler. There is no commentary or particular theme through this collection, but if you like biting commentary and witticisms, it is very enjoyable.

GENTILESCHI

The Passion of Artemisia: A Novel, Susan Vreeland. London: Penguin Books, 2002. This novel based on the life of Gentileschi is entertaining to read and provides a wealth of information about her life and times. It may stray from what is absolutely known about Gentileschi at times, but it does a very good job of giving a sense of who she was and what she accomplished.

Artemisia Gentileschi, Mary D. Garrard. Princeton, NJ: Princeton University Press, 1991. This is the authorative work on Gentileschi. It is not light reading, but if you really want to know what is known about this great Baroque artist, this would be the book to read.

REMINGTON

Frederic Remington: The Color of Night, Nancy K. Anderson. Washington, DC: National Academy of Art/Princeton University Press, 2003. This is a catalogue that accompanied an exhibition at the National Gallery of Art (and elsewhere) of the same name. It focuses on Remington's *nocturne* paintings and has beautiful reproductions of them. It isn't a biography *per se*, but does discuss his life as it relates to the nocturnes.

Frederic Remington, Peggy Samuels and Harold Samuels. Austin: University of Texas Press, 1985. This biography, although now over thirty years old, is the defnitive work on the life of Frederic Remington.

YOSHITOSHI

Yoshitoshi, Chris Uhlenbeck and Amy Reigle Newland. Leiden, Netherlands: Brill Publishers, 2011. It is hard to find works dedicated to Yoshitoshi, but this one explores the development of his work and the context in which he worked.

Ukiyo-e Explained, David Bell. Kent, UK: Global Oriental, 2004. This scholarly but highly readable work explores the process of making ukiyo-e prints and the "floating world" of ukiyo-e in general. If you are intrigued by the chapter on Yoshitoshi and want to understand this very different approach to art and life, this would be an excellent resource.

SCHIELE

Schiele, Reinhard Steiner. Cologne, Germany: Taschen Books, 2017. This is an excellent and readable biography of the Viennese painter. It also has a large number of high quality color reproductions of his work.

Egon Schiele: The Complete Works, Jane Kallir. New York: Harry N. Abrams Incorporated, 1990. Jane Kallir is *the* scholar on Egon Schiele, and has published many excellent works on him, any of which might be highlighted here. I chose this one because it presents his life along with 201 illustrations, many in color.

POLLOCK/KRASNER

Jackson Pollock: A Biography, Deborah Solomon. New York: Cooper Square Press, 2001. This is an enjoyable biography of Pollock that looks at his relationship with Lee Krasner and the circle of abstract expressionists of New York with whom Pollock drank, caroused, and fought.

Lee Krasner, Eleanor Nairne. London: Thames & Hudson Publishing Company, 2019. Nairne presents the life and work of this accomplished artist who all too often is simply seen as an appendage to Jackson Pollock. It contains over 200 illustrations of her work.

CONCLUSION

Elizabeth Sparhawk-Jones: The Artist Who Lived Twice, Barbara Lehman Smith. Denver, CO: Outskirts Press, 2010. Smith presents the only biography available on the life and times of the fascinating life story of Sparhawk-Jones, from the early successes through her battle with mental illness and recovery. It is fascinating.

Philip Guston, Robert Storr. New York: Abbeville Press, 1991. A brief biography of the life of Philip Guston with dozens of color illustrations, this book presents the artist's strange and intriguing art. Although not published at the time of this writing, the reader might want to look at *Phillip Guston: A Life Spent Painting*, Robert Storr, London: Lawrence King Publishing, 2020, which promises to be a much more extensive examination of the artist's life.

References

CHAPTER 1. INTRODUCTION

Carr, David, Personal communication, October 14, 2012.

Dempsey, Charles. *The Portrayal of Love. Botticelli's* Primavera *and Humanist Culture at the Time of Lorenzo the Magnificent.* Princeton, NJ: Princeton University Press, 1992.

El Greco (n.d.). El Greco Quotes. Accessed October 7, 2019. https://www.elgreco.net/el-greco-quotes.jsp

Fitzgerald, F. Scott. "The Rich Boy." In *The Short Stories of F. Scott Fitzgerald*, edited by Matthew J. Bruccoli, 335. New York: Scribner's, 1989.

Garmen, Emma. "Beauty Marks." *The Paris Review*, September 1, 2016. Accessed October 4, 2019, https://www.theparisreview.org/blog/2016/09/01/beauty-marks/

Hauser & Wirth. "Musa Mayer and Anders Bergstrom on Philip Guston," accessed October 9, 2019, https://www.hauserwirth.com/stories/24740-conversation-musa-mayer-anders-bergstrom

McNair, Philip. "The Bed of Venus: Key to Poliziano's Stanze." *Italian Studies* 25, no. 1 (1970); 40–48. https://doi.10.1179/its.1970.25.1.40 1970

Palombo, Alyssa. "An Ode to Florence: The Church of the Ognissanti." *The Spellbook of Katrina Van Tassel*. https://alyssapalombo.com/2017/06/08/an-ode-to-florence-the-church-of-the-ognissanti/

Smith, Jeffrey K., Lisa F. Smith, and Pablo Tinio. "Rogues Gallery: Why We Like Art from Bad People." Paper presented at annual meeting of American Psychological Association, Chicago, IL, August 7, 2019.

Vasari, Georgio. *The Lives of the Artists*. Oxford: Oxford University Press, 1998.

CHAPTER 2. CARAVAGGIO

Graham-Dixon, Andrew. *Caravaggio: A Life Sacred and Profane*. New York: Norton, 2010.

Hunt, Patrick. *Caravaggio*. London: Haus Publishing Limited, 2004.

Langdon, Helen. *Caravaggio: A Life*. New York: Farrar, Straus and Giroux, 2012.

Locher, Paul J. "Empirical Investigation of an Aesthetic Experience with Art." In *Aesthetic Science: Connecting Minds, Brains, and Experience*, ed. Arthur P. Shimamura and Stephanie E. Palmer. New York: Oxford University Press, 2012, 163–88.
Lubbock, Tom. "Caravaggio: Cardsharps (1595)." *Independent*, September 26, 2008. https://www.independent.co.uk/arts-entertainment/art/great-works/caravaggio-cardsharps-1595-942660.html
Morris, Roderick C. "Caravaggio's Revolution in Light and Dark." *The New York Times,* November 9, 2016. https://www.nytimes.com/2016/11/09/arts/design/caravaggios-revolution-in-light-and-dark.html
Smith, Jeffrey K. *The Museum Effect: How Museums, Libraries, and Cultural Institutions Educate and Civilize Society*. New York: Rowman & Littlefield, 2014.
Willey, David. "Caravaggio's Crimes Exposed in Rome's Police Files." *BBC News*, February 18, 2011. https://www.bbc.com/news/world-europe-12497978

CHAPTER 3. COURBET

Berman, Avis. "Larger Than Life." *Smithsonian Magazine*, April, 2008. https://www.smithsonianmag.com/arts-culture/larger-than-life-31654689/
Clark, Timothy J. *Image of the People: Gustave Courbet and the 1848 Revolution*. London: Thames & Hudson, 1999.
Fried, Michael. *Courbet's Realism*. Chicago: University of Chicago Press, 1990.
King, Ross. *The Judgment of Paris: The Revolutionary Decade that Gave the World Impressionism*. London: Pimlico, 2007.
Kleiner, Fred S. *Gardener's Art Through the Ages: The Western Perspective*, Boston: Wadsworth, 2010.
Lindsay, Jack. *Courbet: His Life and Art.* London: Jupiter Books Limited, 1973.
Lubbock, Tom. "Why Gustave Courbet Still Has the Power to Shock." *The Independent*, 29 October, 2007. https://www.independent.co.uk/arts-entertainment/art/features/why-gustave-courbetstill-has-the-power-to-shock-744386.html
Nochlin, Linda. *Courbet*. New York: Thames & London, 2007.
Rubin, James H. *Courbet*. London: Phaidon Press, Inc., 2013.
ten-Doesschate Chu, Petra. *The Most Arrogant Man in France: Gustave Courbet and the Nineteenth-Century Media Culture*. Princeton, NJ: Princeton University Press, 2007.

CHAPTER 4. WHISTLER

Baumer, William H. *Not All Warriors*. New York: Smith & Durrell, 1941.
Curry, David Park. *James McNeill Whistler: Uneasy Pieces*. New York: Quantuck Lane Press, 2004.
Harris, Frank. *Oscar Wilde*. London: Wordsworth Editions, 2007.
King, Ross. *The Judgment of Paris: The Revolutionary Decade that Gave the World Impressionism*. London: Pimlico, 2007.
Koval, Anne. "The 'Artists' Have Come Out and the 'British' Remain." In *After the Pre-Raphaelites: Art and Aestheticism in Victorian England,* edited by Elizabeth Prettejohn, 90–111. Manchester: Manchester University Press, 1999.

Menpes, Mortimer. *Whistler as I Knew Him.* Tucson, AZ: Hol Art Books, 2009.

Parks, Adam. *A Sense of Shock: The Impact of Impressionism on Modern British and Irish Writing.* New York: Oxford University Press, 2011.

Pearson, Hesketh. *The Man Whistler.* New York: Harper & Row, 1952.

Pennell, Elizabeth R., and Joseph Pennell. *The Life of James McNeill Whistler*, 6th ed. London: W. Heinemann, 1920.

Peters, Lisa N. *James McNeil Whistler.* New York: Smithmark, 1996.

Sutherland, Daniel. E. *Whistler: A Life for Art's Sake.* New Haven, CT: Yale University Press, 2014.

Taylor, K. *James McNeill Whistler.* London: Studio Vista, 1978.

Thorp, Nigel, ed. *Whistler on Art: Selected Letters and Writings of James McNeill Whistler.* Manchester, UK: Carcanet Press, 2004.

Weintraub, Stanley. *Whistler: A Biography.* New York: Weybright and Talley, 1974.

Whistler, James McNeill. *The Gentle Art of Making Enemies.* New York: Dover Publications, Inc., 1967.

CHAPTER 5. GENTILESCHI

Bal, Mieke, ed. *The Artemisia Files.* Chicago: University of Chicago Press, 2005.

Bissell, R. Ward. *Artemisia Gentileschi and the Authority of Art: Critical Reading and Catalogue Raisonne.* University Park: Pennsylvania State University Press, 1999.

Bohn, Babette. "Death, Dispassion, and the Female Hero: Artemisia Genileschi's *Judiths.* In *The Artemisia Files*, edited by Mieke Bal, 63–107. Chicago: University of Chicago Press, 2005.

Christiansen, Keith, and Judith Walker Mann. *Orazio and Artemisia Gentileschi.* New Haven, CT: Yale University Press, 2001.

Garrard, Mary D. *Artemisia Gentileschi: The Image of the Female Hero in Italian Baroque Art.* Princeton, NJ: Princeton University Press, 1989.

Locker, Jesse M. *Artemisia Gentileschi: The Language of Painting.* New Haven, CT: Yale University Press, 2015.

CHAPTER 6. REMINGTON

Anderson, Nancy, K., William Sharpe and Alexander Nemerov. *Frederic Remington: The Color of Night.* Washington, DC: National Academy of Art/Princeton University Press, 2003.

Balestrieri, James D. "The Horse in Time." *Western Art Collector*, 1 October, 2018. https://www.pressreader.com/usa/western-art-collector/20181001/282578788965120

Bigelow, Poultney. "Frederic Remington; with Extracts from Unpublished Letters." *The Quarterly Journal of the New York State Historical Association*, 10, no. 1 (January, 1929): 45–52.

Biggott, Joseph C. *From Cottage to Bungalow: Houses and the Working Class in Metropolitan Chicago, 1869–1929.* Chicago: University of Chicago Press, 2001.

Cool, Paul. "Did Remington Capture Clanton's Last Breath?" *True West*, May 20, 2016. https://truewestmagazine.com/did-remington-capture-clantons-last-breath/

Dippie, Brian W. "Frederic Remington's Wild West." *American Heritage* 26, no. 3 (1975). https://www.americanheritage.com/frederic-remingtons-wild-west

Foster, Laura. "Frederic Remington: Treasures from the Frederic Remington Art Museum." *Resource Library,* July 11, 2007. http://www.tfaoi.com/aa/7aa/7aa796.htm

Hassrick, Peter H. "'They Are a Fine Outfit: Those Blackfeet': Frederic Remington in Western Canada." *Alberta History,* 52, no. 2 (Spring, 2004): 27–48.

Jennings, Kate. F. *Remington & Russell and the Art of the American West.* New York: Smithmark, 1993.

Langellir, John. "Remington's Buffalo Soldiers: Frederic Remington and His Groundbreaking Illustrations of the 10th Cavalry in Arizona." *True West: History of the American Frontier,* September 4, 2011. https://truewestmagazine.com/remingtons-buffalo-soldiers-2/

Lazarus, Emma. "The New Colossus." National Park Service, 1883. https://www.nps.gov/stli/learn/historyculture/colossus.htm

McCullough, David G. *Brave Companions: Portraits in History.* New York: Touchstone, 1992.

O'Tool, Patricia, ed. *In the Words of Theodore Roosevelt: Quotations from the Man in the Arena.* Ithaca, NY: Cornell University Press, 2012.

Samuels, Peggy, and Harold Samuels. *Remington: A Biography.* Garden City, NY: Doubleday & Co., 1982.

Schubert, Frank N. *Voices of the Buffalo Soldier: Records, Reports, and Recollections of Military Life and Service in the West.* Albuquerque: University of New Mexico Press, 2003.

Taft, Robert. *Artists and Illustrators of the Old West 1850–1900.* New York, Scribner, 1953.

Tolles, Thayer. "Frederic Remington (1861–1909)." Heilbrunn Timeline of Art History, The Metropolitan Museum of Art, 2010. http://www.metmuseum.org/toah/hd/remi/hd_remi.htm

Twain, Mark, and Charles Dudley Warner. *The Gilded Age: A Tale of Today.* Penguin Books, 2001. First published 1873 by American Publishing Company.

Vorpahl, Ben Merchant. *Frederic Remington and the West with the Eye of the Mind.* Austin: University of Texas Press, 1978.

White, G. Edward. *The Eastern Establishment and the Western Experience: The West of Frederic Remington, Theodore Roosevelt, and Owen Wister.* New Haven, CT: Yale University Press, 1968.

CHAPTER 7. EGON SCHIELE

Barry, John M. *The Great Influenza: The Epic Story of the Greatest Plague in History.* New York: Viking Penguin, 2004.

Binlot, Ann. "A Century After His Death, Egon Schiele's Nudes Still Provoke Controversy." *Forbes.* July 31, 2018, https://www.forbes.com/sites/abinlot/2018/07/31/a-century-after-his-death-egon-schieles-nudes-still-provoke-controversy/#61dd0d7c6ac5

Bradley, Kimberly. "Egon Schiele Is Still too Racy for Some, Nearly 100 Years after His Death." *The New York Times,* November 10, 2017. https://www.nytimes.com/2017/11/10/arts/design/egon-shiele-ads-london-tube.html

Kallir, Jane. "Egon Schiele Was Not a Sex Offender." *The Art Newspaper,* June 1, 2018. https://www.theartnewspaper.com/comment/egon-schiele-was-not-a-sex-offender

Kallir, Jane. *Egon Schiele: The Complete Works.* New York: Harry N. Abrams Incorporated, 1990.

Pruitt, Sarah. "When Hitler Tried (and Failed) to Be an Artist." *History Stories,* September 13, 2019. https://www.history.com/news/adolf-hitler-artist-paintings-vienna.

Schröder, Klaus Albrecht, and Harald Szeemann. *Egon Schiele and His Contemporaries.* Munich: Prestel-Verlag, 1989.

Simonton, Dean K. "Creative Genius in Literature, Music, and the Visual Arts. In *Handbook of the Economics of Art and Culture*, edited by Victor Ginsburgh and David Throsby, vol. 2, 15–48. Oxford: Elsevier, 2014.

Steiner, Reinhard. *Schiele*. Cologne, Germany: Taschen, 2017.

Whitford, Frank. *Egon Schiele*. London: Thames & Hudson, 1981.

CHAPTER 8. YOSHITOSHI

Bell, David. "Explaining Ukiyo-e." Unpublished PhD thesis. University of Otago, 2004. Retrieved from http://hdl.handle.net/10523/598

Stevenson, John. *Yoshitoshi's One Hundred Aspects of the Moon*. Leiden, The Netherlands: Hotei Publishing, 2001.

Stevenson, John. *Yoshitoshi's Strange Tales*. Amersterdam: Hotei Publishing, 2005.

Stevenson, John. *Yoshitoshi's Women: The Woodblock-Print Series*. Seattle, WA: The University of Washington Press, 1995.

CHAPTER 9. JACKSON POLLOCK AND LEE KRASNER

Barnes, Lucinda, ed. *Hans Hoffman: The Nature of Abstraction*. Berkley, CA: University of California Press, 2019.

Broun, Elizabeth. "Thomas Hart Benton: A Politician in Art." *Smithsonian Studies in American Art*, 1, no. 1 (1987): 58–77.

Gompertz, Will. *What Are You Looking At? 150 Years of Modern Art in the Blink of an Eye*. London: Penguin Books, 2016.

Karmel, Pepe, ed. *Jackson Pollock: Interviews, Articles and Reviews*. New York: The Museum of Modern Art, 1999.

Kingsley, April. *The Turning Point: The Abstract Expressionists and the Transformation of American Art*. New York: Simon & Schuster, 1992.

Lord, M. G. "Art; Lee Krasner, Before and After the Ball Was Over," *New York Times,* August 27, 1995. https://www.nytimes.com/1995/08/27/arts/art-lee-krasner-before-and-after-the-ball-was-over.html

Niafeh, Steven, & Gregory W. Smith. *Jackson Pollock: An American Saga*. London: Barrie & Jenkins, 1989.

"Obituaries: Willem de Kooning." *The Telegraph,* March 20, 1997, https://www.telegraph.co.uk/news/obituaries/7441670/Willem-de-Kooning.html

Pollock, Sylvia Winter. ed. *American Letters 1927–1947: Jackson Pollock & Family*. Malden, MA: Polity Press, 2011.

Ronzio, Katie. "Jackson Pollock's Wife? You Mean Lee Krasner," *DOMA Insider,* November 8, 2016, https://domainsiderbsu.wordpress.com/2016/11/08/jackson-pollocks-wife-you-mean-lee-krasner/

Russo, Jillian. "The Works Progress Administration Federal Art Project Reconsidered." *Visual Resources* 34, no1-2 (2018): 13–32. DOI: 10.1080/01973762.2018.1436800

Smee, Sebastian. *The Art of Rivalry: Four Friendships, Betrayals, and Breakthroughs in Modern Art*. New York: Random House, 2016.

Solomon, Deborah. *Jackson Pollock: A Biography*. New York: Cooper Square Press, 2001.

CHAPTER 10. CONCLUSION

Blume, Mary. "The Rise and Fall of Rosa Bonheur." *The New York Times*, October 4, 1997. https://www.nytimes.com/1997/10/04/style/IHT-the-rise-and-fall-of-rosa-bonheur.html
Smith, Barbara Lehman. *Elizabeth Sparhawk-Jones: The Artist Who Lived Twice*. Parker, CO: Outskirts Press, 2010.
Smith, Jeffrey K. "Art as Mirror: Creativity and Communication in Aesthetics." *Psychology of Aesthetics, Creativity, and the Arts*, 8, no. 1 (2014): 110–18.

Index

absinthe, 37
Abstract Expressionism, 122, 123
Academy of Fine Arts, Schiele, Egon at, 92, 94
Aesthetic Movement, 54
After Dinner at Ornans (Courbet), 30–31, *31*
Albertina Museum, *103*
alcoholism, 37
 Pollock and, 121–22, 126, 130, 131
allegorical painting, 65
Allegory of Inclination (Gentileschi, A.), 67, *67*
Allegory of Painting (Gentileschi, A.), *58*, 68–69
"all over" style, 123, 125, 130, 135
altarpiece art, 15, 108, 142
America. *See* United States
American Gothic (Wood), 129–30, *130*
America Today (Benton), 123, *124*
Amon Carter Museum of American Art, *81*, *84*
Arrangement in Grey and Black, No. 1 (Whistler, J.), *48*, 48–49
art. *See also* movements, art; museums; styles, art
 viewing, 139–41
Art Gallery of New South Wales, *106*, *107*
Arthur, Chester, 77
Art Institute of Chicago, *137*, 138, *140*
Art Students League, 78, 123
Austrian army, 100, 101

Bacchus (Caravaggio), 12, *12*
Back View (Guston), 4, *4*, 6
Baglione, Giovanne, 17
Baroque, art, xviii, 17, 66
 Caravaggio and, 11, 20
 Gentileschi and, 60
Beaudelaire, Charles, 39

The Beheading of St. John the Baptist (Caravaggio), *9*, 15–16, 142
Belvedere Gallery, *100*, *104*
Benton, Thomas Hart, 123
Besançon College, 24
Bey, Khalil, 34–35
Biblioteca Marucelliana, *8*
Binet, Virginie, 33
Birth of Venus (Stott), 54
The Birth of Venus (Botticelli), 1, *1*
Blackfoot tribe of Canada, 83
body of work (oeuvre), 12, 68
Bonaparte, Louis-Napoleon, 43
Bonheur, Rosa, *142*, 142–43
Bōtarō's Nurse Otsuji Prays to the God of Konpira for His Success (Yoshitoshi), 116, *116*
Botticelli, Sandro, 1, *1*
Bourbons, 27
The Bronco Buster (Remington), 86, *86*
"bronco busters," 86
bronze sculpture, 84, 86
The Brooklyn Museum, *87*
brothels, xix, 102, 107, 111, 112, 114
"Buffalo Soldiers," 83–84
Buonarroti, Michelangelo, 66–67
A Burial at Ornans (Courbet), 32, *32*
Busa, Peter, 127
butterfly monograms, by Whistler, J., 49

Café Society, 99
Caillebotte, Gustave, *140*, 140–41
Caravaggio, Michelangelo Merisi da, xviii, *8*, 142
 Bacchus by, 12, *12*
 The Beheading of St. John the Baptist by, *9*

The Cardsharps by, 10–11, *11*
The Conversion of Mary Magdalene by, *13*, 13–14
The Crucifixion of Saint Peter by, 18, *19*
early life of, 10–11
era and style of, 17–19
final years of, 16–17
in Malta, 14–16
Martha and Mary Magdalene by, *13*, 13–14
Portrait of Alof de Wignacourt by, *15*, *15*
sexuality of, 12–13
The Supper at Emmaus by, 18, *20*, 20–21
Tomassoni duel with, xviii, 9, 14
Caravaggisti, 62
The Cardsharps (Caravaggio), 10–11, *11*
Caricature of Courbet (Gill), *36*
Casa Buonarroti, 67, *67*
catalogue raisonné, 125
Caten, Eva, 75, 76, 77, 78
Catholic Church, 13
Centre Pompidou, *132*
Century Magazine, 80
Cézanne, Paul, 5, 5–7
Champfleury, 39
Chase, William Merritt, *40*
chiaroscuro style
 Caravaggio and, 10, 16, 20, 21
 Gentileschi, A. and, 62
 tenebrism as, 18
"Chicago Under the Mob" illustration (Remington), 83, *83*
Chilean navy, 47
Christ, in *The Supper at Emmaus*, *20*, 20–21
Christian art, 21
Clanton, Newman Haynes, 76–77
Clark Art Institute. *See* Sterling and Francine Clark Art Institute
Classicism style, 27, 29, 39
Cleopatra (Gentileschi, A. or Gentileschi, O.), *63*, 63–64
Coast Guard, Whistler, J. working for, 43
Collier's (magazine), 78
Coming through the Rye (Remington), 86, *86*
Convergence (Pollock), *134*, 134–35
The Conversion of Mary Magdalene (Caravaggio), *13*, 13–14
Cooling off at Shijō by the Kamo River (Yoshitoshi), 113, *118*, 118–19
Courbet, Jean Désiré Gustave, xviii, 29, *36*
 A Burial at Ornans by, 32, *32*
 death of, 37
 After Dinner at Ornans by, 30–31, *31*
 early life of, 24
 Man in Despair by, 26, *26*
 The Origin of the World by, 23, 34–35
 The Painter's Studio by, *38*, 38–39
 Self-Portrait (Man with Pipe) by, *22*
 self portraits and, 25, 26–27
 Self-Portrait with a Black Dog by, 24–25, *25*
 The Sleeping Spinner by, 33–34, *34*
 Woman with a Parrot by, 23, *23*, 34, 47
 women and, 33–35
courtesan, 13, 14, 115
cowboys, 76, 80–81, 86
Cow-boys of Arizona—Roused by a Scout (Rogers and Remington), 76–77, *77*
creative process, xviii, 6, 139
Crepuscule in Flesh Colour and Green—Valparaiso (Whistler, J.), *47*, 47–48
The Crucifixion of Saint Peter (Caravaggio), 18, *19*
Cuba, 84

A Dash for the Timber (Remington), 80–81, *81*
David (Michelangelo), xx, 1
David Owsley Museum of Art, *133*
David with the Head of Goliath (Caravaggio), 16, 16–17
"death poem," 117
deaths
 of Caravaggio, 17
 of Courbet, 37
 of Gentileschi, A., 71
 of Pollock, 132–33
 of Remington, 86
 of Schiele, Edith and Egon, 101–2
 of Whistler, J. and T., 55
 of Yoshitoshi, 117
The Deep (Pollock), *132*, 132
de Kooning, Willem, 126–27, 132–33
Delacroix, Eugène, 27–28, *28*, 31
Delaware Art Museum, *138*
del Monte, Francesco Maria, 11
Detroit Institute of Arts, *52*
Dickens, Charles, 27
dog, of Leyland, Frederick, 41, 50, 52
A drawing of Caravaggio (Leoni), *8*
Drawing of the Hand of Artemisia Gentileschi with Paintbrush (le Neveu), 65, *65*
The Dreamer (Sparhawk-Jones), 138, *138*
drip paintings, by Pollock, 130–31
dry point, 44
duel, Caravaggio and Tomassoni, xviii, 9, 14
Dutch painting, 30

early life
 of Caravaggio, 10–11
 of Courbet, 24

of Gentileschi, A., 59–61
of Krasner, 126
of Pollock, 122–23
of Remington, 76–78
of Schiele, Egon, 92
of Whistler, 42–43
of Yoshitoshi, 108–9
Edo (Tokyo, Japan), 107, 108, 109
El Greco, 2
The Embroidered Curtain (Whistler, J.), 54, *55*
emotions, 2, 3, 62, 99
 Baroque style and, 20–21
 Romanticism and, 28
 Yoshitoshi and, 115, 116
The End of the Day (Remington), 85, *85*
en grisaille (in grey tones), 78
eras. *See also* movements, art
 of Caravaggio, 17–18
 the Gilded Age, 81–82
Ernst, Max, 139
ero goru (erotic grotesque), 110
eroticism, in art
 Courbet and, 33–34
 Schiele, Egon and, 92, 96, 99, 101, 102
etching, 43, 44, *44*
Expressionism, 122

The Falling Rocket. *See Nocturne in Black and Gold* (Whistler, J.)
The Family (Schiele, Egon), *104*, 104–5
feelings, art evoking, 2, 4, 6, 135
Ferdinand, Franz, 94
Fillmore, Millard, 42
Fitzgerald, F. Scott, 2
Les Fleurs du mal (Baudelaire), 39
Florence, Italy, 66–67
Four Trees (Schiele, Egon), *100*, 100–101
Franklin, Maud, 50, 54
Frederic Remington Art Museum, *74*, *85*
French Revolutions, 24, 27, 28
 of 1849, 30
Fumette (Whistler, J.), *44*

Galerie Arnot, 99
Galerie Arnot Poster (Schiele, Egon), 99, *100*
Galilei, Galileo, 66
Galleria Borghese, *16*
Galleria d'Arte Moderna, *95*
Garden of Eden, 21
geisha, 107, 111, 114
Gentileschi, Artemesia, xviii, 65
 Allegory of Inclination by, 67, *67*
 Allegory of Painting by, *58*, 68–69
 Cleopatra possibly by, *63*, 63–64

death of, 71
early life of, 59–61
in Florence, Italy, 66–67
Jael and Sisera by, 70, *70*
Judith and Her Maidservant by, 66, *72*, 72–73
Judith and Holofernes by, 60, *61*, 62, 67
rape and trial of, 59–60, 62–63, *64*
Sleeping Venus by, 68, *69*
Susanna and the Elders by, *59*, 61–62
Gentileschi, Orazio, 59, 62–63, *63*
The Gentle Art of Making Enemies (Whistler, J.), xviii
Geronimo, 80
ghosts, 116
the Gilded Age, of United States, 81–82
Gill, Andre, 36
Godwin, Beatrice. *See* Whistler, Trixie
Going West (Pollock), 123, *124*, 125
Goldstein, Philip. *See* Guston, Philip
Goya, Francisco de, 3, *3*
grisettes, 44
Guggenheim, Peggy, 121, 128–29, 130
Guggenheim, Solomon R., 128
Guston, Philip, 4, 4–5

"half tone" process, 78
Hanai Oume Killing Minekichi (Yoshitoshi), 112, *114*
Harms, Adele, 98–99
Harms, Edith. *See* Schiele, Edith
Harper's Weekly (journal), 76, 78, *79*, 83
Hearst, William Randolph, 84
Heloise, 44
Hiffernan, Joanna, *23*, 34–35, 44–45, *45*
Hitler, Adolf, 92
Holland, 30
Holofernes, 62, 70, 72–73
horses, in art, 81, 87
Hudson River School, 28, 82

Igor (Krasner), 126, *127*
illustrator, Remington as, 78
immigration, to United States, 81
Imperative (Krasner), *127*, 127–28, 133
Imperial Academy of Fine Arts, 42
Impressionism movement, 82
Impressionist style, 37
An Indian Trapper (Remington), 83, *84*
influenza pandemic. *See* Spanish flu
In from the Night Herd (Remington), 78, *79*
Ingres, Jean Auguste Dominique, *29*, 29–30, 31
interpretations, of art, xix, 6, 105
Italy, 17
 Florence, 66–67

166 INDEX

Jade Rabbit—Sun Wukong (Yoshitoshi), *107*, 114–15
Jael and Sisera (Gentileschi, A.), 70, *70*
Japan, politics, 109, 111
Joseph, Franz, 94
Judith, 71, 72–73
Judith and Her Maidservant (Gentileschi, A.), 66, *72*, 72–73
Judith and Holofernes (Gentileschi, A.), 60, *61*, 62, 67
Judith II (Salome) (Klimt), 95

Kabuki theatre, 107, 108, 116, 118
Kamo River, 118
Kansas City, 77–78
kidnapping, Schiele, Egon, 91, 98
Kligman, Ruth, 132
Klimt, Gustav, 94, *95*, 96, 102, 105
Knights Hospitallers. *See* Knights of Malta
Knights of Malta, 14–15
Krasner, Leonore, xviii, xix, *120*, 121, 133
 early life of, 125
 Igor by, 126, *127*
 Imperative by, *127*, 127–28, 133
 Pollock and, 125–28, 131–32
 Right Bird Left by, 133, *133*
Kuniyoshi, 108, 109

la vie bohème, Whistler, J. and, 42, 46
Lee Krasner and Jackson Pollock in their garden, Springs, East Hampton (Zogbaum), *120*
le Neveu, Peirre Dumostier, 65, *65*
Leoni, Ottavio, *8*
Leopold Museum, *90*, 97
Leyland, Francis, 50
Leyland, Frederick, 50, 52
Liberty Leading the People (Delacroix), 27–28, *28*
Life (magazine), 130
London, England, 44
Los Angeles County Museum of Art, *110*, *113*, *114*, *116*
The Louvre, *15*, *25*, *28*

Madonna with the Long Neck (Mazzola), 17–18, *18*
Magritte, Rene, 2
Malta, Caravaggio in, 14–16
Man in Despair (Courbet), 26, *26*
Mannerism style, 11, 17–18
Marianna (Millais), 52, 53, *53*
Maringhi, Francesco Maria di Niccolo, 66
marks, on woodblock prints, 113
Martha and Mary Magdalene (Caravaggio), *13*, 13–14

Massachusetts, United States, 42
Mazzola, Girolamo "Parmagiano" Francesco Maria, 17–18, *18*
McKim, Musa, 4
Melandroni, Fillide, 13, *13*, 14
mental health
 Pollock and, 128
 Sparhawk-Jones and, 138
 of Yoshitoshi, 111, 112, 116
The Metropolitan Museum of Art, *5*, *23*, *29*, *40*, *43*, *55*, *86*, *124*
Michelangelo, xx, 1
Michelangelo the Younger. *See* Buonarroti, Michelangelo
Milan, Italy, 10
Millais, John Everett, 52, *53*
Milly Finch (Whistler, J.), *41*, 54
Minneapolis Institute of Art, 95
Mitsuhira, Tomobayashi Rokuro, 116–17
models, 18, 26, 39
 Franklin as, 50, 54
 Gentileschi, A. as, 61, 70
 Harms, A. as, 98
 Hiffernan as, 34, 35, 44–45
 Neuzil as, 96–97
 Schiele, G. as, 96
 Whistler, A. as, 48–49
modern art, Pollock influencing, 133
Modernism, 94
Mondrian, Piet, 128
moon, in art, 119
morality, and art, 92
Morris, Jane, 2
The Most Arrogant Man in France (Chu), 26
movements, art
 Aesthetic, 54
 Impressionism, 82
 Modernism, 94
 Post-impressionism, 82
 Regionalism, 123
 Vienna Secession, 94
murder, 73, 142
 Caravaggio and, 9, 17
 Yoshitoshi series on, 109, 118
"murder" series, by Yoshitoshi, 109, 118
Musée d'Orsay, *32*, *35*, *38*, *48*, *143*
Musée Fabre, *22*, *34*
Museo del Prado, *3*
Museum of Fine Arts, Budapest, *70*
The Museum of Fine Arts, Houston, *79*
Museum of Modern Art, *129*, *136*, 139
Museum of Non-Objective Art, 128
museums
 Albertina Museum, *103*

Amon Carter Museum of American Art, *81, 84*
Art Gallery of New South Wales, *106, 107*
Belvedere Gallery, *100, 104*
Biblioteca Marucelliana, *8*
The Brooklyn Museum, *87*
Centre Pompidou, *132*
David Owsley Museum of Art, *133*
Delaware Art Museum, *138*
Detroit Institute of Arts, *52*
Frederic Remington Art Museum, *74*
Galleria Borghese, *16*
Leopold Museum, *90, 97*
Los Angeles County Museum of Art, *110, 113, 114, 116*
The Louvre, *15, 25, 28*
The Metropolitan Museum of Art, *5, 23, 29, 40, 43, 55, 86, 124*
Minneapolis Institute of Art, *95*
Musée d'Orsay, *32, 35, 38, 48, 143*
Musée Fabre, *22, 34*
Museo del Prado, *3*
Museum of Modern Art, *129*, 139
National Gallery London, *20*
National Gallery of Art, *45, 127*
Palais des Beaux-Arts de Lille, *31*
Petit Palais, *25*
Philadelphia Museum of Art, *118*
San Francisco Museum of Modern Art, *4*
Santa Maria del Popolo, *19*
Smithsonian American Art Museum, *124*
Tate Britain, *47, 53, 56*
Uffizi Gallery, *1, 12, 18*
Virginia Museum of Fine Arts, *69*

Naples, Italy (under Spanish rule)
 Caravaggio in, 14
 Gentileschi, A. in, 68
Napoleon, 3, 27
Napoleon III, 30, 39
National Gallery London, *20*
National Gallery of Art, *45, 127*
Native Americans, 83, 86–87
Neoclassicism style, 27, 28, 29–30
Neuzil, Valerie "Wally," 96–97, *97*, 98–99, 102
"New Forms of Thirty-Six Ghosts" (Yoshitoshi), 116
New Rochelle, New York, 76, 80–81
New York, United States, 76, 77, 78
No. 1A (Pollock), 131, *131*
nocturne, paintings
 Remington and, 85, 88
 Whistler and, 50, 51, 56–57
Nocturne in Black and Gold (Whistler, J.), 51, *51*
Nocturne in Blue and Gold (Whistler, J.), *56*, 56–57

Non-Objective Art, 128
nudes, 67, 96, 98, 101, 102

oeuvre (body of work), 12, 68
O'Keeffe, Georgia, 2
Okoto, 111
Old Battersea Bridge, 56
The Old Warrior Tomobayashi Rokuro Mitsuhira (Yoshitoshi), 116–17, *117*
Old West, 77–78, 89
 cowboys and, 76, 80–81, 86
One Hundred Aspects of the Moon series (Yoshitoshi), 114, 115, 118
Oraku, 111–12
The Origin of the World (Courbet), 23, 34–35
Ornans, France, 24, *31*, *32*, 33, 38
The Outlier (Remington), 87, *87*

painterly art, 87
The Painter's Studio (Courbet), *38*, 38–39
painting. *See specific topics and artists*
Palais des Beaux-Arts de Lille, *31*
palette knife, 14, 69, 71
pandemic. *See* Spanish flu
Pantuhoff, Igor, 125
Paris, France, 24–25, 27. *See also* the Paris Salon
 Paris Commune and, 35
 Whistler, J. in, 44–45
Paris Commune, 35
the Paris Salon, 25, 31, 46
Paris Street (Caillebotte), 140, *141*
Paris World's Fair (1855), 38
Parmagiano. *See* Mazzola, Girolamo "Parmagiano" Francesco Maria
passion, 2
patronage, 66
Peisse, Louis, 31
Peterzano, Simone, 10
Petit Palais, *25*
Philadelphia Museum of Art, *118*
photography, invention of, 27
Place Vendôme, 35
Ploughing in the Nivernais (Bonheur), *142*, 142–43
poem, by Yoshitoshi, 117
politics, Japan, 109, 111
Pollock, Paul Jackson, xviii, xix
 alcoholism and, 121–22, 126, 130, 131
 "all over" style, 123, 125, 130, 135
 Convergence by, *134*, 134–35
 death of, 132–33
 The Deep by, 132, *132*
 early life of, 122–23
 Going West by, 123, *124*, 125

Guggenheim, P. and, 128–29, 130
Krasner and, 125–28, 131–32
modern art influenced by, 133
No. 1A by, 131, *131*
Portrait and a Dream by, *120*
Silver over Black, White, Yellow and Red by, *121*
Stenographic Figure by, 128, 129, *129*
Pollock-Krasner House and Study Center, *120*
pornography, 91, 103
Portrait and a Dream (Pollock), *120*
Portrait of Alof de Wignacourt (Caravaggio), 15, *15*
Portrait of Wally (Schiele, Egon), 97, *97*
Portrait of Whistler (Chase), *40*
Portrait of Yoshitoshi (Toshikage), *106*
Post-impressionism movement, 82
poverty, and Yoshitoshi, 112
Pre-Raphaelite Brotherhood, 51, 52, 53
Princess de Broglie (Ingres), 29
prints. *See* woodblock prints
prison
 Courbet in, 35
 Schiele, Egon in, 91, 98
Proserpine (Rossetti), 2, *2*
prostitution, 97
provenance, of a painting, 68

racism, 82–84
Ranch Life and the Hunting Trail (Roosevelt, T.), 80
rape and trial, of Gentileschi, A., 59–60, 62–63, 64
Realism, 31
Reclining Nude (Schiele, Egon), 102, *103*
Reclining Woman (Schiele, Egon), 98, *98*, 101
Regionalism movement, 123
Remington, Frederic Sackrider, xviii, *74*, 75
 The Bronco Buster by, 86, *86*
 "Chicago Under the Mob" illustration by, 83, *83*
 Coming through the Rye by, 86, *86*
 Cow-boys of Arizona—Roused by a Scout by, 76–77, *77*
 A Dash for the Timber by, 80–81, *81*
 death of, 86
 early life of, 76–78
 The End of the Day by, 85, *85*
 An Indian Trapper by, 83, *84*
 In from the Night Herd by, 78, *79*
 The Outlier by, 87, *87*
 The Scout by, 88, 88–89
 Self-Portrait by, *75*, 80
 in the West, 80
 xenophobia and, 82–84

Renaissance style, 11, 17, 20, 63
Revolution of 1848 (France), 30
"The Rich Boy" (Fitzgerald), 2
Right Bird Left (Krasner), 133, *133*
Rogers, William Allen, 77, *77*
Romanticism style, 27, 28, 39, 78
Romantic style. *See* Romanticism style
Rome, Italy, 64
 Caravaggio in, 9–10, 11–13
Roosevelt, Franklin D., 123
Roosevelt, Theodore, 80, 82, 84
Rosenberg, Harold, 132
Rossetti, Dante Gabriel, 2, *2*
Rousseau, Henri, 2
Royal Academy of Art, 39
Royal Collection, *58*
Ruskin, John, 51

Sag Harbor, 132
Saint Peter, 18, *19*
San Francisco Museum of Modern Art, *4*
Santa Maria del Popolo, *19*
Savonarola, 1
Schiele, Edith, 99, 100, 101–2
Schiele, Egon, xviii–xix
 death of, 101–2
 early life of, 92
 eroticism and, 92, 96, 99, 101, 102
 The Family by, *104*, 104–5
 Four Trees by, *100*, 100–101
 Galerie Arnot Poster by, 99, *100*
 Klimt and, 94, 96
 Portrait of Wally by, 97, *97*
 in prison, 91, 98
 Reclining Nude by, 102, *103*
 Reclining Woman by, 98, *98*, 101
 Seated Woman with Bent Knee by, *91*
 Self-Portrait by, 90
 Standing Girl in a Plaid Garment by, 94, *95*
 Standing Nude with Large Hat by, 96, *96*
 Summer Landscape by, *101*
 Trieste Harbor by, 92, *93*
Schiele, Gertrude, 95, *96*
school
 Courbet in, 24
 Pollock in, 122–23
 Schiele, Egon at, 92, 94
The Scout (Remington), *88*, 88–89
Seated Woman with Bent Knee (Schiele, Egon), *91*
Self-Portrait (Man with Pipe) (Courbet), 22
Self-Portrait (Remington), *75*, 80
Self-Portrait (Schiele, Egon), 90

INDEX

self portraits, and Courbet, 24–25, *25*, 26–27, *62*
Self-Portrait with a Black Dog (Courbet), 24–25, *25*
self-reflection, 2
sexuality, 12–13, 61, 142
The Shoe Shop (Sparhawk-Jones), 137, *137*
sibille (torture device), 59, 60, 64
signature, by artist, 113
Silver over Black, White, Yellow and Red (Pollock), *121*
Sketches on the Coast Survey Plate (Whistler, J.), 43, *43*
Sketch of Hanai Oume Killing (Yoshitoshi), 112, *113*
The Sleeping Spinner (Courbet), 33–34, *34*
Sleeping Venus (Gentileschi, A.), 68, *69*
Smith, Jeffrey K., *136*
Smithsonian American Art Museum, *124*
Solomon R. Guggenheim Museum of New York City, 128
spada da lato (type of sword), 14
Spain, 3, 17, 84
Spanish American War, 84
Spanish flu, 101–2, 104
Sparhawk-Jones, Elizabeth
 The Dreamer by, 138, *138*
 The Shoe Shop by, 137, *137*
Standing Girl in a Plaid Garment (Schiele, Egon), 94, *95*
Standing Nude with Large Hat (Schiele, Egon), 96, *96*
Stenographic Figure (Pollock), 128, 129, *129*
Sterling and Francine Clark Art Institute, 88, *88*
Stiattesi, Pietro Antonio, 65
still lifes, 5–6
Still Life with Apples and a Pot of Primroses (Cézanne), *5*, 5–6
St. John's Co-Cathedral, 9
Stott, William, 54
St. Petersburg, Russia, 42
styles, art
 Abstract Expressionism, 122, 123
 "all over," 123, 125, 130, 135
 baroque, xviii, 11, 17, 20, 60, 66
 chiaroscuro, 10, 16, 18, 20, 21, 62
 Classicism, 27, 29, 39
 en grisaille (in grey tones), 78
 ero goru (erotic grotesque), 110
 Expressionism, 122
 Impressionist, 37
 Mannerism style, 11, 17–18
 Neoclassicism, 27, 28, 29–30
 painterly, 87

 Renaissance, 11, 17, 20, 63
 Romanticism, 27, 28, 39, 78
 sublime, 57
 tenebrist, 30–31
sublime, art, 57
Summer Landscape (Schiele, Egon), *101*
The Supper at Emmaus (Caravaggio), 18, *20*, 20–21
Susanna and the Elders (Gentileschi, A.), 59, 61–62
Switzerland, Courbet in, 35, 37
sword fighting, 14
symbolism, 21, 33, 38, 39, 60, 73. *See also* allegorical painting
Symphony in White No. 1 (Whistler, J.), 34, *45*, 45–46

Taiko, Sakamaki, 114
A Tale of Two Cities (Dickens), 27
Tassi, Agostino, 61, 65
 trial against, 59–60, 62–63, 64
Tate Britain, *47*, *53*, *56*
Ten-Doesschate Chu, Petra, 26
tenebrism (chiaroscuro), 18
tenebrist style, 30–31
"The Ten O'Clock" (Whistler, J.), 54
The Third of May 1808, in Madrid (Goya), 3, *3*, 4, 6
Thirty-two Aspects of Customs and Manners series (Yoshitoshi), 114, 115, *115*
Tokugawa Shogunate, 109
Tokyo, Japan. *See* Edo (Tokyo, Japan)
Tomassoni, Ranuccio, 9, 14, 17
 The Beheading of St. John, the Baptist referencing, 15–16
torture device (*sibille*), 59, 60
Toshikage, Tanaki, *106*
trials
 against Tassi, 59–60, 62–63, 64
 Whistler and, 50–53
"trick of the eye," trompe l'oeil, 21
Trieste Harbor (Schiele, Egon), 92, *93*
triptych, 108
trompe l'oeil, "trick of the eye," 21
Turner, J. M. W., 51
Tuzia, 61, 62
"Twenty-eight Murders with Verse" (Yoshitoshi), 109

Uffizi Gallery, *1*, *12*, *18*
ukiyo, "floating world," 107, 108
ukiyo-e woodblock prints, 107, 109, 112, 118–19

United States
 Gilded Age in, 81–82
 Immigration to, 81
 old West, 76, 77–78, 81, 89
United States Military Academy at West Point, 41, 42–43

Valparaiso, Chili, 47
Van Gogh, Vincent, 2
Vendôme Column, 35
Vespucci, Simonetta, 1
Vienna, Austria, 92
Vienna Secession art movement, 94
viewing art, 139–41
Vignon, Claude, 32
Virginia Museum of Fine Arts, 69

Wally. *See* Neuzil, Valerie "Wally"
Wanting to Meet Someone (Yoshitoshi), 115, *115*
watercolors, 84
the West, United States. *See* Old West
West Point. *See* United States Military Academy at West Point
Whistler, Anna McNeill, 46, 48
Whistler, James Abbott McNeill, xviii, 34, *40*, 41
 Arrangement in Grey and Black, No. 1 by, *48*, 48–49
 Crepuscule in Flesh Colour and Green—Valparaiso by, *47*, 47–48
 early life of, 42
 The Embroidered Curtain by, 54, *55*
 Fumette by, *44*
 Hiffernan and, 44–47
 military training of, 42–43
 Milly Finch by, *41*, 54
 Nocturne in Black and Gold by, 51, *51*
 Nocturne in Blue and Gold by, 56, 56–57
 Ruskin trial with, 51–53
 Sketches on the Coast Survey Plate by, 43, *43*
 Symphony in White No. 1 by, 34, *45*, 45–46
 in Valparaiso, 47
 Whistler's butterfly signatures by, 49, *49*
Whistler, Trixie, 54–55
Whistler's butterfly signatures (Whistler, J.), 49, *49*
"Whistler's Mother." *See Arrangement in Grey and Black, No. 1* (Whistler, J.)
The White Girl. See Symphony in White No. 1
Wignacourt, Alof de, 15, *15*
Wilde, Oscar, 50, 54, 56

The Woman Kansuke Slaying an Assailant with a Sword (Yoshitoshi), 109, *110*
Woman with a Parrot (Courbet), 23, *23*, 34, 47
Wood, Grant, 129–30, *130*
woodblock prints, 107, 109, 119. *See also* ukiyo-e woodblock prints
 process of, 112–14
Works Progress Administration (WPA), 123
World War I, 100, 105
World War II, 128
WPA. *See* Works Progress Administration
The Wrestler Chōgorō Throwing a Devil (Yoshitoshi), 111, *111*

xenophobia, 82–84
X-ray analysis, of art, 18

Yale, Remington at, 76
Yōnejiro, Owariya. *See* Yoshitoshi, Tsukioka
Yoshitoshi, Tsukioka, xix, 107
 Bōtarō's Nurse Otsuji Prays to the God of Konpira for His Success by, 116, *116*
 Cooling off at Shijō by the Kamo River by, 113, *118*, 118–19
 death of, 117
 early life of, 108–9
 Hanai Oume Killing Minekichi by, 112, *114*
 Jade Rabbit—Sun Wukong by, *107*, 114–15
 mental health of, 111, 112, 116
 "New Forms of Thirty-Six Ghosts" by, 116
 The Old Warrior Tomobayashi Rokuro Mitsuhira by, 116–17, *117*
 One Hundred Aspects of the Moon series by, 114, 115, 118
 Sketch of Hanai Oume Killing by, 112, *113*
 Thirty-two Aspects of Customs and Manners series by, 114, 115, *115*
 "Twenty-eight Murders with Verse" by, 109
 Wanting to Meet Someone by, 115, *115*
 The Woman Kansuke Slaying an Assailant with a Sword by, 109, *110*
 The Wrestler Chōgorō Throwing a Devil by, 111, *111*
"Yoshitoshi's Selection of One Hundred Warriors" by, 109, 110
"Yoshitoshi's Selection of One Hundred Warriors" (Yoshitoshi), 109, 110

Zogbaum, Wilfrid, *120*

About the Author

Jeffrey K. Smith, PhD, is professor and dean of the College of Education at the University of Otago in New Zealand. From 1976 to 2005, he was a professor at Rutgers University. He has also served as head of the Office of Research and Evaluation at The Metropolitan Museum of Art from 1987 to 2005. He received the Rudolph Arnheim Award from the American Psychological Association and the Gustav Fechner Award from the International Association of Empirical Aesthetics for his research on the psychology of aesthetics. He received his AB from Princeton University and his PhD from the University of Chicago.